DRAWING
MANGA
FACES & EXPRESSIONS
A STEP-BY-STEP BEGINNER'S GUIDE

WITH OVER
1200
Drawings

YANAMi

TUTTLE Publishing

Tokyo | Rutland, Vermont | Singapore

Five Key Points to Drawing Males and Females

You may have picked up this book because you're struggling with how to draw boys without them appearing to be girls or women so they're not so masculine. If you master the 5 points introduced here, you'll be able to freely express a wide range of characters.

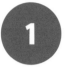

Outlines—Circle for Women, Circle + Irregular Pentagon for Men

Front profile

When you draw a character's face, use the shape of a circle for women and a circle plus a slightly irregular pentagon for men. Doing this gives women's faces a round, cute look, and men bold looks with a strong chin.

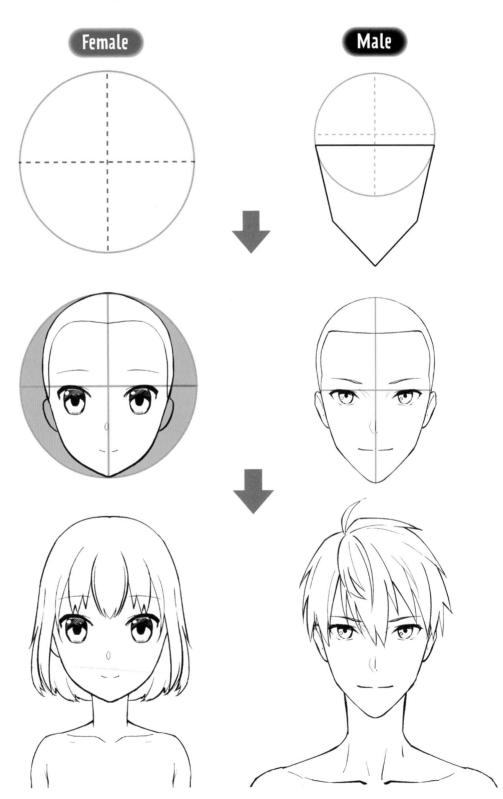

At an angle

The characters don't have to be looking face-on, as the same rules apply for any angle. So women's faces are drawn shaped within the circle and men's faces are shaped to fit the circle plus a slightly irregular pentagon.

This outline is the first and most important point. If you can start drawing from here, even if there are two twin characters, you can differentiate between them by gender. This will let you greatly expand the range of characters you can draw.

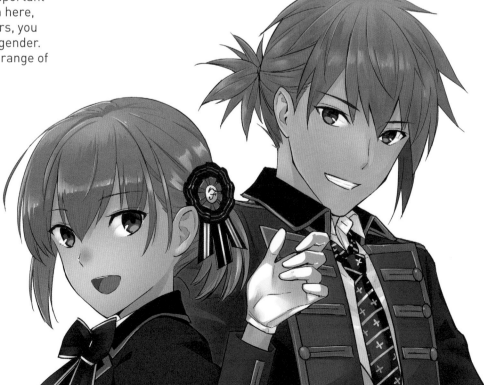

3

2 Learn to Draw the Eyes, Nose, Mouth and Other Facial Features

The shape of the eyes, nose and mouth—all of these have differences, depending on whether the character is male or female. In manga and anime, these features are drawn using distortion to emphasize them. As you learn the differences in features, remember how each part is positioned as well to make it easier to draw them.

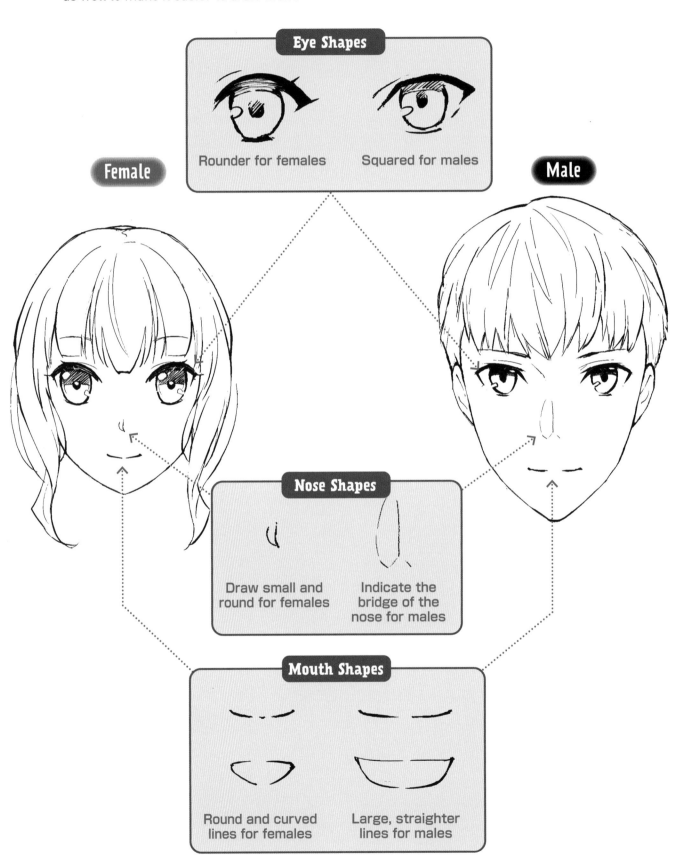

Eye Shapes

Rounder for females Squared for males

Female

Male

Nose Shapes

Draw small and round for females Indicate the bridge of the nose for males

Mouth Shapes

Round and curved lines for females Large, straighter lines for males

Female

Male

Flows from a part

Flows from a whorl

The hair style is also an important feature, not only to differentiate between male and female, but also to add individual character. Understand the difference in male and female hair textures and how hair flows in order to be able to draw it.

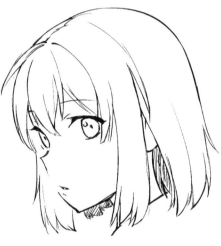

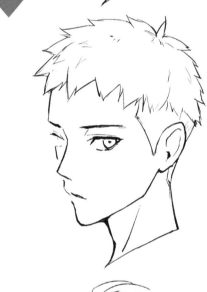

By understanding the different textures of hair and how it flows, you will be able to draw a character with short hair that looks like a female and one with long hair that looks like a male.

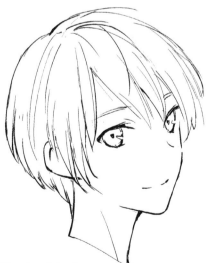

Girl with short hair

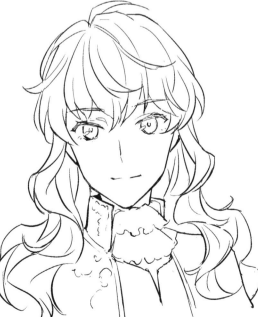

Boy with long hair

3 Drawing Male and Female Faces from Different Angles

Female **Male**

Males and females have different bone structures. In manga and anime, distortion is used to add emphasis to the bone structure. These differences can be seen in various ways depending upon the viewer's perspective. By understanding how the differences in gender appear, you can draw male and female faces from various angles.

Significant distortion ("super deformation")

A realistic mouth

From the side, it's easy to see the distortions and gender differences for the nose and mouth.

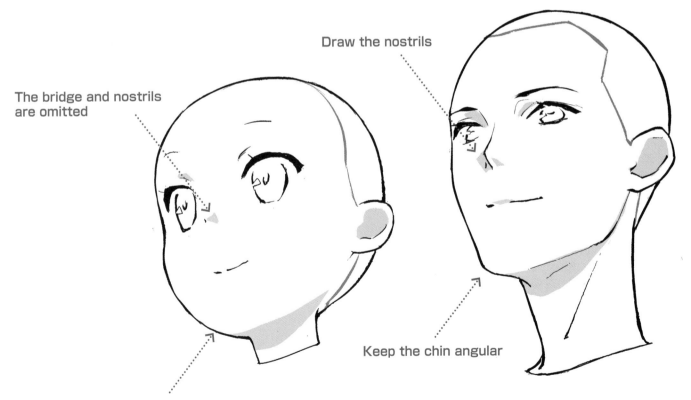

Draw the nostrils

The bridge and nostrils are omitted

Keep the chin angular

Round, cute chin that doesn't protrude

When the head is tilting slightly up, the nostrils and area under the chin are visible. It is important here to choose whether to draw it realistically or to omit parts so as to differentiate between male and female.

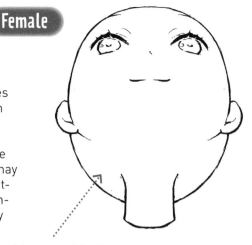

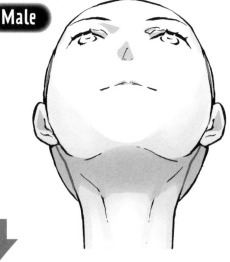

In manga and anime, females in particular are drawn in an extremely exaggerated way using "super deformation." Due to this, depending on the angle, there are parts that may appear unnatural. It's important to think about how to conceal those areas so that they don't look strange.

Unnatural-looking area

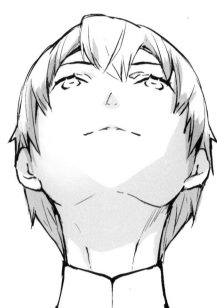

Cover with hair or the body

Examples of super-low angles. Depending on the amount of distortion, the area around the chin and back of the head may look unnatural. Add hair and body structure to adequately conceal those areas.

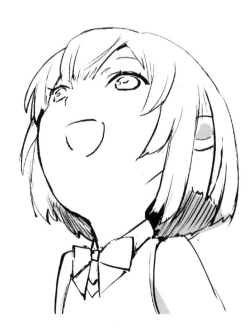

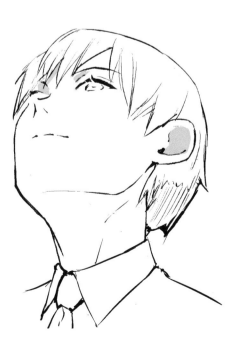

How do male and female faces change depending on the angle of perspective? Should you draw them realistically or add distortion? By considering these questions before drawing, you will come to be able to draw faces from various angles.

4 Adjusting Facial Outlines for Age

Begin by drawing a circle outline for females and a circle plus irregular pentagon outline for males. Then, by adjusting those shapes, you can draw males and females of various ages.

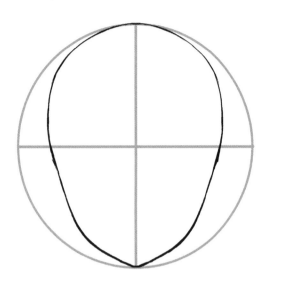

Child

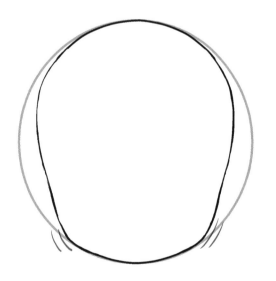

Draw a slightly compressed outline.

Draw a narrow and slightly vertical outline for women and a wider one for men.

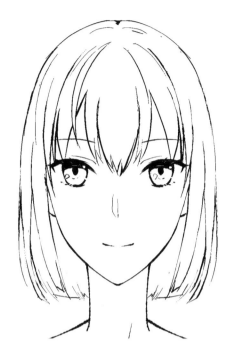

Young adult

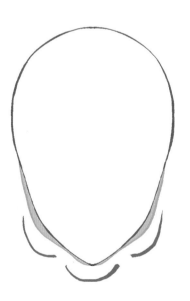

Add slackness around the jaw of the adult's outline.

Middle-aged adult

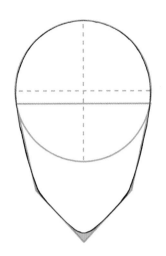

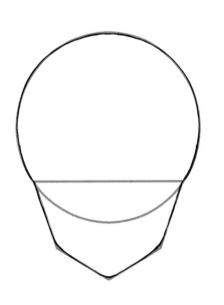

Child

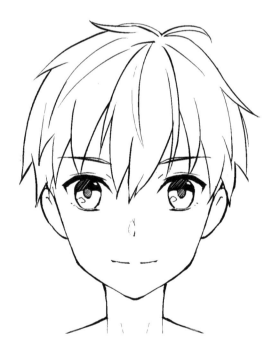

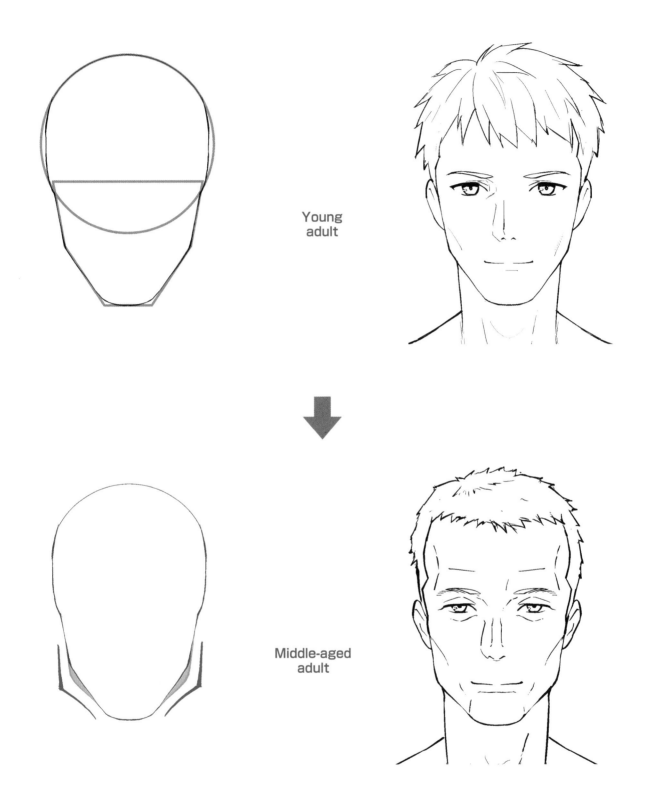

Young
adult

Middle-aged
adult

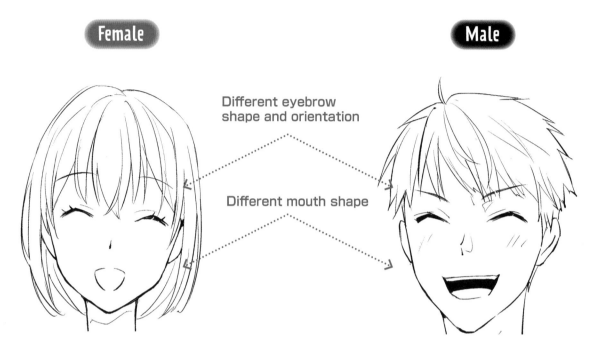

Female | Male

Different eyebrow shape and orientation

Different mouth shape

Examples of happy, smiling expressions, where the shape of the mouth and eyebrows have been adjusted by gender.

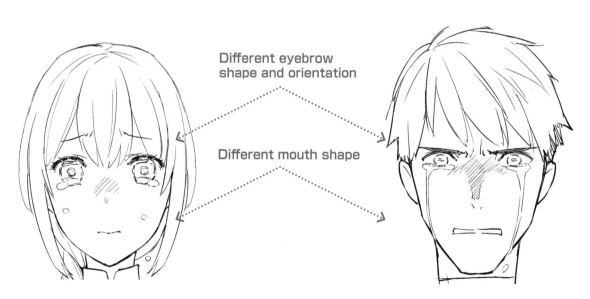

Different eyebrow shape and orientation

Different mouth shape

Even with a single expression like tears of sadness, males and females knit their eyebrows and clench their mouths differently.

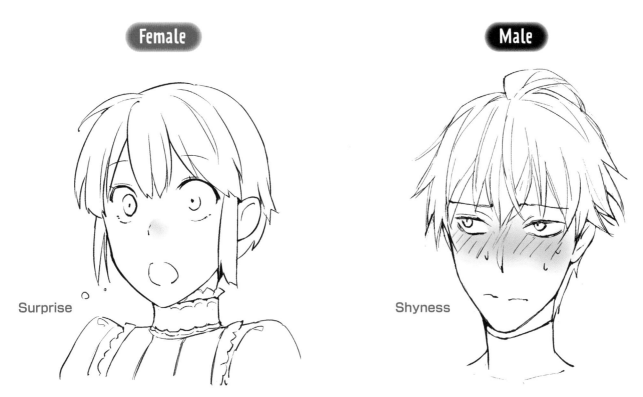

Female

Male

Surprise

Shyness

By learning how to change facial features, you can express even complex expressions like shyness, surprise or fright.

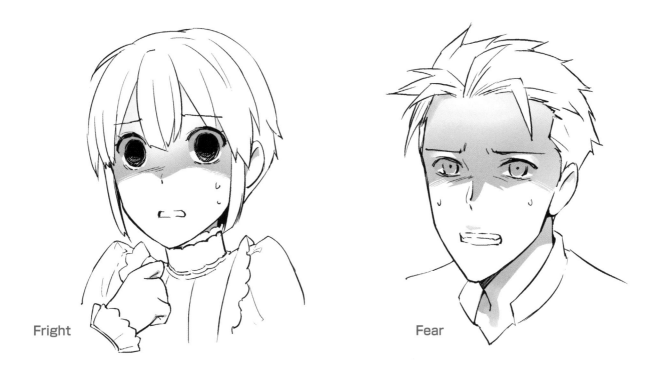

Fright

Fear

To express fearful eyes well, keep the irises large and remove the high-lights. Add lines under the eyes to look like bags and draw the teeth lightly clenched to express fear. If you fill in the irises completely for a female, it will look cute even when she is expressing fear.

CONTENTS

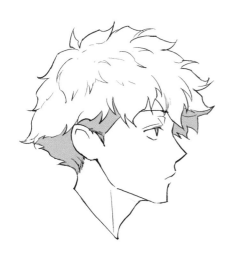
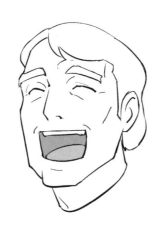

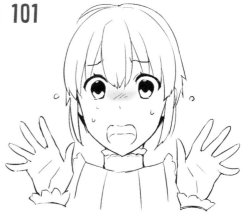

Foreword

Learn to Draw Male and Female Faces!

Become an Artist of Faces

This is the basic concept of this book.

It is, of course, important to be able to draw character bodies too. But the most expressive part of a character is the face. By choosing this book, you are probably wanting to become an expert at drawing characters' faces.

It can be a tall order to draw a picture when you're concerned with how to draw the body or preoccupied with having to add a background too. So, once you have the basics down, master drawing the most rewarding part—the face!

But even if you sketch a real person's face as you see it, it won't look like a face from manga or anime. I often hear statements like, "I tried drawing a beautiful young girl, but her chin ended up looking rugged" and "I wanted to draw a cool-looking young boy, but I couldn't get his nostrils to look right." Many people have trouble drawing manga-style males and females well.

This book focuses on drawing characters' faces, as this can be a huge stumbling block for beginners. I will show you each of the character design techniques so you can learn how to add distortion and draw your own adorable female and cool male characters.

While you are reading this book, pick up a pencil and try to see yourself as an artist who can effortlessly draw faces.

If you can draw the faces of your favorite characters with ease, it will make drawing so much more fun. This will encourage you to go on to draw characters' bodies and backgrounds.

CHAPTER 1

The Basics of Drawing Faces

Let's begin by drawing faces from the front, the side and at an angle to learn the basics for distinguishing between drawing males and females. If you can remember the size and positioning of the eyes, nose, mouth and ears, you'll be able to consistently draw both male and female faces.

Drawing Faces from the Front

When you look at male and female characters' faces straight on from the front, you will notice their different characteristics. Try drawing while paying attention to the size of the eyes, the shape of the nose and mouth, and the position of the individual features.

Ways to Draw Female Faces

Using a Circle to Create a Soft Outline

Female characters can be made distinguishable from male ones by expressing the softness and roundness of their cheeks. Begin by drawing a circle and then create an outline that tapers in curves on both sides.

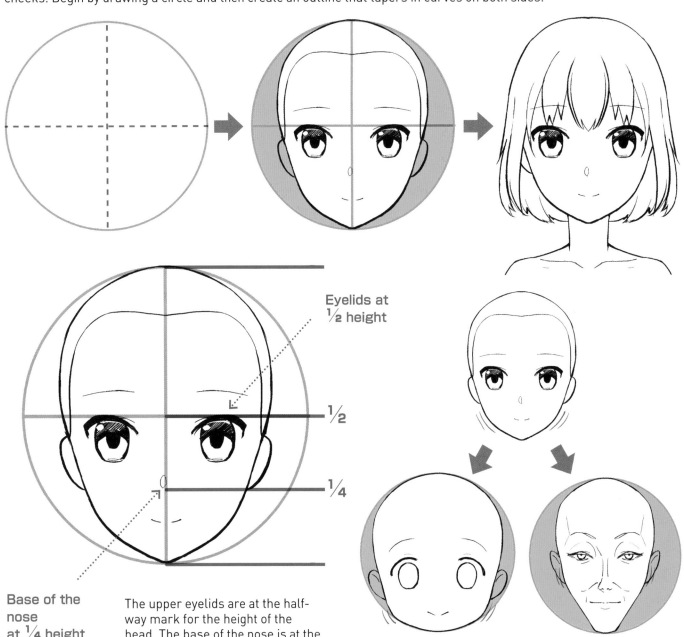

Eyelids at ½ height

½

¼

Base of the nose at ¼ height

The upper eyelids are at the halfway mark for the height of the head. The base of the nose is at the one-quarter mark for the height of the head. If you remember this, you will be able to maintain better balance.

The swell of the cheeks shows the position for the height of the mouth. The lower the position of the cheeks, the younger and rounder the face. If the cheeks are higher, it will create a narrower adult face.

18

Create the Outline

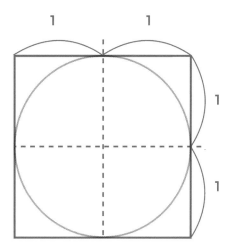

1 Draw a well-formed circle, and then add crossed lines through it. The vertical line is the midline (the line running through the center of the face) and the horizontal line marks where the upper eyelids are placed.

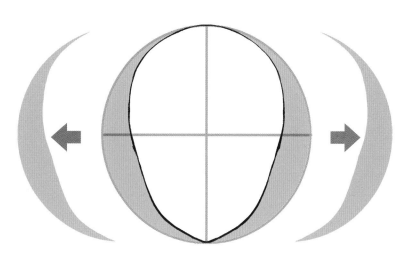

2 Next, create an outline that tapers in from both sides of the circle. The space between the outline and circle edge should resemble an angled, irregular crescent moon. The key here is to reduce the area around the height of the eyes and nose. Don't look at the shape of the face, but rather focus on the shape of the part you are cutting out, so you can draw it clearly.

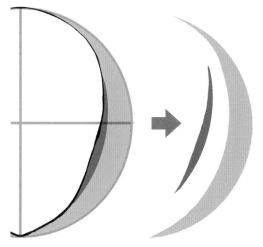

If you're finding it difficult to form the irregular crescent shape, start by drawing a perfect crescent, and then add a shape like a blade of grass or thin leaf.

Be sure to check the shape of the outline. The outline from the upper eyelid down to the base of the nose is almost straight.

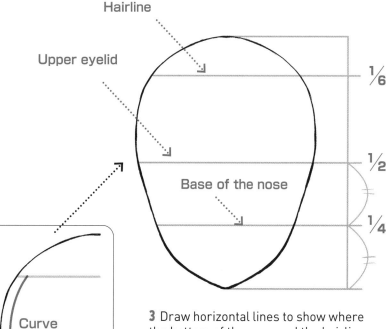

Hairline

Upper eyelid

Base of the nose

Curve

Straight

Curve

3 Draw horizontal lines to show where the bottom of the nose and the hairline will go. The bottom of the nose is ¼ of the way up from the chin. The position of the hairline is about ⅙ of the way from the top of the head (with the area above the eyes divided into 3 equal parts).

Drawing Eyes

The space between the eye and outline is less than $\frac{1}{2}$ of the eye width

Make a space slightly larger than the size of 1 eye

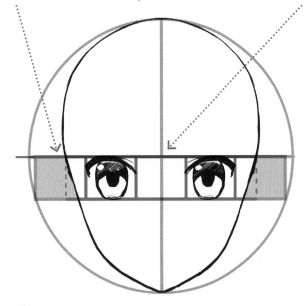

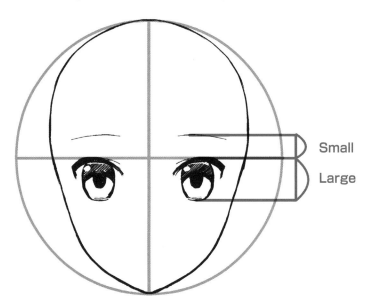

Small

Large

1 Add 2 boxes under the horizontal midline and draw eyes in them. Make the space between the eyes slightly larger than the size of 1 eye.

2 Draw the eyebrows. Make the space above the eyes smaller than the height of 1 eye. Here, the eyebrows have been simplified, making them thinner and shorter than a male's.

The ratio of the height to width of the eyes should be 1:1, or have the width slightly longer. Slightly compress the square box and draw the image of the eye within it.

1 (approx.)

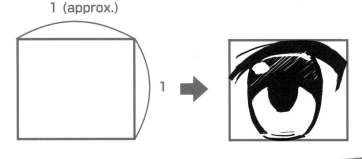

TIP

What To Do When You Can't Get The Correct Eye Shape?

If you feel eyes are complicated and too difficult to draw, try looking carefully at the negative space in the box, rather than the eyes themselves. The corners of those areas will be shaped like triangles with concave inner edges and their sizes will be different, depending on whether the eyes are slanting up or down.

Character's left eye

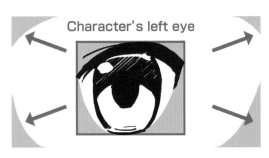

Character's left eye

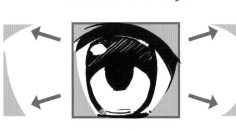

Slanting up Omit a smaller triangle at the top outer corner of the eye.

Slanting down Make the triangle at the top inner corner of the eye smaller to show eyes slanting downward.

Drawing the Nose, Mouth and Ears

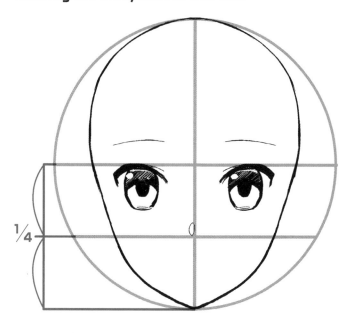

1 Draw the highlight of the nose (the part that catches the light) above the ¼ horizontal line to express the nose.

From the side, the nose sticks out at an angle, making it easy to draw, but from the front it's really difficult to draw the outline of the nose. In manga and anime, rather than drawing the nose itself, its shape is expressed by defining the area where the light catches the projecting feature.

2 Draw the mouth. Aim for the center between the nose and the chin. This is slightly lower than for males.

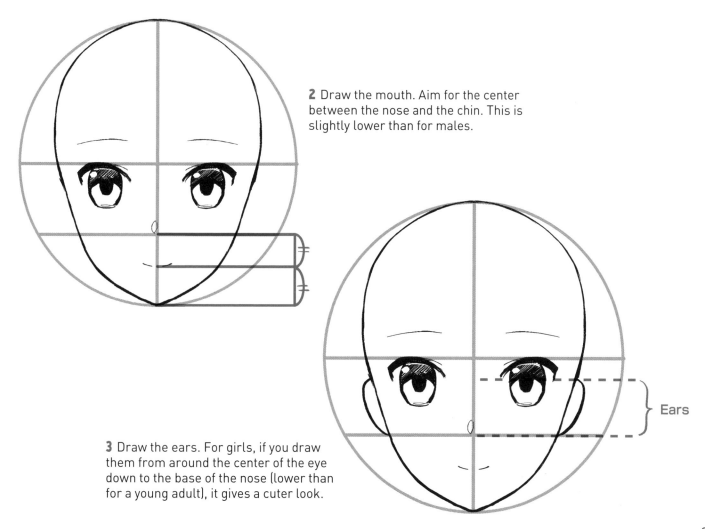

3 Draw the ears. For girls, if you draw them from around the center of the eye down to the base of the nose (lower than for a young adult), it gives a cuter look.

Drawing the Neck and Shoulders

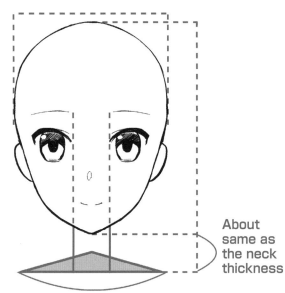

The same or slightly wider than the head width

About same as the neck thickness

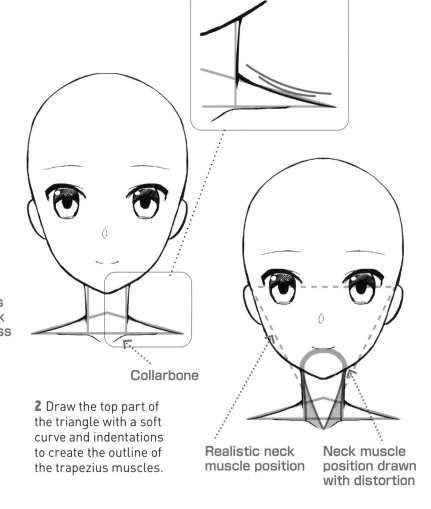

Collarbone

Realistic neck muscle position

Neck muscle position drawn with distortion

1 Create the shape of the neck. The width between the eyes is a good gauge for how thick the neck should be. The length should be about the same size as the thickness. Draw a triangle of a size equal to or slightly wider than the head to create the area of the trapezius muscles that extend to the shoulders.

2 Draw the top part of the triangle with a soft curve and indentations to create the outline of the trapezius muscles.

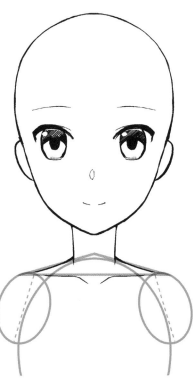

3 Draw an oval about the size of the head so that it overlaps the triangle and creates the chest area. Then, draw two small ovals, one on each side, to create the shoulder areas.

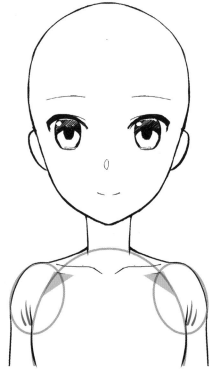

4 Draw the indentations and slack skin around the armpit area to create a natural join between the shoulders and torso.

Finishing Touches

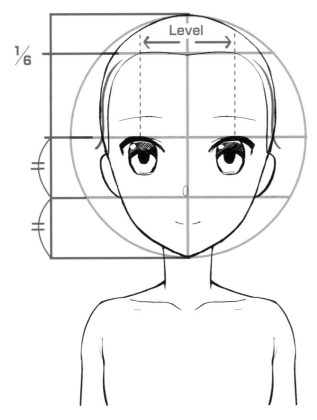

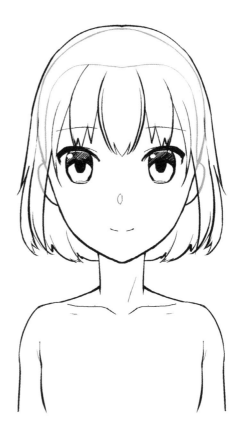

5 Draw the hairline. The center of the forehead is almost level. Sketch in the vertical edges of the hair with a very gentle S shapes.

6 Add 3 sections of hair to the front, and then add sections at the sides and back to complete the look. (See page 136 for more on how to draw hair.)

NOTE

Use Wide Spacing for Young Girls' Eyes

Young girls' large eyes are expressed through distortion by omitting the inner corners of the eyes. Due to this, if the space between the eyes is narrow, it can look like crossed eyes and seem unnatural. If you draw the eyes leaving a space between them that is the width of 1 eye or slightly more, it looks cuter.

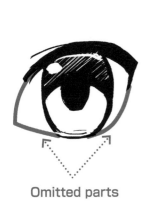

Omitted parts

Adjusting the Position of Features

While you can position the features as they are shown on page 19, it may make your faces look a bit elongated. If that happens, try slightly lowering the placement of the eyes, nose and mouth to create a cuter effect.

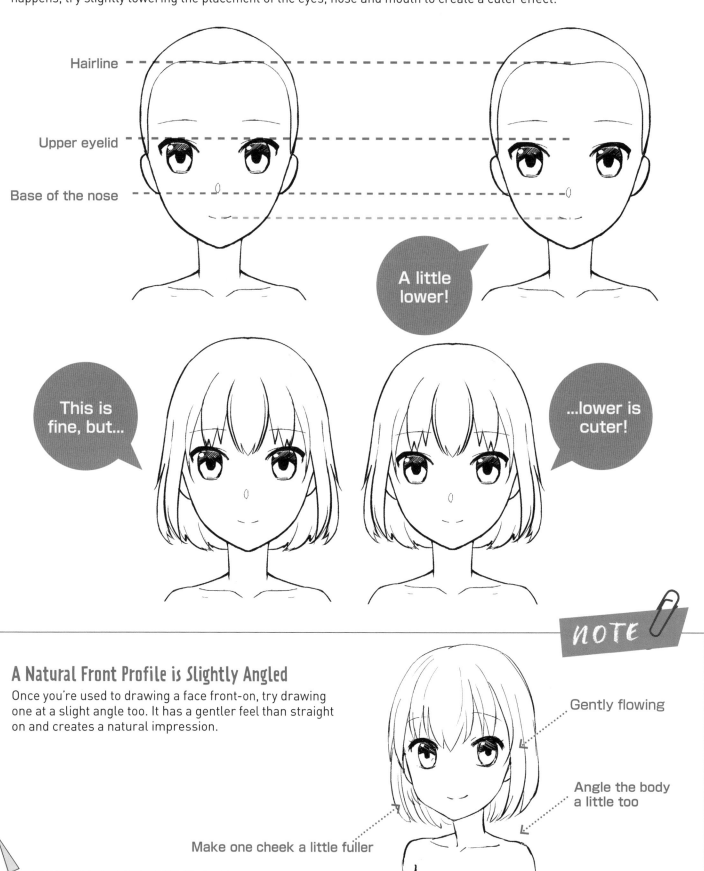

Hairline

Upper eyelid

Base of the nose

A little lower!

This is fine, but...

...lower is cuter!

NOTE

A Natural Front Profile is Slightly Angled

Once you're used to drawing a face front-on, try drawing one at a slight angle too. It has a gentler feel than straight on and creates a natural impression.

Gently flowing

Angle the body a little too

Make one cheek a little fuller

Once you've drawn the basic front-on face, let's make some changes to the character.

Creating a Scornful Look with Lowered Eyelids

Chapter 4 gives a more detailed explanation on how to draw expressions, so here we'll focus on how to change just the eyes to create a character giving a simple scornful look (eyes half-closed). The eyelids are drawn in a straight line and faint lines are added to where the upper eyelids would normally be.

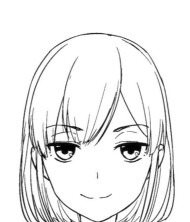

If you raise the eyebrows and add a slight smile, it creates a character with a somewhat provocative expression.

Tips for Drawing Females Wearing Glasses

Manga-style female characters have large eyes and low-placed ears, so if you have them wearing glasses, the frames will cover the eyes. You'll need a technique to keep this from happening when you draw glasses.

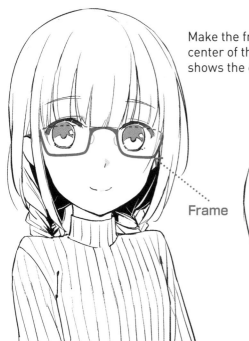

Frame

Make the frames of glasses larger so they don't cover the center of the eye. If you draw half-framed glasses, it clearly shows the entirety of the eyes.

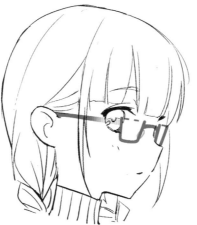

When drawing faces from the side, the temples of the glasses tend to cover the eyes. You can omit part of the temple or draw from an angle where it doesn't cover the eye.

Ways to Draw Male Faces

Using an Irregular Pentagon to Create a Masculine Chin

A circle is used to draw a female face and a circle plus an irregular pentagon is used to create the outline of a male face. By doing this, the shape of the face becomes naturally longer and creates a defined, masculine chin.

Approx. 3

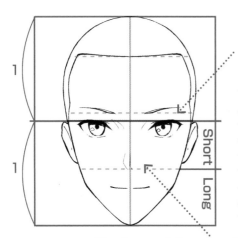

The trick is to position the top edge of the irregular pentagon a little lower than the horizontal center of the circle. This placement matches the outline of a young adult's face.

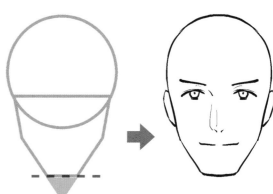

The more you trim the pointed end of the irregular pentagon, the more masculine the face becomes.

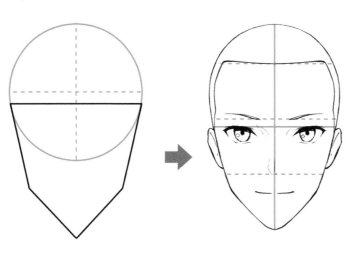

Eyelids at ½ height

The upper eyelids are at ½ head height, the same as for women. However, the placement of the nose and mouth change, so let's take a closer look at how to draw them.

The base of the nose is a little higher than ¼ of the height of the face

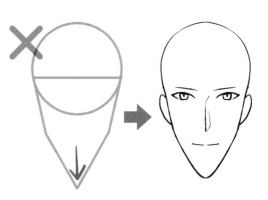

If you draw a long, thin irregular pentagon, it will make the chin extremely pointy and the face will not look well balanced.

Create the Outline

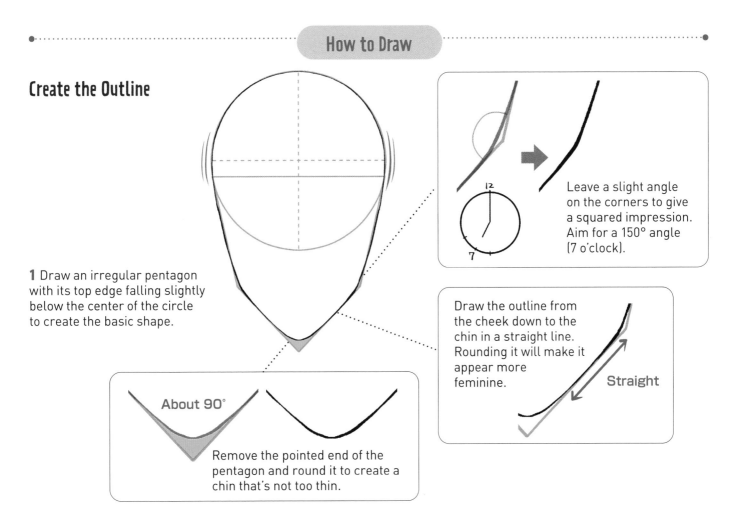

1 Draw an irregular pentagon with its top edge falling slightly below the center of the circle to create the basic shape.

Leave a slight angle on the corners to give a squared impression. Aim for a 150° angle (7 o'clock).

Draw the outline from the cheek down to the chin in a straight line. Rounding it will make it appear more feminine.

Straight

About 90°

Remove the pointed end of the pentagon and round it to create a chin that's not too thin.

Drawing Eyes

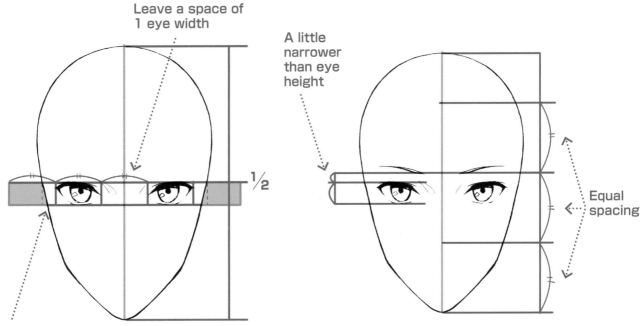

Leave a space of 1 eye width

A little narrower than eye height

½

Equal spacing

The space between the eye and outline is about ⅓ of an eye width

2 Add 2 boxes below the horizontal midline and draw eyes in them. Make the space between the eyes about the width of 1 eye.

3 Draw eyebrows, leaving a space that is slightly narrower than the height of the eyes. The spaces between the eyebrows, hairline and base of the nose are all equal.

27

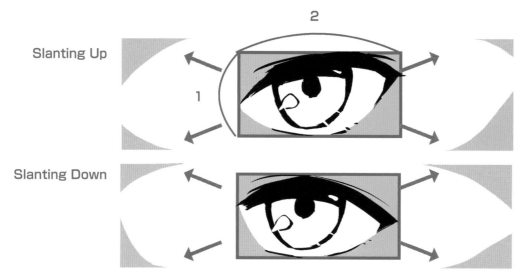

Slanting Up

Slanting Down

4 Create a shape, imagining that triangles are being cut out from the 4 corners of the box. The height to width ratio of the eye is about 1:2.

Drawing Nose, Mouth and Ears

1 The base of the nose is placed a little higher than ¼ height. Draw the bridge of the nose and add a highlight shape to either the left or right.

Bridge of the nose

Slightly higher than ¼

Highlight

Male noses tend to protrude more than female noses, so the highlight (the area that catches the light) and the shadow on the other side are larger. Draw the bridge of the nose with a vertical line and then on one side add a highlight to express its depth. It's fine to indicate small nostrils.

Nostrils

Front

Side

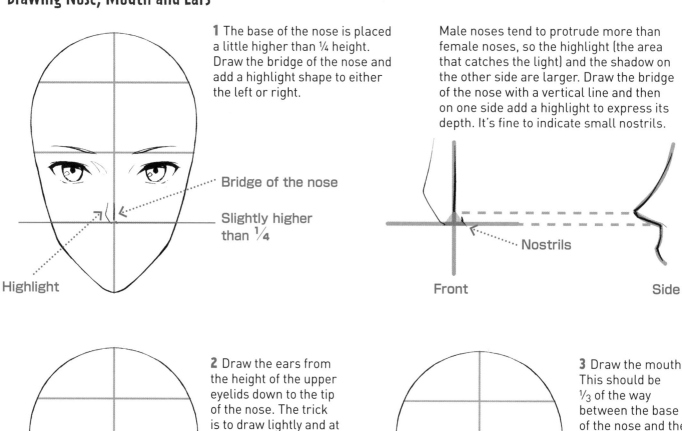

2 Draw the ears from the height of the upper eyelids down to the tip of the nose. The trick is to draw lightly and at an angle.

Draw the ears at this height

⅓ of the distance between the base of nose and the chin

3 Draw the mouth. This should be ⅓ of the way between the base of the nose and the chin. If you draw the mouth slightly higher than for a young woman, it will create a young man with a sharp chin.

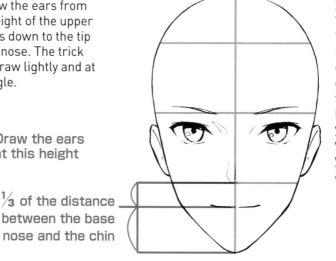

Drawing the Neck and Shoulders

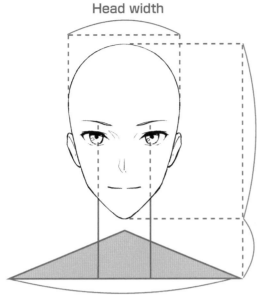

Head width

Head height

⅓ of head height

A little more than twice the width of the head

1 Mark the area for the neck and shoulders. The width of the neck is about the same as the space between the pupils of the eyes. Draw a triangle that is a little wider than 2 times the width of the head to create the area of the trapezius muscles that extend to the shoulders.

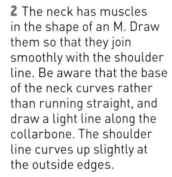

2 The neck has muscles in the shape of an M. Draw them so that they join smoothly with the shoulder line. Be aware that the base of the neck curves rather than running straight, and draw a light line along the collarbone. The shoulder line curves up slightly at the outside edges.

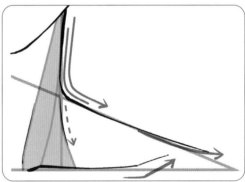

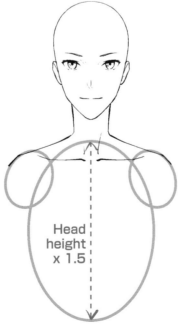

Slightly wider than head height

3 Draw ovals to create the area for the chest and the shoulders. The width of the oval is slightly wider than the height of the head.w

Head height x 1.5

Draw the height of the oval 1.5 times the height of the head.

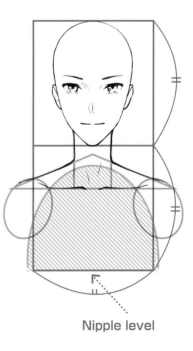

Nipple level

The level of the nipples is exactly one head-length down from the chin.

29

Finishing Touches

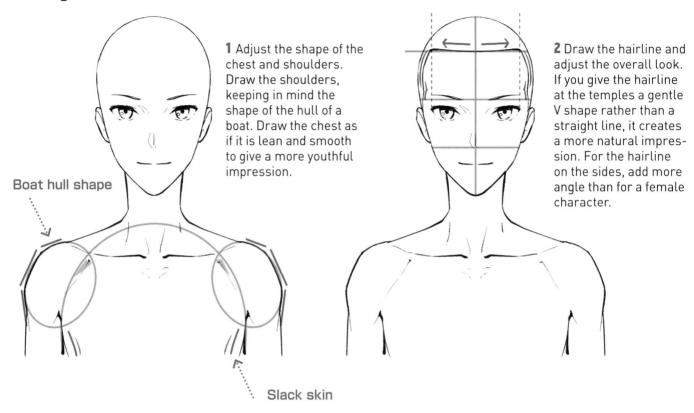

1 Adjust the shape of the chest and shoulders. Draw the shoulders, keeping in mind the shape of the hull of a boat. Draw the chest as if it is lean and smooth to give a more youthful impression.

Boat hull shape

Slack skin

2 Draw the hairline and adjust the overall look. If you give the hairline at the temples a gentle V shape rather than a straight line, it creates a more natural impression. For the hairline on the sides, add more angle than for a female character.

Adjusting the Position of Features

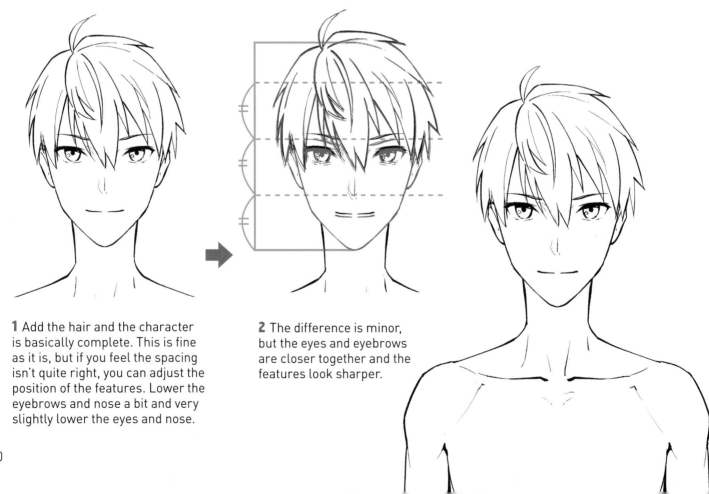

1 Add the hair and the character is basically complete. This is fine as it is, but if you feel the spacing isn't quite right, you can adjust the position of the features. Lower the eyebrows and nose a bit and very slightly lower the eyes and nose.

2 The difference is minor, but the eyes and eyebrows are closer together and the features look sharper.

Tips for the Body When Drawing Natural Front Poses

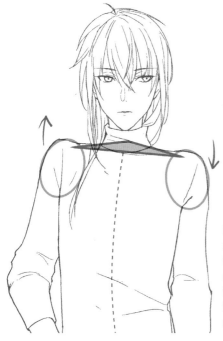

Even if the face is front-on, by changing the position of the hand slightly, it angles the body. This creates a natural impression if you draw the body at an angle from the neck down.

If you have difficulty drawing the body like that, try just slanting the shoulders a little to twist the torso. It will reduce the robotic appearance and look more natural.

Male Characters Wearing a Variety of Glasses

Male characters have smaller eyes and higher-placed ears than female characters, so when they wear glasses, the eyes aren't hidden. You can give them full-frame glasses or smaller lenses too.

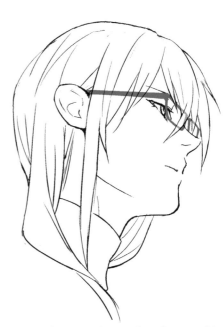

For females, when you draw a face from a side-on low angle perspective, much of the eye is covered by the temple of the glasses. With male characters, you can draw the pupil without it being hidden, so you have a greater choice of angles.

31

Drawing Faces from the Side

For side profiles, there are differences in the curvature of the forehead, nose and chin between male and female characters. In particular, the area around the nose and chin is an important factor for differentiating between male and female. The trick is to draw men quite realistically and use stronger distortion for women.

Ways to Draw Female Faces

Draw a Sharp-pointed Nose Using Distortion

Add an L shape to the circle to create a rough shape and then have the nose point upward to give it a cute look. Using distortion that omits the shape of the lips is the key for making the distinction.

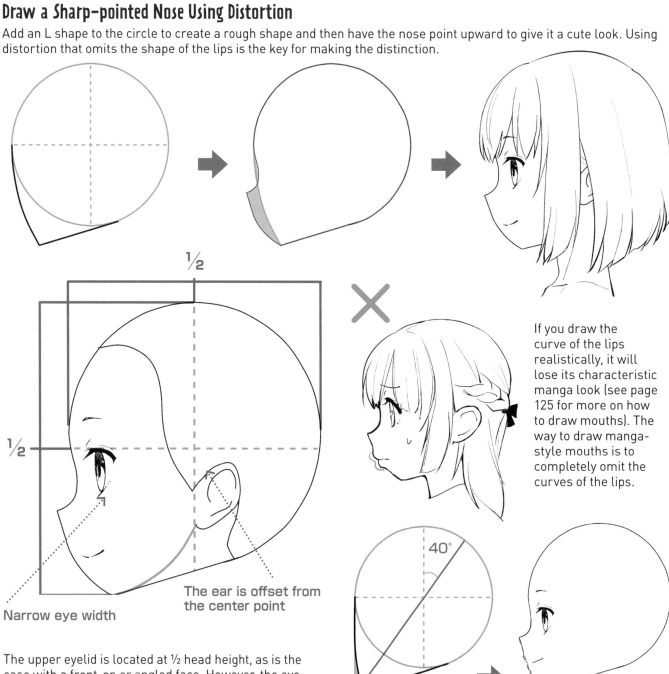

½

½

Narrow eye width

The ear is offset from the center point

If you draw the curve of the lips realistically, it will lose its characteristic manga look (see page 125 for more on how to draw mouths). The way to draw manga-style mouths is to completely omit the curves of the lips.

40°

The upper eyelid is located at ½ head height, as is the case with a front-on or angled face. However, the eye width is narrower and the shape changes a lot too. The position of the ear is just over halfway widthwise from the forehead to the back of the head.

When you want to draw the shape of the lips, have the chin protrude slightly forward and express the lips with small, gentle curves to keep the manga aesthetic.

Create the Outline

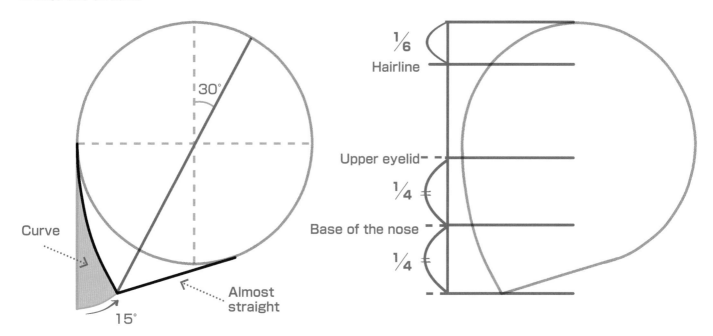

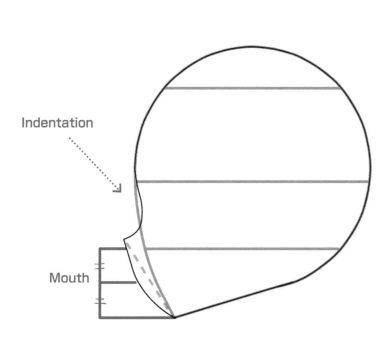

1 Draw a straight vertical line on the left edge of the circle, and then add an L shape approximately 15° in from that line. Gently curve the vertical line of the L shape and draw the horizontal line almost straight.

2 At this point, decide where to place each part. The upper eyelid comes halfway between the head and the tip of the chin. The base of the nose is placed ¼ of the distance from the bottom. The hairline falls at ⅙ of the head length down from the top of the head.

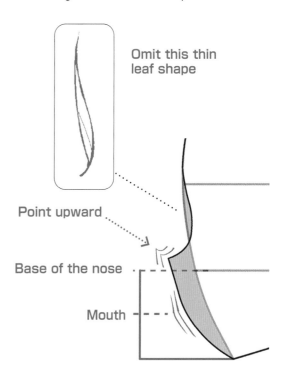

3 Create a nose that points sharply upward. Carry on from step 2 by indenting the eye area slightly, sharpening the tip of the nose and curving the chin. The lips are placed between the base of the nose and the chin, but the curves are omitted.

4 Close-up view of the nose and chin. The area to be omitted around the eyes resembles a thin leaf. The tip of the nose should point up past the horizontal line indicating the base of the nose. Draw the outline from the nose to the chin so that it swells out a bit at the height of the mouth.

Drawing the Mouth and Ears

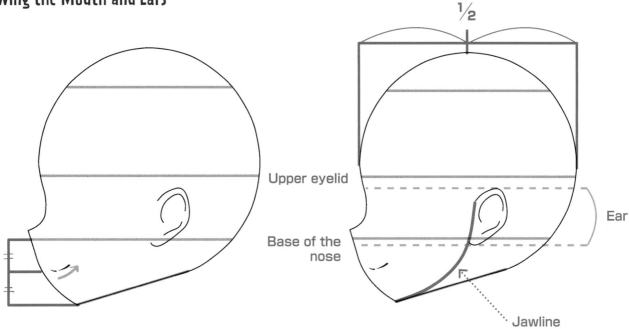

1 Draw the mouth between the base of the nose and the chin. Here, it's key to have the line flip upward inside the outline. This is an expression of distortion particular to manga and anime.

2 Draw the ear slightly over ½ of the distance from the forehead to the back of the head. If you place it so it runs slightly lower from the line of upper eyelid past the base of the nose, it creates a younger-looking face.

Drawing Eyes

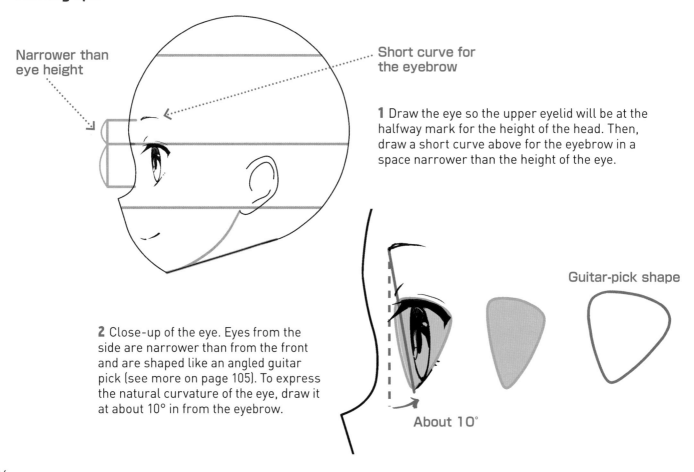

1 Draw the eye so the upper eyelid will be at the halfway mark for the height of the head. Then, draw a short curve above for the eyebrow in a space narrower than the height of the eye.

2 Close-up of the eye. Eyes from the side are narrower than from the front and are shaped like an angled guitar pick (see more on page 105). To express the natural curvature of the eye, draw it at about 10° in from the eyebrow.

Drawing the Neck and Shoulders

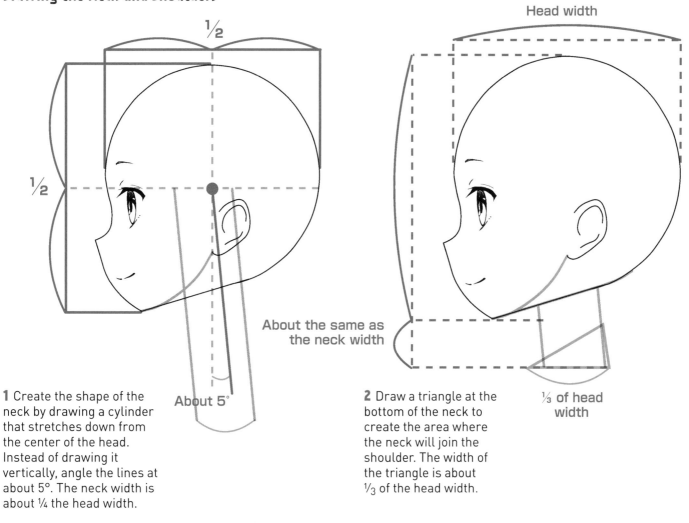

1 Create the shape of the neck by drawing a cylinder that stretches down from the center of the head. Instead of drawing it vertically, angle the lines at about 5°. The neck width is about ¼ the head width.

2 Draw a triangle at the bottom of the neck to create the area where the neck will join the shoulder. The width of the triangle is about ⅓ of the head width.

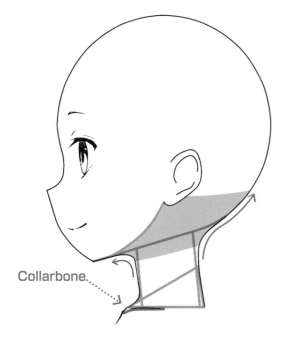

3 Join the head and neck with curved lines. The neck is thinner than that of a real person, so the front and back are joined by quite sharp curves.

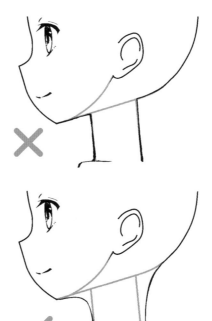

If you use straight lines, it creates a hard, doll-like image.

With a real person, the head and neck are joined with gentle curves as shown. But for a manga-style female character, it makes the jaw look saggy and adds the appearance of advancing age.

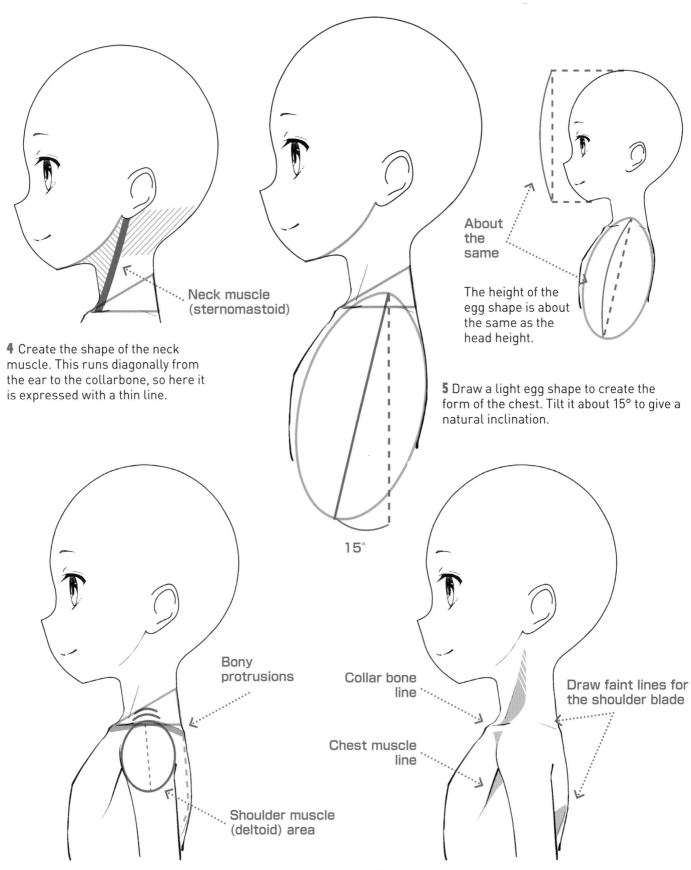

Neck muscle
(sternomastoid)

4 Create the shape of the neck muscle. This runs diagonally from the ear to the collarbone, so here it is expressed with a thin line.

About the same

The height of the egg shape is about the same as the head height.

5 Draw a light egg shape to create the form of the chest. Tilt it about 15° to give a natural inclination.

15°

Bony protrusions

Shoulder muscle (deltoid) area

Collar bone line

Chest muscle line

Draw faint lines for the shoulder blade

6 Identify the placement for the shoulder muscles and bones. If you draw an oval from the base of the triangle, this will mark the area for the shoulder muscles. The bumps of the collarbone and shoulder blade (clavicle and scapula) appear above this oval.

7 Instead of drawing clear lines for all the shoulder bones and muscles, just add lines for the necessary parts you identified in step 6. Draw a line diagonally down from the armpit to express the chest muscle too. (The pink area shows indented areas where there is more likely to be a shadow.)

Finishing Touches

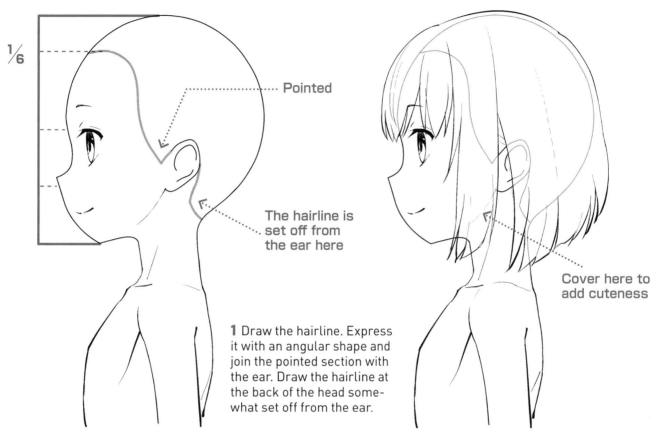

1/6

Pointed

The hairline is set off from the ear here

1 Draw the hairline. Express it with an angular shape and join the pointed section with the ear. Draw the hairline at the back of the head somewhat set off from the ear.

Cover here to add cuteness

2 Draw the hair to complete the character. If you cover the jawline with hair, it creates a youthful impression.

Adjusting the Position of Features

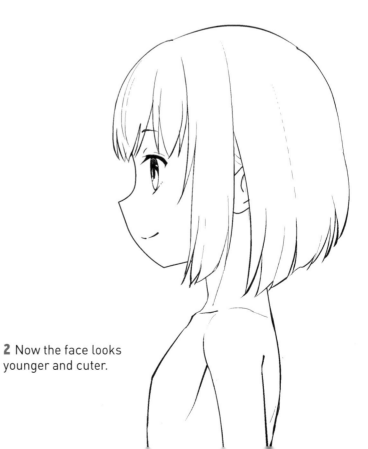

1 If the face looks elongated, slightly lower the placement of the eyebrow, eye, nose and mouth.

2 Now the face looks younger and cuter.

A Straight-Contoured Nose Creates an Intrepid Look

Draw an egg shape inside the box and then under that a shape similar to the blade of a shovel. Instead of an upturned nose like you might draw for a cute look, if you draw the bridge of the nose in a straight line down from the eye, it creates a fearless-looking face.

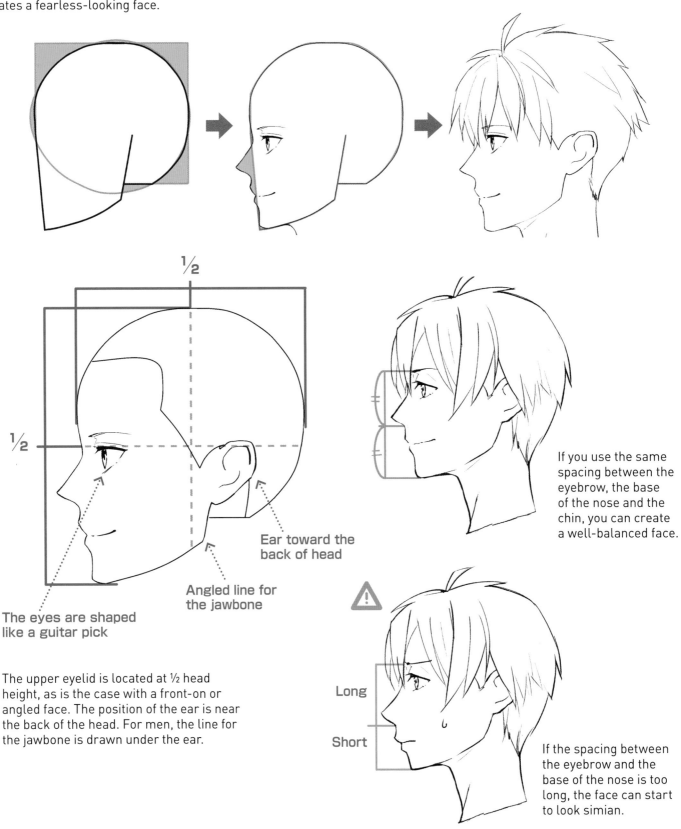

½

½

Ear toward the back of head

Angled line for the jawbone

The eyes are shaped like a guitar pick

The upper eyelid is located at ½ head height, as is the case with a front-on or angled face. The position of the ear is near the back of the head. For men, the line for the jawbone is drawn under the ear.

If you use the same spacing between the eyebrow, the base of the nose and the chin, you can create a well-balanced face.

Long

Short

If the spacing between the eyebrow and the base of the nose is too long, the face can start to look simian.

Create the Outline

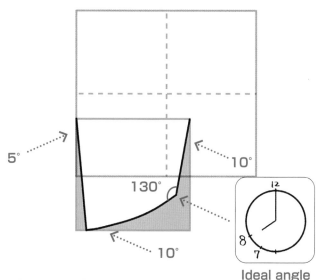

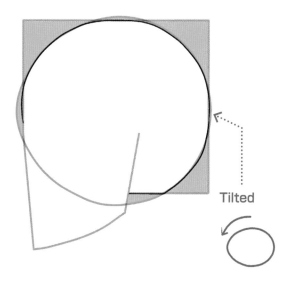

Ideal angle

Tilted

1 Draw a shape very slightly longer than a square and mark centerlines in it. To create the jaw, draw a box under the horizontal midline on the left side that forms a shape roughly like the blade of a shovel.

2 Draw a shape like an egg that's been tilted on its side that extends slightly out of the box to create the shape of the head (the pointed part of the egg forms the forehead). Slightly square off the areas for the forehead, crown and back of the head.

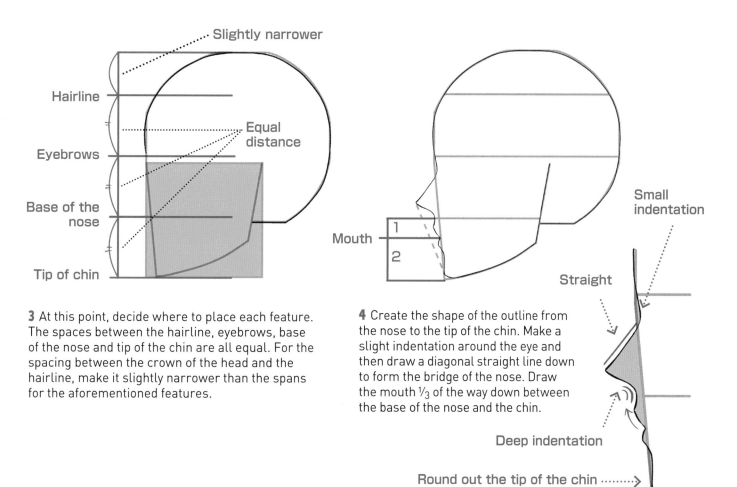

Slightly narrower

Hairline

Equal distance

Eyebrows

Base of the nose

Tip of chin

Mouth

Small indentation

Straight

Deep indentation

Round out the tip of the chin ·········>

3 At this point, decide where to place each feature. The spaces between the hairline, eyebrows, base of the nose and tip of the chin are all equal. For the spacing between the crown of the head and the hairline, make it slightly narrower than the spans for the aforementioned features.

4 Create the shape of the outline from the nose to the tip of the chin. Make a slight indentation around the eye and then draw a diagonal straight line down to form the bridge of the nose. Draw the mouth 1/3 of the way down between the base of the nose and the chin.

Drawing the Mouth and Ears

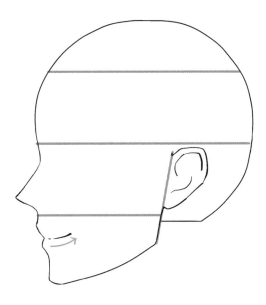

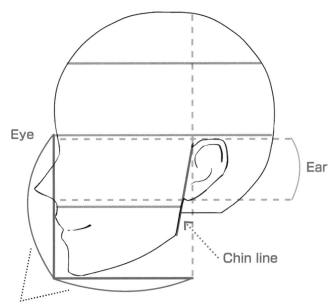

Eye

Ear

Chin line

Same length

1 Draw the mouth ⅓ of the way down from the base of the nose to the chin. For males, you can connect the mouth to the face outline, but if you place it slightly within the outline, it creates eye-pleasing distortion.

2 Draw the ear more than ½ way over from the forehead toward the back of the head. Having it closer to the back gives a more realistic masculine balance. The height of the ear is from approximately just below the eyebrow down to the base of the nose.

Drawing Eyes

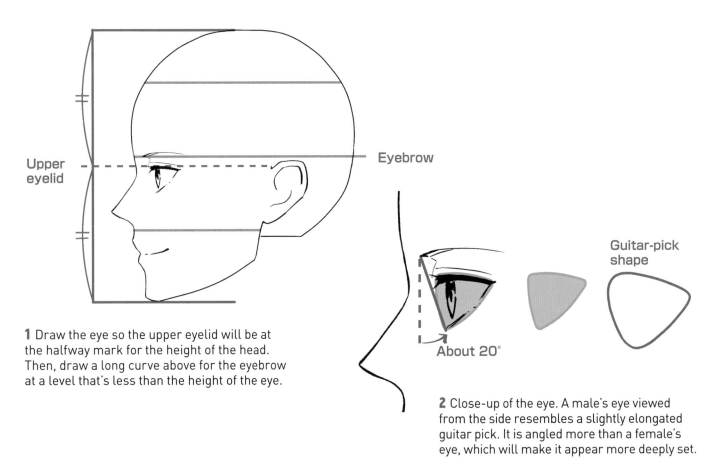

Upper eyelid

Eyebrow

Guitar-pick shape

About 20°

1 Draw the eye so the upper eyelid will be at the halfway mark for the height of the head. Then, draw a long curve above for the eyebrow at a level that's less than the height of the eye.

2 Close-up of the eye. A male's eye viewed from the side resembles a slightly elongated guitar pick. It is angled more than a female's eye, which will make it appear more deeply set.

Drawing the Neck and Shoulders

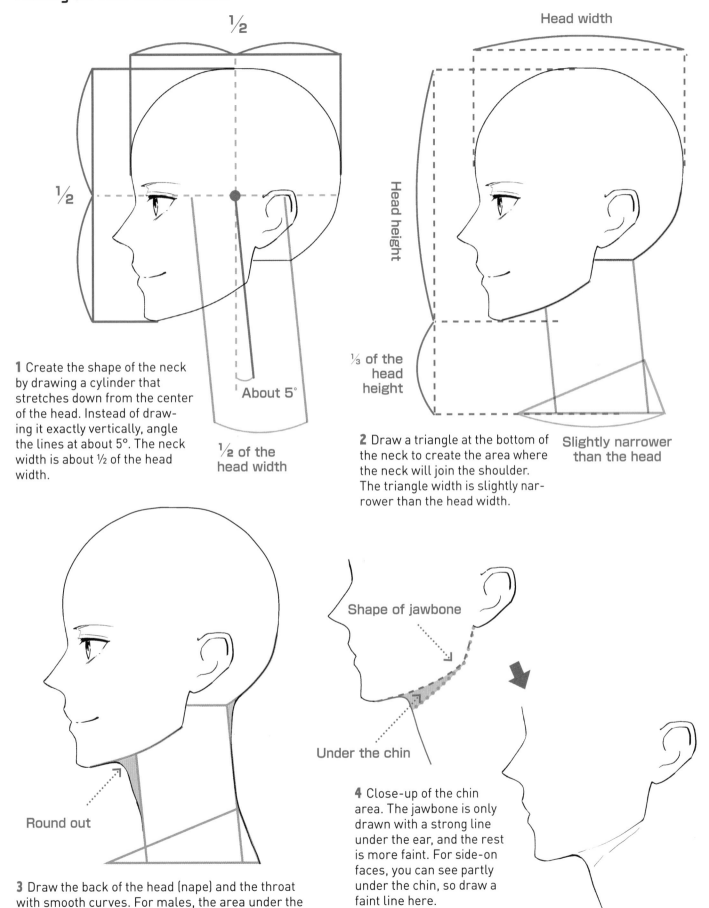

1 Create the shape of the neck by drawing a cylinder that stretches down from the center of the head. Instead of drawing it exactly vertically, angle the lines at about 5°. The neck width is about ½ of the head width.

½ of the head width

About 5°

½

½

2 Draw a triangle at the bottom of the neck to create the area where the neck will join the shoulder. The triangle width is slightly narrower than the head width.

Head width

Head height

⅓ of the head height

Slightly narrower than the head

3 Draw the back of the head (nape) and the throat with smooth curves. For males, the area under the jaw and around the throat are more rounded out.

Round out

4 Close-up of the chin area. The jawbone is only drawn with a strong line under the ear, and the rest is more faint. For side-on faces, you can see partly under the chin, so draw a faint line here.

Shape of jawbone

Under the chin

41

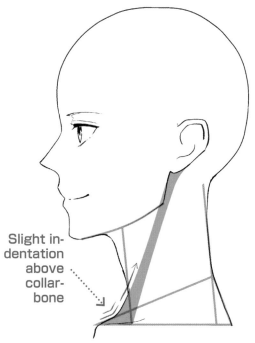

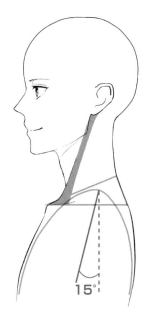

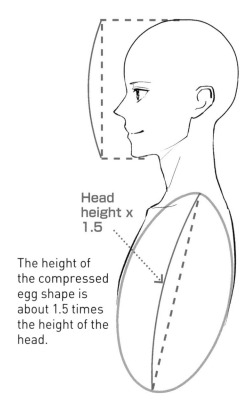

Slight in-
dentation
above
collar-
bone

5 Create the shape of the neck muscle.
This runs diagonally from behind the ear
to the collarbone, so here it is expressed
with a thin line.

15°

6 Draw a slightly compressed
egg shape to create the form
of the chest. Tilt it about 15° to
give a natural posture.

Head
height x
1.5

The height of
the compressed
egg shape is
about 1.5 times
the height of the
head.

Bony
protrusion

Shoulder muscle
(deltoid) area

7 Draw an oval so it overlaps the base of the tri-
angle, creating the area for the shoulder muscles.
Male shoulder muscles are usually larger than
those of females. The shape of the bones over the
oval curve more for males, forming a protrusion.

Indentation
where the
collarbone and
shoulder blade
overlap

Protruding
collarbone

Pectoralis
major muscle
line

Lightly
draw the
outline
of the
deltoid
muscle
for a
mascu-
line look

8 Draw the shoulder muscles and bones using light
lines. Draw a line diagonally down from the armpit
to express the chest muscle too. The pink areas
show where there are indentations. If you're using
color or shading, add shadows to these parts.

Finishing Touches

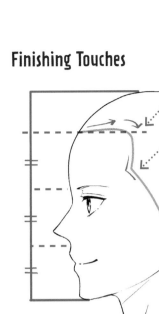

Curve

Hard angle

Slightly separate from the ear

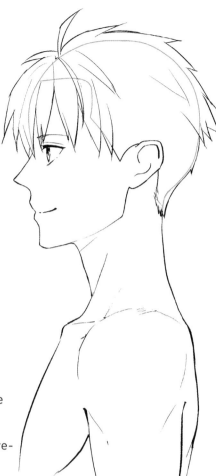

1 Draw the hairline. After curving gently upward, make a sharp curve downward, and then an obtuse angle a little bit above the eyebrow. Draw the point of the sideburn so that it's slightly off the ear.

2 Draw the hair to complete the character. For men, make the jaw area clearly visible by not covering it with the hair. This creates a bold impression.

Adjusting the Position of Features

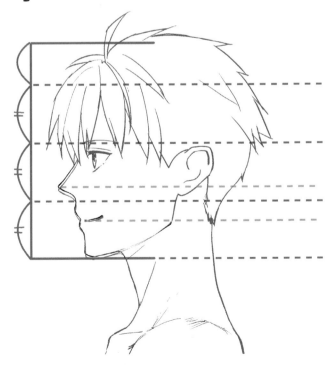

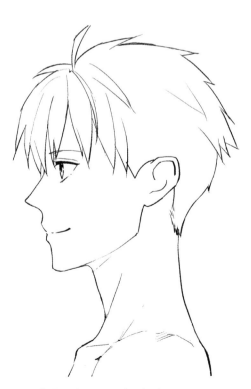

1 If the face looks elongated, slightly lower the placement of the nose and mouth. Slightly lower the jaw too.

2 The features look sharper now.

Variations

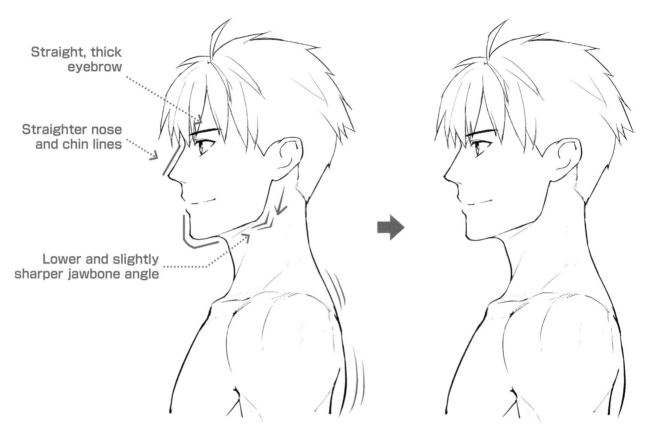

Straight, thick eyebrow

Straighter nose and chin lines

Lower and slightly sharper jawbone angle

If you want to draw a more rugged-looking young man, make the outline more angled. Add thickness to the neck and shoulders at the back for a stronger look.

NOTE

Angle Slightly for a Natural Side Profile

Once you're used to drawing a straight side profile, try drawing a slightly angled one. It softens the artificial impression and creates a natural look.

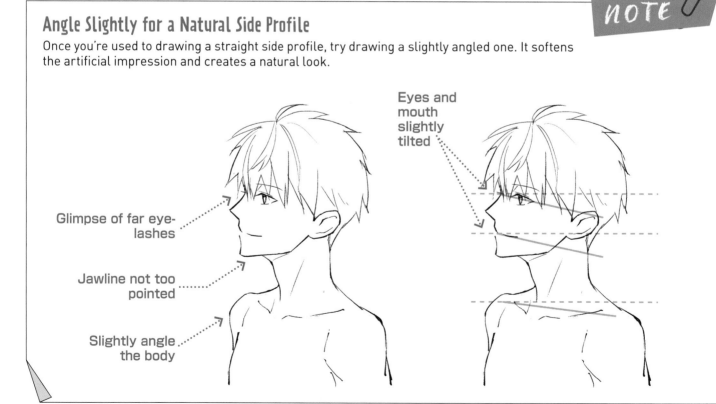

Eyes and mouth slightly tilted

Glimpse of far eye-lashes

Jawline not too pointed

Slightly angle the body

Checkpoints for Improving Side Profile Drawings

Side profiles, which clearly show the curvature of the outline, make it difficult to hide imperfections. Let's take a look here at some checkpoints for when you feel there's something wrong with a side profile and how to fix it.

Shape Not Quite Right?

Adjust the back of the head so it doesn't bulge

Reduce this part

If the shape of the head is voluminous or undefined, check whether it is bulging at the back. Draw a head-sized circle from the front bangs and reduce the back part of the head that sticks out.

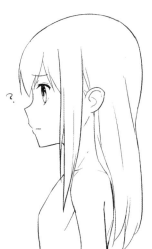
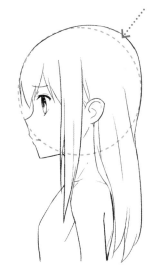
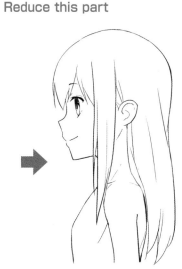

A Strained Look?

Adjusting the jaw angle for a more natural look

Characters with thin necks and distortion tend to look a bit unbalanced and the jaw can appear strained. If this is the case, start over with a pose where the chin is pulled in. The chin won't stand out as much and the back of the head becomes smoother, so it looks more natural.

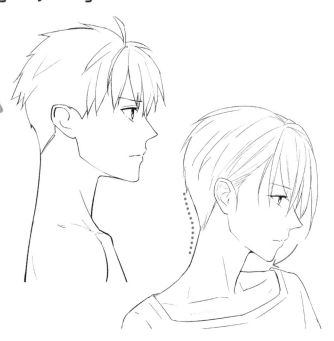
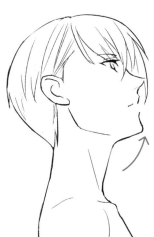

If you angle the head upward, the jaw loses that strained look.

Drawing Faces at an Angle

Many people find it difficult to draw faces at an angle because they have depth. If you learn how the eye shape changes compared to a front profile and where the features are placed, it becomes a lot easier to draw.

Ways to Draw Female Faces

Using a Circle to Form a Strawberry-shaped Outline

The angled outline for a female face is asymmetrical. This is easier to draw if you imagine a shape like a slightly distorted strawberry.

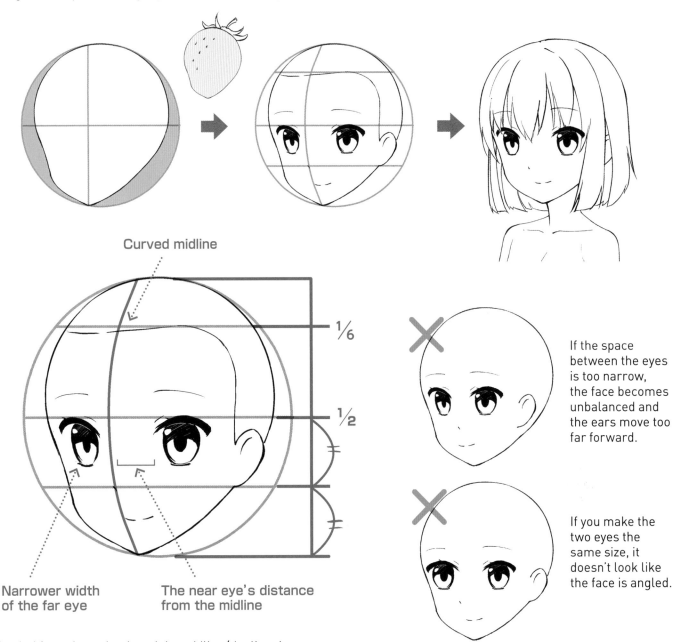

Curved midline

⅙

½

Narrower width of the far eye

The near eye's distance from the midline

If the space between the eyes is too narrow, the face becomes unbalanced and the ears move too far forward.

If you make the two eyes the same size, it doesn't look like the face is angled.

Angled faces have depth and the midline (the line that runs down the center of the face) curves either to the left or right of center. The width of the far eye looks narrower. The near eye is placed farther from the midline than the far eye.

Create the Outline

1 Draw a circle and then a horizontal line across the center. Draw a vertical line a little to the left of center.

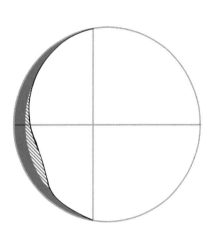

2 Reduce the circle on the left side. Omit a thin crescent moon and then an additional thin leaf shape to reduce it even more.

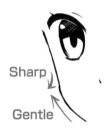

3 Reduce the circle on the right side. Omit a space like a tilted thin crescent moon, and then omit more on the bottom to make it balanced.

NOTE

Slightly Raised Cheeks Look Adorable

It depends on the design and style, but if you expand the outline a little upward for the back cheek, it gives a cuter look.

Sharp

Gentle

Raise and round out the cheek by drawing the top part of the outline using a slightly sharper curve.

Sharp

Gentle

For a design with strong distortion, the pronounced, raised cheek can be clearly seen.

Drawing Eyes

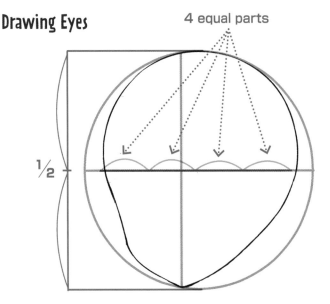

4 equal parts

½

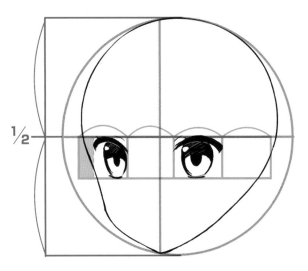

½

1 Divide the center of the face horizontally into 4 equal parts. The tip is to have the equal parts offset slightly to the left.

2 Draw 4 boxes under the line for the 4 equal parts and add the eyes. Make the near eye about the same size as the eye for a front-on face. The width of the far eye is a little narrower.

Reduce the width

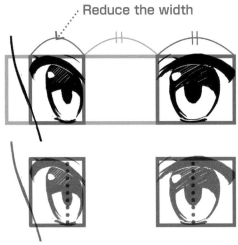

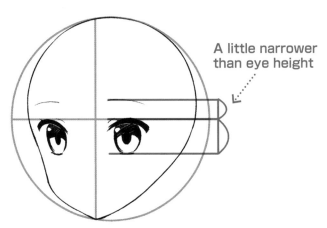

A little narrower than eye height

3 Make the distance between the eyes about the width of the near eye. Draw the far eye so it is about 70% the width of the near eye. The near eye should have the pupil in the center. The pupil of the far eye should be slightly right of center.

4 Draw the eyebrows. Position them above a space a little narrower than the height of the eye. For a character with large exaggerated eyes, it's fine to make this distance a bit wider.

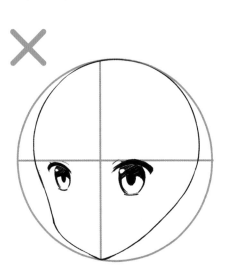

Distant objects are supposed to look smaller, but if you shrink the height of the far eye, it will look strange. The far eye isn't actually much farther away from the viewer than the near eye, so there's hardly any difference in height.

This example shows a common problem. When you draw the hair, it will look normal at first glance, but the near eye and ear are too close. Depending on the look you're going for, it can still work, but it can make the drawing look two-dimensional, so it's best to avoid this.

Drawing the Nose, Mouth and Ears

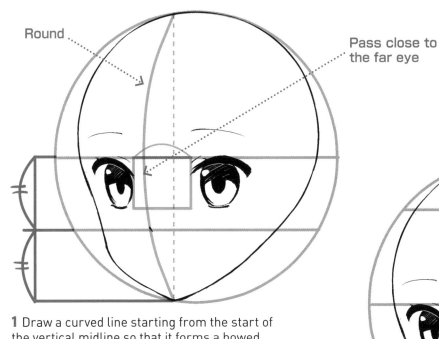

Round

Pass close to the far eye

1 Draw a curved line starting from the start of the vertical midline so that it forms a bowed shape. Mark the nose with a small dot on this line at the midpoint between the upper eyelid and the chin.

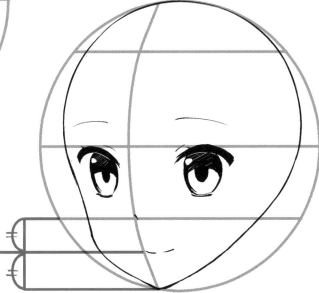

2 Draw the mouth at the midpoint between the nose and the chin. Real people's mouths fall along the midline, but for manga-style characters, draw the mouth forward for a cuter look.

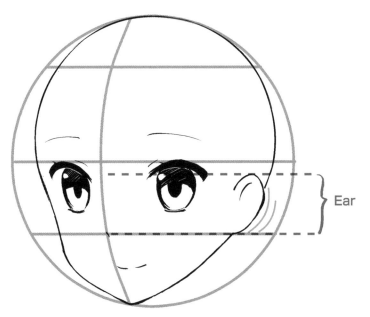

Ear

3 Draw the ear from just below the upper eyelid down to the level of the tip of the nose. If you have it protruding slightly from the head outline, it creates a more natural impression.

If you draw the ear inside the outline, it will be too close to the near eye.

Drawing the Neck and Shoulders

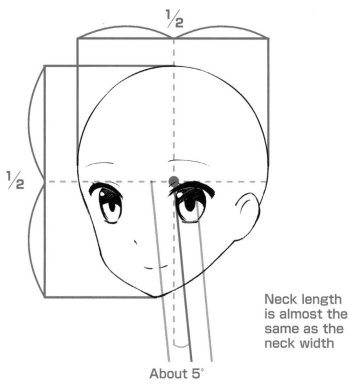

Neck length is almost the same as the neck width

About 5°

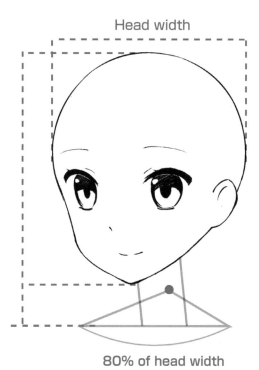

Head width

80% of head width

1 Create the shape of the neck by drawing a cylinder that stretches down from the center of the head. Instead of drawing it exactly vertical, angle the lines at about 5°. The neck width is about ¼ of the head width.

2 Draw an asymmetrical triangle below the neck to create the area of the trapezius muscles that extend to the shoulders. The width of the triangle is about 80% of the head width.

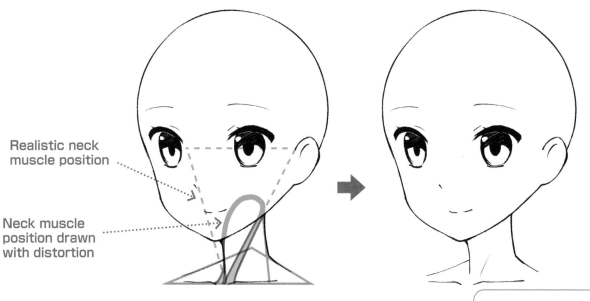

Realistic neck muscle position

Neck muscle position drawn with distortion

3 Draw the neck muscles very lightly. Manga-style characters have thinner necks, so the neck muscles use distortion that makes them smaller. Imagine them circling the nape like a loop.

The lines of the neck slope slightly back at the end to smoothly join to the head and shoulders.

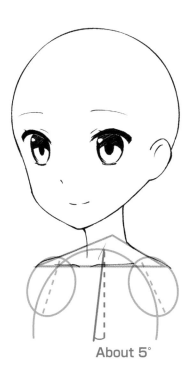

About 5°

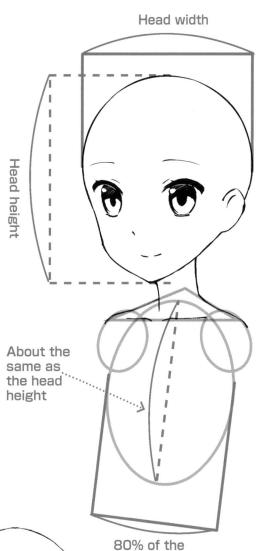

Head width

Head height

About the same as the head height

80% of the head width

The height of the oval for the chest is about the same as the head height. The width is about 80% of the head width.

4 Draw ovals to create the shape of the chest and shoulders. The trick is to angle the chest oval about 5° in the opposite direction to the neck. Both shoulder ovals are about the same size, but the back one is slightly obscured by the torso.

5 Adjust the shape of the chest and shoulders. The red areas are the shoulders. If they are viewed from an angle, the front shoulder looks wider and the back shoulder is mostly hidden by the chest.

Front view for comparison

6 Indicate the armpits. The front shoulder is in front of the chest, so draw a line on the chest to indicate the front armpit. For the back armpit, curve the chest line to create volume and add slack where the limb separates from the torso.

Finishing Touches

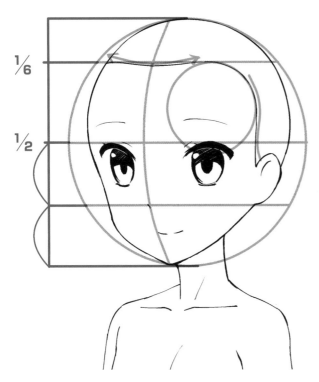

1 Draw the hairline. The hairline in the center of the forehead is slightly curved. At the sides, it's drawn with a curve resembling a large semi-circle and a very gentle S shape. The hairline at the back of the head can't be seen from this angle.

2 Add 3 sections of hair to the front, as well as sections at the sides and at the back, and then neaten the tips to complete the look. (See page 136 for more information on how to draw hair.)

Adjusting the Position of Features

1 This looks cute, but if you adjust the position of the features, it will become even more so. Slightly lower the position of the eyes and nose.

2 The face looks shorter and the character has a cuter, younger appearance.

How to Keep a Standing Character from Looking Stiff

The drawing basics introduced on pages 46-52 focus on standing poses. It's not very noticeable in small illustrations, but larger ones can have a slightly robotic appearance. When that happens, angle the eyes and shoulders a little to give a more natural, dynamic presentation.

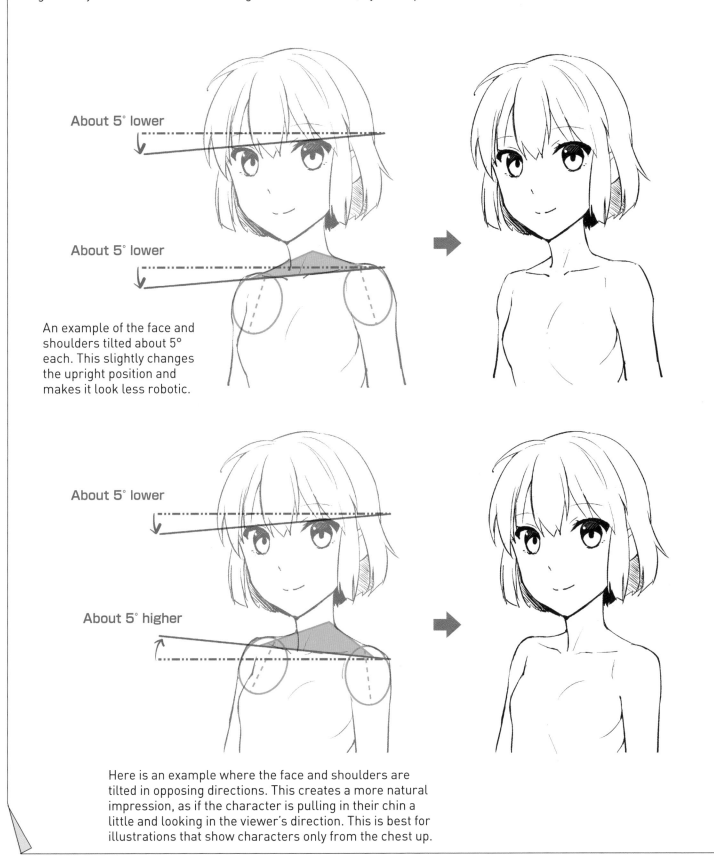

About 5° lower

About 5° lower

An example of the face and shoulders tilted about 5° each. This slightly changes the upright position and makes it look less robotic.

About 5° lower

About 5° higher

Here is an example where the face and shoulders are tilted in opposing directions. This creates a more natural impression, as if the character is pulling in their chin a little and looking in the viewer's direction. This is best for illustrations that show characters only from the chest up.

Positioning the irregular pentagon to create the jaw shape

For front profiles, draw a circle and add an irregular pentagon. For angled faces, slightly distort the irregular pentagon, and then shift it either to the left or right to create the shape of the jaw.

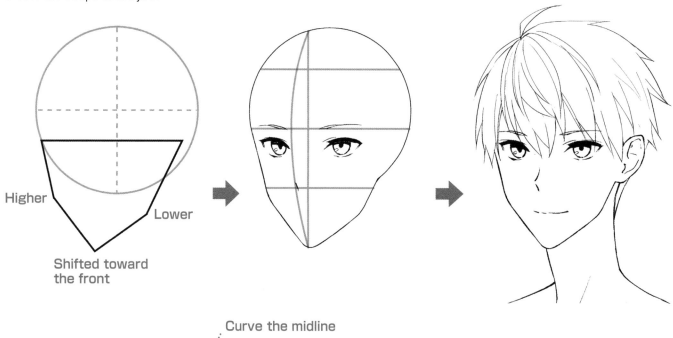

Higher

Lower

Shifted toward the front

Curve the midline

½

Narrower width for the far eye

Distance the near eye from the midline

For males as well as females, the far eye width is narrower and the near eye is placed away from the midline. Men are usually depicted with straight noses, so an angled nose is represented by a line with an obtuse angle.

If the near eye is too close to the midline, the eyes will look cramped and strange.

If you make the front and far eyes the same size, it doesn't look like they are angled.

Create the Outline

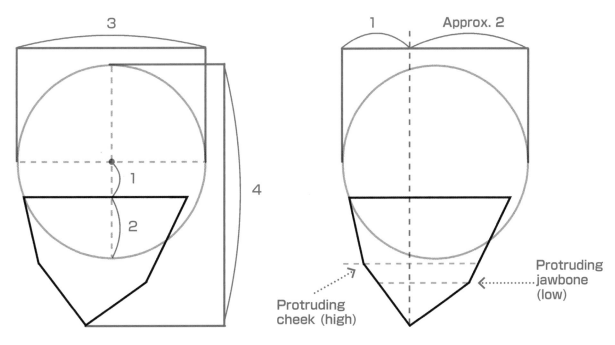

1 Draw a circle and then add an irregular pentagon to the left and below the center of that circle. For angled faces, slightly elongate and distort the irregular pentagon.

2 The left corner of the irregular pentagon is the protruding cheek. The right corner will be the protruding part of the jawbone. The trick is to draw the left corner higher. The downward-facing point is the tip of the chin. Draw a straight vertical line through to this point.

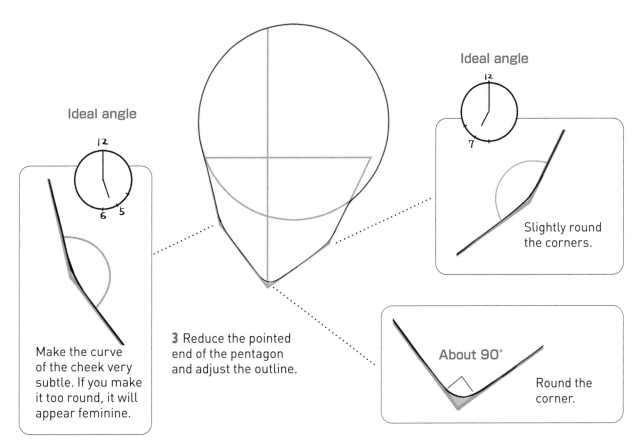

Make the curve of the cheek very subtle. If you make it too round, it will appear feminine.

3 Reduce the pointed end of the pentagon and adjust the outline.

Slightly round the corners.

About 90°

Round the corner.

Drawing Eyes

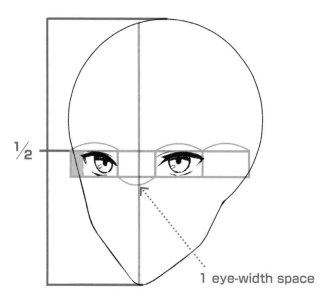

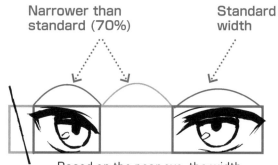

½

1 eye-width space

Narrower than standard (70%)

Standard width

Based on the near eye, the width of the far eye should be about 70%. The space between the eyes is about 70% of the near eye width.

Pupil location

For the near eye, the pupil is placed in the center of the eye. The pupil of the far eye should be slightly right of center.

1 Draw the eye so the upper eyelid is at the halfway mark for the height of the head. The far eye width is slightly narrower than that for the near eye. For males, the space between the eyes is narrower than it is for females, and is equal to the width of the far eye.

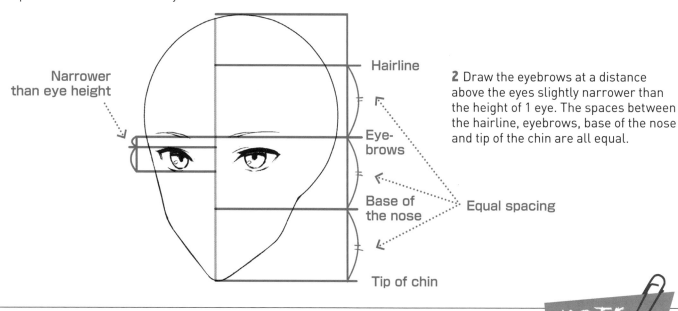

Narrower than eye height

Hairline

Eye-brows

Base of the nose

Tip of chin

Equal spacing

2 Draw the eyebrows at a distance above the eyes slightly narrower than the height of 1 eye. The spaces between the hairline, eyebrows, base of the nose and tip of the chin are all equal.

NOTE

The eye-to-eyebrow space is slightly narrower than eye height

The distance between the eye and the eyebrow is slightly narrower than the eye height
This ratio is about the same for rounder female eyes and more almond-shaped male eyes.

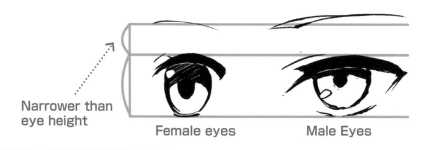

Narrower than eye height

Female eyes Male Eyes

Drawing the Nose, Mouth and Ears

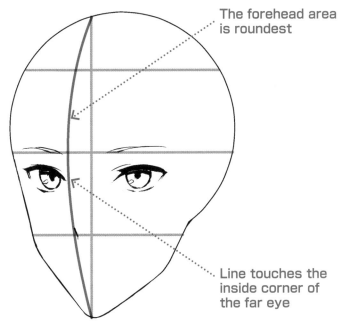

The forehead area is roundest

Line touches the inside corner of the far eye

1 Draw a midline from the chin to the top of the head using a curved line shaped like a bow. Make it so the line is roundest at the level of the forehead. Draw the base of the nose so it is centered between the eyebrows and the chin and touches the curved midline.

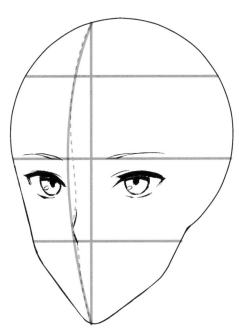

2 Draw the bridge of the nose. Use a simple obtuse angled line to express the bridge of the nose to the base.

3 Draw the mouth ⅓ of the way down from the base of the nose toward the chin. The trick is to place it slightly forward of the midline. Be careful not to place the mouth too low, as it will look like the base of the nose is stretched out.

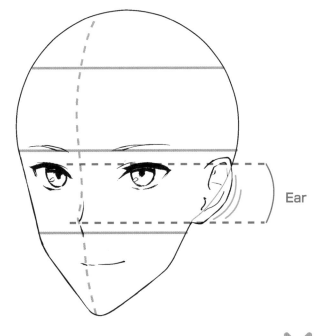

Ear

4 Draw the ear. The top of the ear falls at the height of the upper eyelid and the earlobe ends at the height of the tip of the nose. Draw the earlobe so that it protrudes slightly from the outline.

If you draw the ear inside the outline, it will look like the ear is positioned right by the eyes.

Drawing the Neck and Shoulders

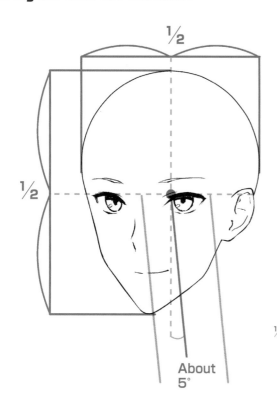

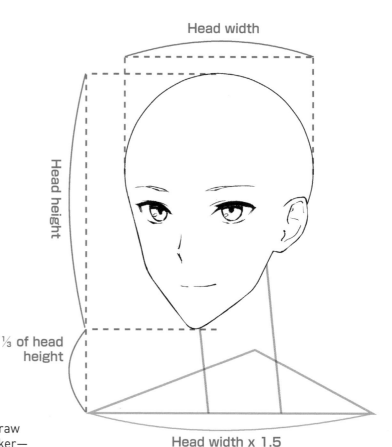

1 Starting slightly behind the point of the chin, draw the neck at an angle. For males, the neck is thicker—just under half the size of the head width.

2 Draw an asymmetrical triangle below the neck to create the area of the trapezius muscles that extend to the shoulders. The width of the triangle is about 1.5 times the head width.

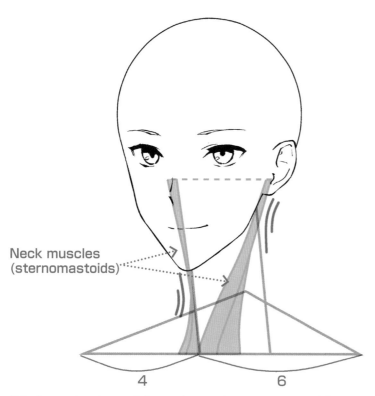

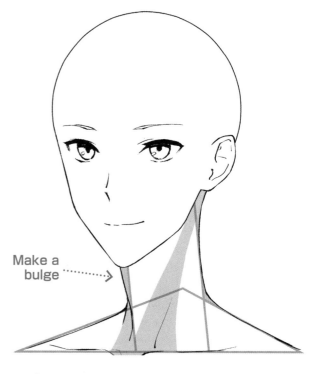

3 Indicate the shape of the neck muscles (sternomastoid). This muscle runs from behind the ear down to the center of the collarbone, smoothly connecting the head and neck.

4 Shape the head, neck and shoulders by joining them with smooth lines, and create a bulge in the throat for the Adam's apple.

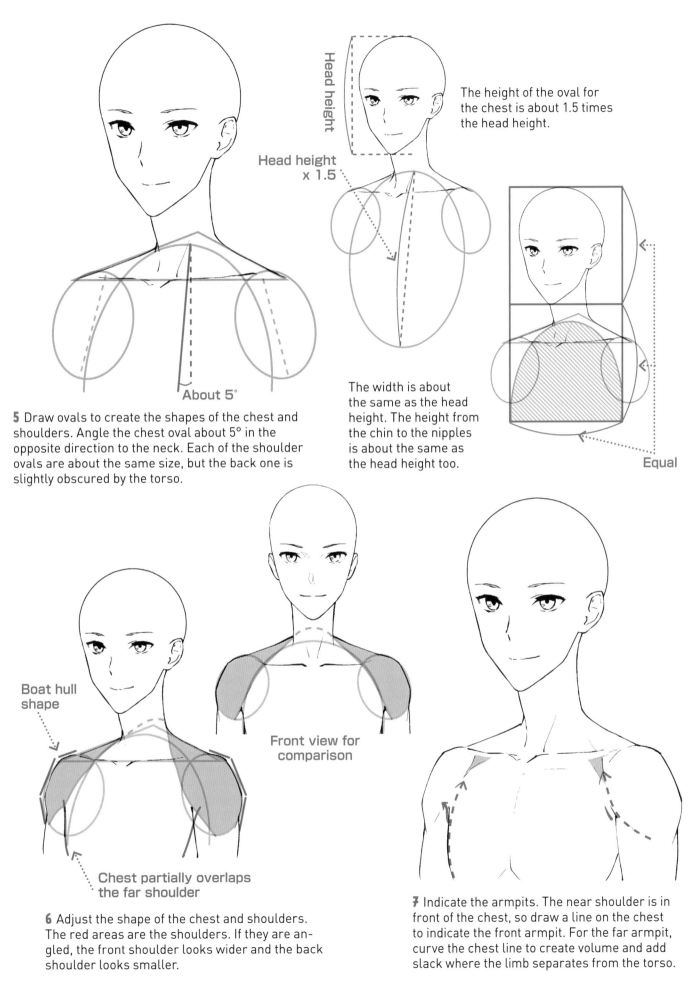

Head height

The height of the oval for the chest is about 1.5 times the head height.

Head height x 1.5

About 5°

5 Draw ovals to create the shapes of the chest and shoulders. Angle the chest oval about 5° in the opposite direction to the neck. Each of the shoulder ovals are about the same size, but the back one is slightly obscured by the torso.

The width is about the same as the head height. The height from the chin to the nipples is about the same as the head height too.

Equal

Boat hull shape

Front view for comparison

Chest partially overlaps the far shoulder

6 Adjust the shape of the chest and shoulders. The red areas are the shoulders. If they are angled, the front shoulder looks wider and the back shoulder looks smaller.

7 Indicate the armpits. The near shoulder is in front of the chest, so draw a line on the chest to indicate the front armpit. For the far armpit, curve the chest line to create volume and add slack where the limb separates from the torso.

Finishing Touches

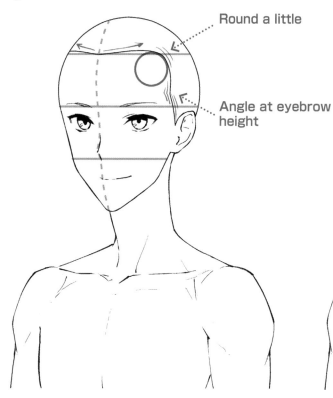

Round a little

Angle at eyebrow height

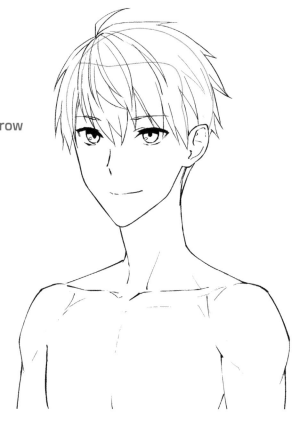

1 Draw the hairline. The hairline in the center of the fore-head is a shallow V shape. If you angle the hairline on the side at eyebrow height, it creates a masculine look.

2 Draw the shape of the hair flowing from a whorl on the head to complete the character (see page 136 for more information on how to draw hair).

Adjusting the Position of Features

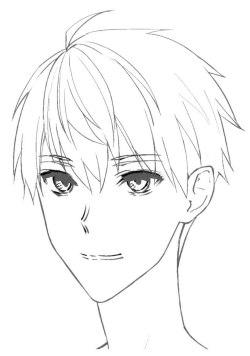

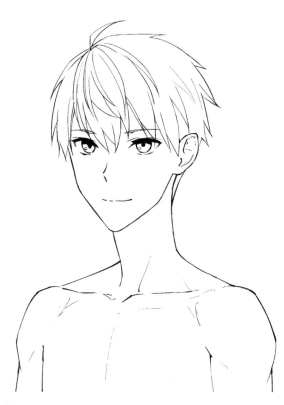

1 If you adjust the position of the features, it creates a bold expression. Bring the eyebrows closer to the eyes and very slightly angle the nose forward and down.

2 The face looks less extended and has become sharper.

Drawing the Back of the Head

You can't see a character's expression from a back angle or from directly behind. There are not many times this pose is needed. However, it's useful for when characters are facing each other in conversation scenes. The eyes and nose can't be seen, making it difficult to form the shape, so the trick is to clearly understand the position of the ear to be able to draw this properly.

How to Draw

Emphasizing the Cheek

1 Draw a circle and then omit a thin crescent shape. The key is to slightly reduce the bottom so it is flat.

Level

2 Omit a thin crescent shape on the other side too, and then further reduce the middle of the curve to create an indentation.

3 Create the shape of the neck by drawing a cylinder angled at about 5° that stretches down from the center of the head. Draw a triangle at the bottom of the neck to create the shoulder area. The neck width and length is about ¼ of the head width.

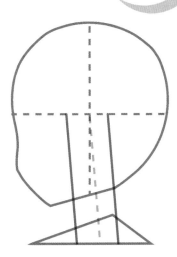

4 Draw a triangle that touches the halfway mark of the height of the head to create the ear area. Place the triangle so that the right point is slightly offset from the neck line.

½

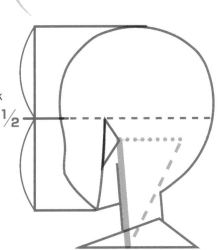

5 Add in the ears (see page 134) and draw the hairline and nape of the neck to complete the look.

Large curve

Zigzag

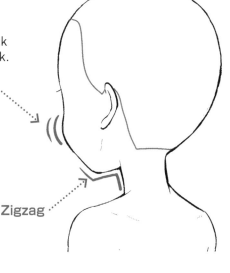

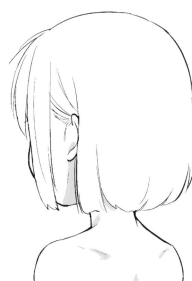

A loose hairstyle covers a lot of the outline.

MALE

An Almost 90° Jaw is Key

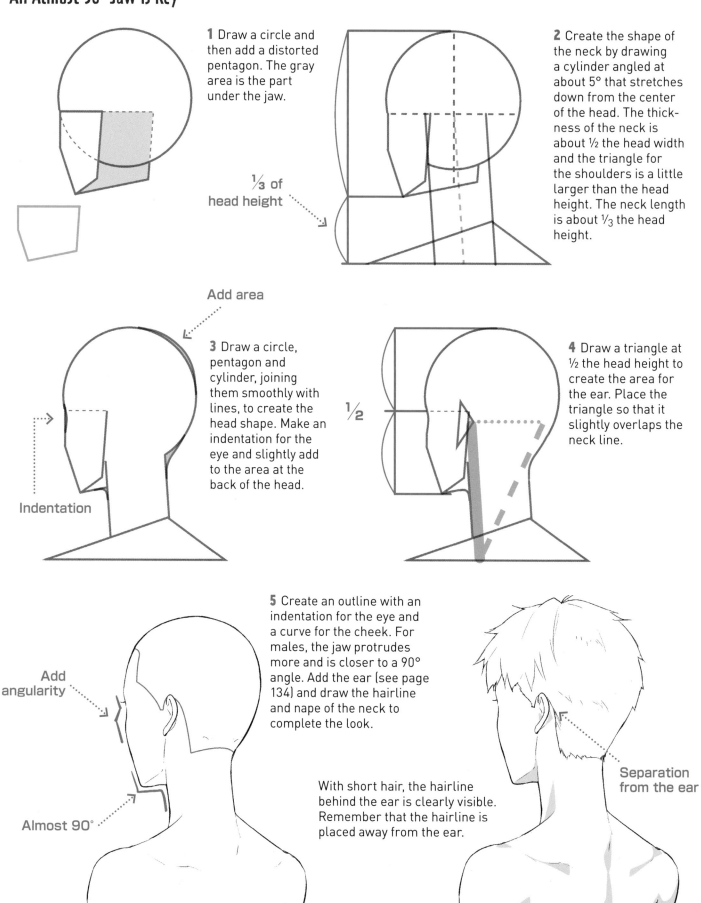

1 Draw a circle and then add a distorted pentagon. The gray area is the part under the jaw.

⅓ of head height

2 Create the shape of the neck by drawing a cylinder angled at about 5° that stretches down from the center of the head. The thickness of the neck is about ½ the head width and the triangle for the shoulders is a little larger than the head height. The neck length is about ⅓ the head height.

Add area

3 Draw a circle, pentagon and cylinder, joining them smoothly with lines, to create the head shape. Make an indentation for the eye and slightly add to the area at the back of the head.

Indentation

½

4 Draw a triangle at ½ the head height to create the area for the ear. Place the triangle so that it slightly overlaps the neck line.

Add angularity

Almost 90°

5 Create an outline with an indentation for the eye and a curve for the cheek. For males, the jaw protrudes more and is closer to a 90° angle. Add the ear (see page 134) and draw the hairline and nape of the neck to complete the look.

With short hair, the hairline behind the ear is clearly visible. Remember that the hairline is placed away from the ear.

Separation from the ear

Differences from a Realistic Neck

1 The outline is the same as that for a face viewed from the front (page 19). Draw both ears so they overlap the outline on each side. Place them starting a little lower than ½ of the head height (the position of the upper eyelids) and ending at ¼ of the head height (the position of the base of the nose).

Tilt about 30°

2 Create the neck and shoulder areas, the same as for the face viewed from the front). The thickness of the neck is about ¼ the head width.

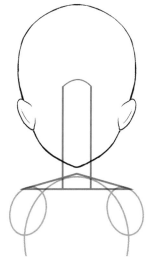

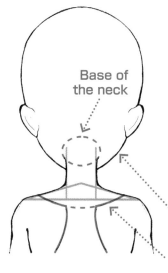

Base of the neck

The jaw is visible

Top of the shoulder blades

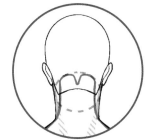

With real people, the jaw can't be seen because it's hidden by the thickness of the neck.

3 For real people, the back of the ear meets the base of the neck. For manga-style female characters, the base of the neck is very slightly lower than the ears, so adjust the shape so that the jaw is visible beyond the thin neck.

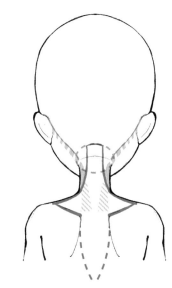

4 Unlike a real person, the back of the neck and the ears are separate, but draw the base of the neck using a curved line that indicates that the neck and ears are connected.

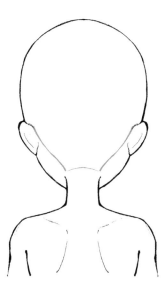

Bowl

5 Draw the nape of the neck the same width as the neck. The hairline is shaped like the curve of a bowl to join the top of the ears. Draw a faint line for the shoulder blades and adjust the shoulder area to complete.

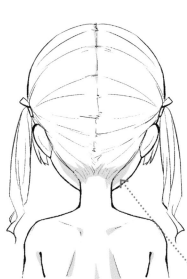

6 When drawing hair, if you add a shadow to the hairline, it reduces the strangeness of the distortion.

Add shadow

Manga-style female characters have large heads, so when the hair is loose, it hides the ears.

Drawing the Neck Area to Look Realistic

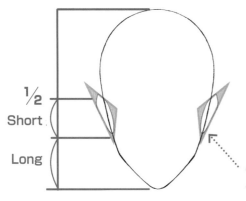

1/2
Short
Long

Only slightly angled

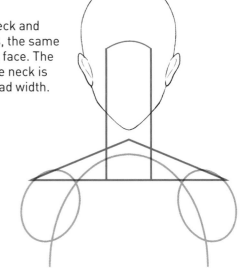

2 Create the neck and shoulder areas, the same as for the front face. The thickness of the neck is about ½ the head width.

1 Create the shape of the same outline as the front-on face (page 27) and draw the ears. Place them starting at about ½ head height (the position of upper eyelids) and ending at the base of the nose (just a little higher than ¼ height). This is a slightly higher position than for females.

Base of the neck

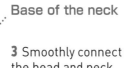

3 Smoothly connect the head and neck. Make the top of the neck thicker and draw the back of the neck so that it joins with the ears.

4 Create a sting-ray-shaped area to indicate the shape of the trapezius muscles that run from the neck along the shoulders.

Indentation

Indentation along the top of the shoulder blades

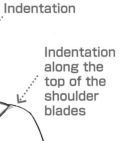

Spine indentation

Top edge of the shoulder blades (angled)

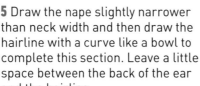

5 Draw the nape slightly narrower than neck width and then draw the hairline with a curve like a bowl to complete this section. Leave a little space between the back of the ear and the hairline.

Leave a space

Here, the hair has been added. For male characters, the neck area is more like a real person's, so there is not as much unnatural distortion.

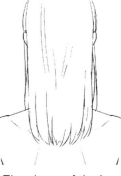

The shape of the head is more realistic too, so even when the hair is long and loose, the ear is partially visible, instead of hidden.

CHAPTER 2
Character Design by Angle and Age

In this chapter, you will try your hand at drawing characters
from more complex angles and of different ages.
If you can learn how to draw character designs from different
angles, you will be able to create compositions including where
you are either looking down on a face or up at one. And if you
master drawing characters of various ages, your range of charac-
ters will increase to include children through adults of all ages.

Expand Your Range of Expressions—Vantage Points and Ages

In this chapter, we will look at how to draw male and female characters from various angles and learn tips on how to draw characters of different ages.

 1 ## Drawing Complex Angles Expands the Range of Characters' Actions

Female 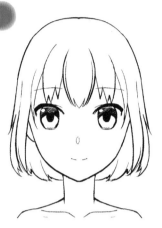 **Male**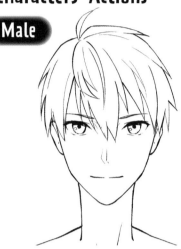

Once you've mastered drawing a basic face, you'll know how to position the eyes, nose and mouth.

Start with this!

Once you've learned the positioning of features, you can change the direction of the eyebrows or the shape of the mouth to draw the character's expressions (see Chapter 4 for more on expressions). This alone is enough to be able to draw character illustrations, but you will want to draw more dynamic actions.

This is attractive, but...

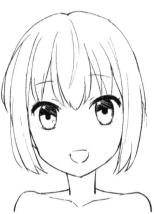 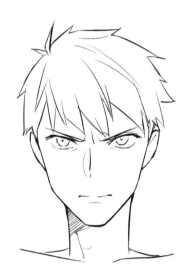

If you can draw complex low and high angles, you can create actions of movement, like looking up and smiling or staring up at you.

...this is really dramatic!

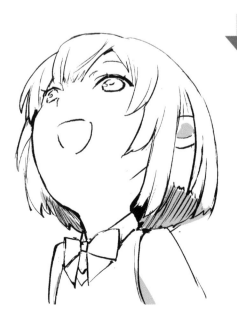

2 Master Drawing Characters of Different Ages to Expand Your Range

Female

Male

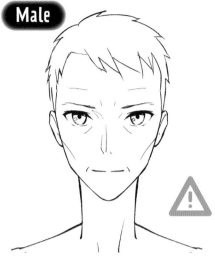

You will probably want to draw a variety of characters—not just young adults, but cute children and the older adults who care for them. However, simply adding a few wrinkles and thinning the flesh around the bones doesn't make the character look like an adult.

For example, as adult characters age, the area around the jaw, neck and shoulders changes, so it's important to understand this and be able to draw it.

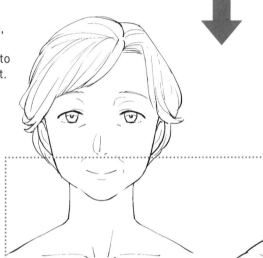

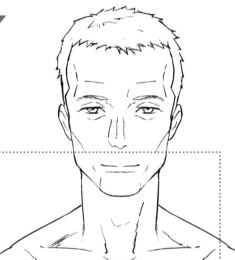

The region of prominent changes

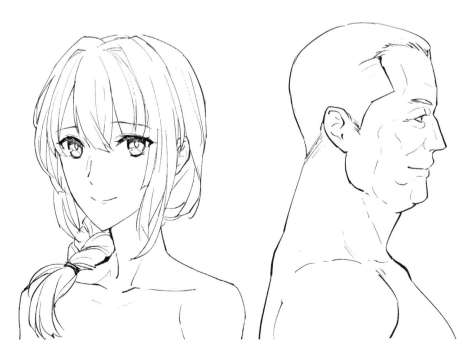

You can draw a young character's family, junior and senior colleagues and more. If you master drawing characters of different ages, you will expand your range. You'll also be able to create manga and anime with rich and detailed storylines.

Drawing from Low and High Angles

From a low angle, with the character gazing up, the jaw looks wide. Use distortion to draw the jaw area so that it doesn't look too rugged. Characters viewed from a high angle, looking down, should be drawn so the head looks large and the eyes, nose and mouth appear in lower positions.

From a Front Low Angle

Move the eyes, nose and mouth up, so the ears look relatively low. Faces are not completely flat. Have the bridge of the nose act as the ridge of the face and add gentle curvature. Here, the curvature of the face is marked with a dotted line. The images in the left column show a ghosted comparison with the basic face viewed horizontally from the front.

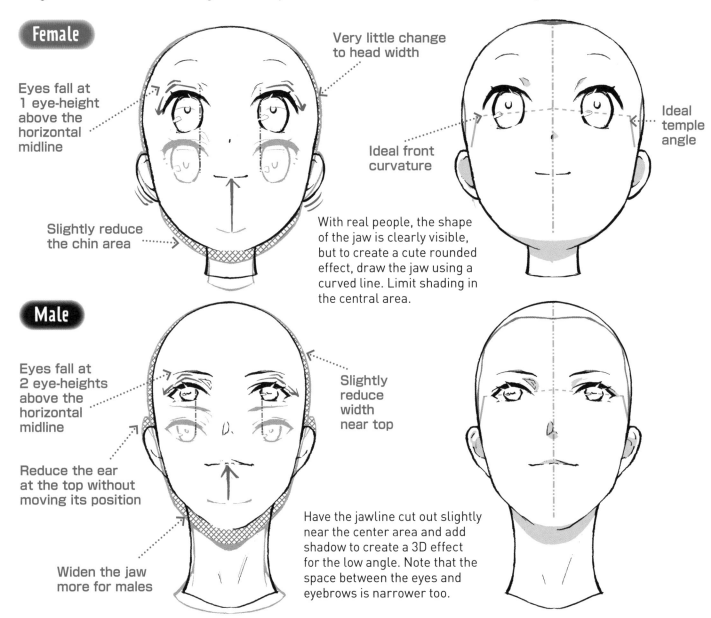

Female

Eyes fall at 1 eye-height above the horizontal midline

Very little change to head width

Ideal front curvature

Ideal temple angle

Slightly reduce the chin area

With real people, the shape of the jaw is clearly visible, but to create a cute rounded effect, draw the jaw using a curved line. Limit shading in the central area.

Male

Eyes fall at 2 eye-heights above the horizontal midline

Reduce the ear at the top without moving its position

Slightly reduce width near top

Widen the jaw more for males

Have the jawline cut out slightly near the center area and add shadow to create a 3D effect for the low angle. Note that the space between the eyes and eyebrows is narrower too.

Drawing Tips (Regardless of the Character's Gender)

● The length of the head should be very slightly shorter than the length of a face viewed horizontally
● Place the ears lower than the eyes
● Make the eyes a little more closely set than when viewed from the horizontal angle

● Make the curve of the upper eyelids steeper and lower the outer corner of the eyes
● Draw a thin crescent-shaped shadow between the jaw and neck
● Raise the nose and mouth up and leave a large space under the mouth.

From a Front High Angle

To depict a character from a high angle, move the eyes, nose and mouth down, so the ears seem relatively high.

Female

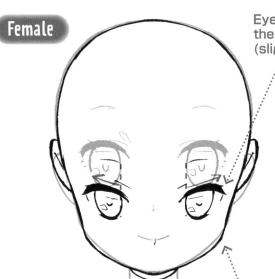

Eyes fall at 1 eye-height below the horizontal midline (slightly condense widthwise)

For high angles, the jaw is usually drawn subtly, but the size of the cheeks hides the projection of the chin, creating a rounded outline at the bottom. It's difficult to see the mouth, so either omit it or use distortion to draw it joined to the outline.

Round out the cheeks at the bottom

Male

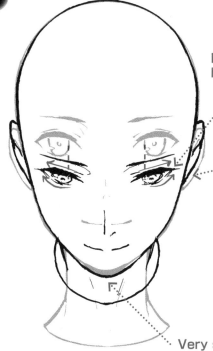

Eyes fall at 2 eye-heights below the horizontal midline

Curve up toward the outer corner

For males, if you make the chin too small and thin, it can easily disturb the balance, so slightly lengthen the chin and emphasize its outline.

Very slightly lengthen and emphasize tip of chin

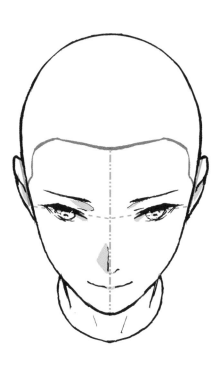

Drawing Tips (Regardless of the Character's Gender)

- The length of the head should be about the same as that for a face viewed horizontally
- Place the ears slightly higher than the eyes
- Draw slightly close-set eyes
- Make the curve of the upper eyelids shallower and raise the outer corner of the eyes
- Shorten the neck and draw the neckline so it looks round
- Draw the eyes and eyebrows close together

From a Side-on Low Angle

Draw the face as if the horizontal side profile is tilted backward.

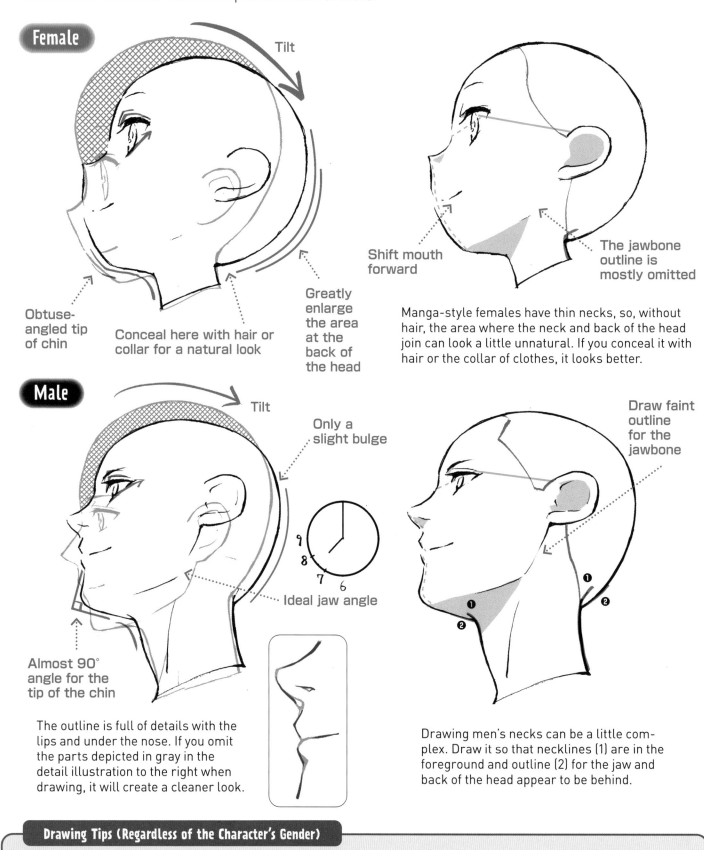

Female

Tilt

Shift mouth forward

The jawbone outline is mostly omitted

Obtuse-angled tip of chin

Conceal here with hair or collar for a natural look

Greatly enlarge the area at the back of the head

Manga-style females have thin necks, so, without hair, the area where the neck and back of the head join can look a little unnatural. If you conceal it with hair or the collar of clothes, it looks better.

Male

Tilt

Only a slight bulge

Ideal jaw angle

Draw faint outline for the jawbone

Almost 90° angle for the tip of the chin

The outline is full of details with the lips and under the nose. If you omit the parts depicted in gray in the detail illustration to the right when drawing, it will create a cleaner look.

Drawing men's necks can be a little complex. Draw it so that necklines (1) are in the foreground and outline (2) for the jaw and back of the head appear to be behind.

Drawing Tips (Regardless of the Character's Gender)

● The lower eyelid rises up toward the outer corner of the eye

● The size of the head is about the same as that for the head viewed horizontally

From a Side-on High Angle

Draw a horizontally angled side profile as if it is tilted and compressed.

Female

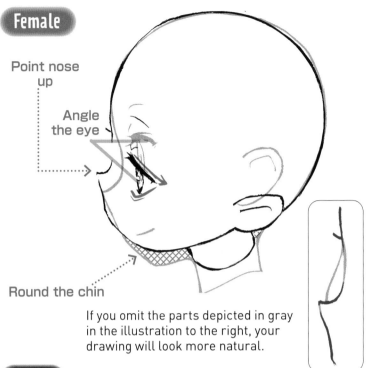

Point nose up

Angle the eye

Round the chin

If you omit the parts depicted in gray in the illustration to the right, your drawing will look more natural.

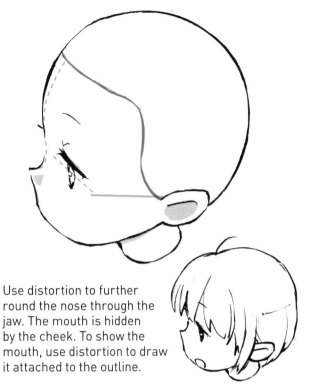

Use distortion to further round the nose through the jaw. The mouth is hidden by the cheek. To show the mouth, use distortion to draw it attached to the outline.

Male

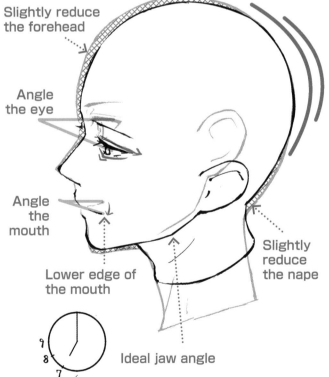

Slightly reduce the forehead

Angle the eye

Angle the mouth

Lower edge of the mouth

Ideal jaw angle

Slightly reduce the nape

If you omit the parts depicted in gray in the illustration above, your drawing will look more natural.

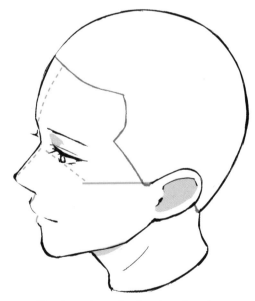

Finely reduce the forehead and nape, and draw the head so as to emphasize its egg shape. Even when smiling, if the corners of the mouth look like they're turned down, it gives a somewhat melancholy expression.

Drawing Tips (Regardless of the Character's Gender)

- The upper eyelid slopes down toward the outer corner of the eye
- The neck is short with a rounded collar line
- Downcast eyes create a slightly pensive look
- Angle the ear to the back

71

A Tilted Low Angle

It's important when drawing this angle to understand the positional relationship between the left and right eyes and ears. The far eye is lower than the front one and the ears are even lower.

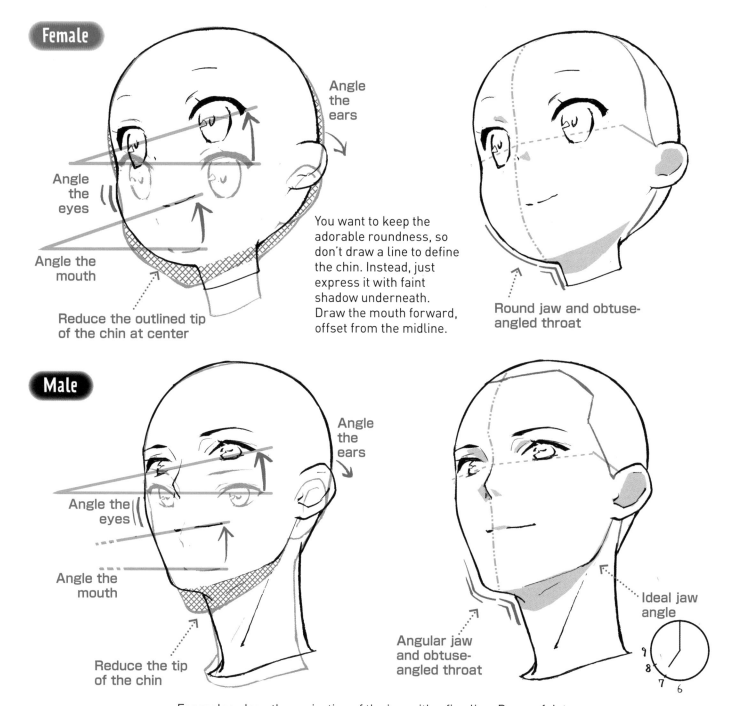

Female

Angle the ears

Angle the eyes

Angle the mouth

Reduce the outlined tip of the chin at center

You want to keep the adorable roundness, so don't draw a line to define the chin. Instead, just express it with faint shadow underneath. Draw the mouth forward, offset from the midline.

Round jaw and obtuse-angled throat

Male

Angle the ears

Angle the eyes

Angle the mouth

Reduce the tip of the chin

Angular jaw and obtuse-angled throat

Ideal jaw angle

For males, draw the projection of the jaw with a fine line. Draw a faint line to define the chin. Male noses are generally depicted as being higher on the face, so the inner corner of the far eye is hidden.

Drawing Tips (Regardless of the Character's Gender)

- The width of the head should be very slightly shorter than the length
- Add a shadow to the border between the chin and neck
- Raise the position of the cheek swell
- Draw the mouth so that it tilts higher toward the front
- Tilt the ear slightly and make it shorter vertically

A Tilted High Angle

Here too, the positional relationship between the left and right eyes and ears is important. Draw so that the ear is highest, followed by the far eye, and the near eye the lowest.

Female

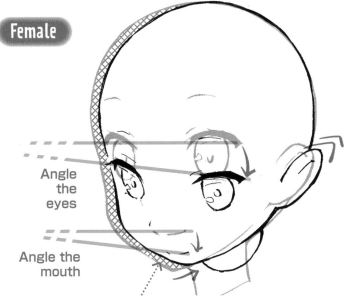

Angle the eyes

Angle the mouth

Pull the cheek in all the way to the tip of the chin

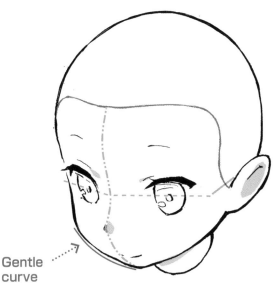

Gentle curve

At this angle, the bulge of the cheek is a gentle curve. Draw the tip of the chin as if it is being pulled in toward the neck.

Male

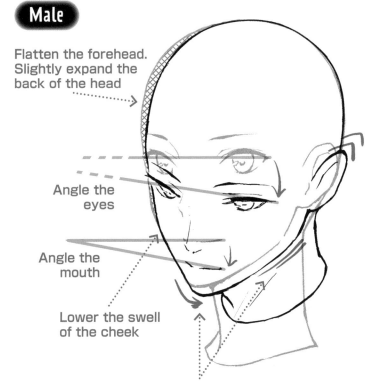

Flatten the forehead. Slightly expand the back of the head

Angle the eyes

Angle the mouth

Lower the swell of the cheek

Lower the outline from the tip of the chin, along the jaw, to the ear

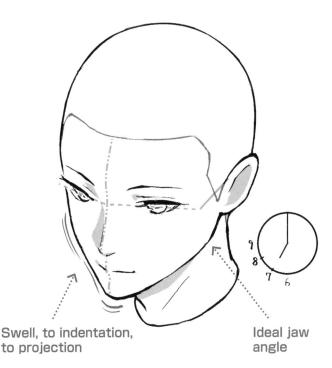

Swell, to indentation, to projection

Ideal jaw angle

Men have curvature from their cheek through to their chin. Draw the outline so the chin seems to be lowering.

Drawing Tips (Regardless of the Character's Gender)

- The size of the head is about the same horizontally between the genders
- The eyes and eyebrows are close together
- The ears are narrow due to foreshortening
- Foreshorten the neck
- The collar on clothing looks more widely elliptical

Drawing Faces At a 70° Angle

A basic angled face is usually 45° from front-on. Here, let's try drawing a face at 70°. While it's very similar to a side profile, it's at an angle where you can just about see both eyes. If you can master this, the range of expressions that you can draw will exponentially increase.

70° Angle Horizontal Angle

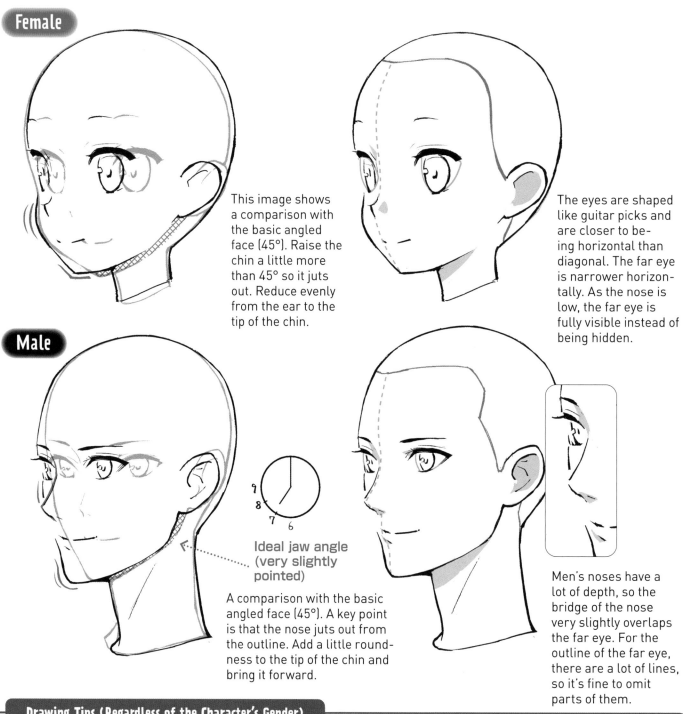

Female

This image shows a comparison with the basic angled face (45°). Raise the chin a little more than 45° so it juts out. Reduce evenly from the ear to the tip of the chin.

The eyes are shaped like guitar picks and are closer to being horizontal than diagonal. The far eye is narrower horizontally. As the nose is low, the far eye is fully visible instead of being hidden.

Male

Ideal jaw angle (very slightly pointed)

A comparison with the basic angled face (45°). A key point is that the nose juts out from the outline. Add a little roundness to the tip of the chin and bring it forward.

Men's noses have a lot of depth, so the bridge of the nose very slightly overlaps the far eye. For the outline of the far eye, there are a lot of lines, so it's fine to omit parts of them.

Drawing Tips (Regardless of the Character's Gender)

- Compared to the tilt of 45°, widen the overall silhouette slightly
- Draw the jaw so it juts forward a little
- Reduce the outline of the lower jaw for a cleaner effect
- Shape both eyes as if they are sideways-facing guitar pick shapes

A 70° Low Angle

Female

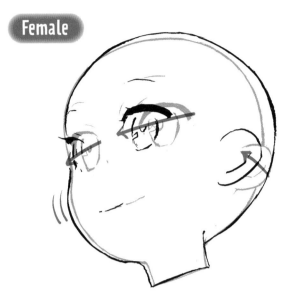

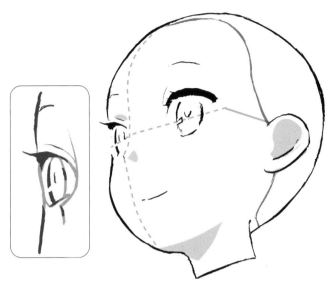

A comparison with the 45° low angle. For women, it's difficult to express the different angle due to the strong distortion of the chin, so draw the swell of the cheek tilted slightly downward to show the change in angle.

The nose overlaps the far eye, but women's noses generally have shallower depth, so that eye isn't completely hidden. Where the outline, eye and nose overlap, leave in the eye lines and omit the rest for a clean look.

Male

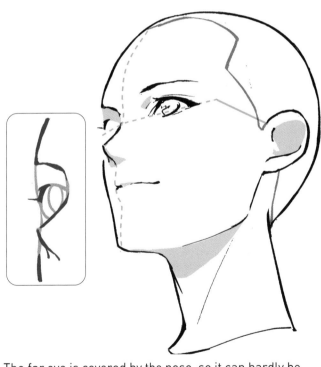

A comparison with the 45° low angle. Draw the eyes, mouth and ears slightly shifted back. The chin juts out slightly.

The far eye is covered by the nose, so it can hardly be seen. A key point is that the nose touches the outline. Where the nose and eyes overlap, give the nose priority and omit the other lines.

Drawing Tips (Regardless of the Character's Gender)

- Draw slightly wider than the 45° low angle face

- Tilt the eyes, nose and chin farther down than for the 45° low angle face. The ears tilt upward.

A 70° High Angle

Female

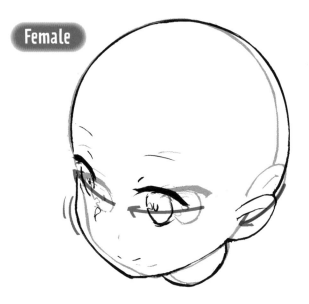

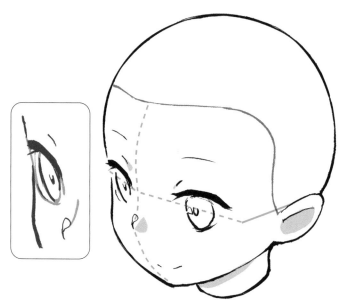

Draw the eyes, mouth and ears slightly shifted in a clockwise direction. Use distortion to draw the mouth forward of the face's midline.

The far eye overlaps the outline, but the nose doesn't. Draw the position of the ears quite low.

Male

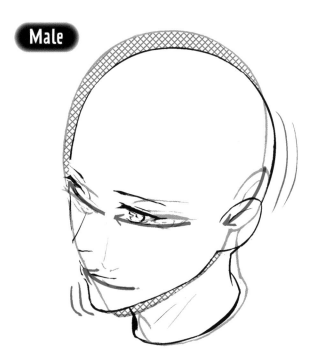

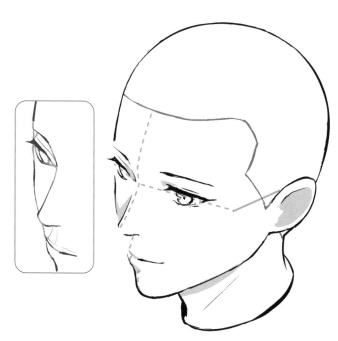

A comparison to a 45° high angle face. Draw the eyes, mouth and ears slightly shifted back. Slightly reduce the area from the forehead to the crown of the head and from the jaw to the ear. Then, have the shape of the chin and lips jut out to express the change in facial direction.

The far eye and the nose both overlap the outline. Draw this part by omitting the lines where they overlap.

Drawing Tips (Regardless of the Character's Gender)

● The ears are drawn a lot lower than for a 45° high angle vantage point

● Angle the eyes, nose and chin farther up than for the 45° high angle face. The ears angle downward.

How and When to Use 45° and 70° Angles

In this book, as well as learning how to draw the usual 45°-angled face, we introduce how to draw at a 70° angle too. This is more difficult, but it has advantages that can't be achieved with 45° angles.

45° Angle

Highly versatile, but it lacks vitality

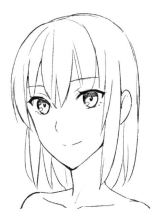

Merits: Easy to convey facial features. Suitable for a wide range of scenes, including in character reference materials or introductions.
Drawbacks: There's little movement and it lacks vitality. Weak impact in scenes where you want the character to stand out.

70° Angle

Creates impact for the character's presence in scenes

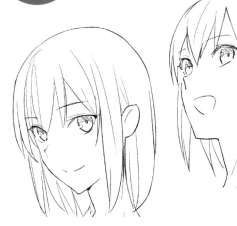

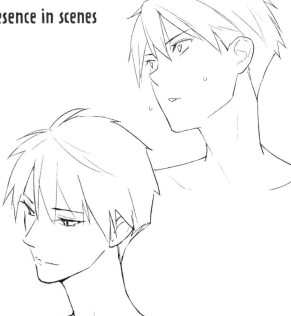

At a 70° angle, you can draw the face at the moment the character is looking back and express strong emotion through the eyes. By having the gaze meet you ahead of the face turning, it creates the impression that the character is looking at you—more than with a front-on face.

Merits: It emphasizes the direction of the line of sight and creates strong eye appeal. As it's like looking into a camera, it works well for manga book covers and cool expressions and action scenes for anime.
Drawbacks: Because the back side of the face tends to be hidden, it's not suitable for introducing a character. It's not flexible enough to be used in all types of scenes.

The 70° angle is perfect for drawing the cool gaze or serious look of a handsome character. The nose looks well-defined and the direction of the eyes works well to show the character gazing off into the distance. As the direction of the line of sight is clearer than for 45°-angle poses, it creates a dramatic impression.

Drawing Extremely Low Angles

This angle can be used for looking up at a character and also for drawing a character who is lying down. One challenge is that manga-style female heads drawn with distortion to exaggerate roundness tend to look strange at this angle. So be sure to learn how to draw this in a natural-looking way.

Extremely Low Front Angle

 Female

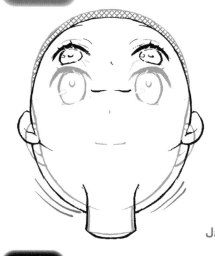

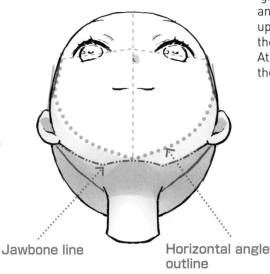

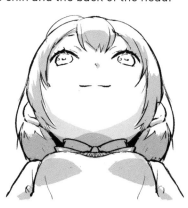

The image to the far left shows a ghosted comparison to a front low angle. The eyes are placed 1 eye-height up compared to the low angle and their size is reduced to half the height. At this angle, you can see both under the chin and the back of the head.

Jawbone line

Horizontal angle outline

Male

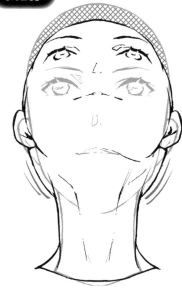

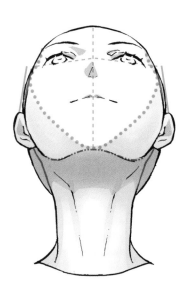

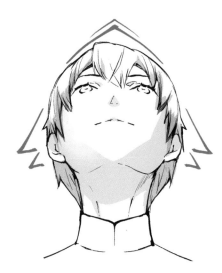

Comparison to a front low angle. The eyes are placed 2 eye-heights up compared to the low angle. Make the width a little narrower. The forehead area is nearly flat.

For men, draw a faint jawbone line to mitigate the unnatural look around the jaw.

At this angle, the face can tend to look large. If you hide part of the outline with long sideburns, it results in the face looking smaller. Draw the bangs piled up and have the hair in the back spreading out a bit like an umbrella.

Drawing Tips (Regardless of the Character's Gender)

- Make the top of the outline (forehead) nearly flat and the bottom (back of the head) round
- The jawbone line is a shallow W shape—add shading under this line

- Where the outline looks strange, cover it with hair or the body to make it look more natural

Super-Low Side Angle

Female

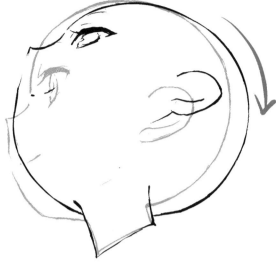

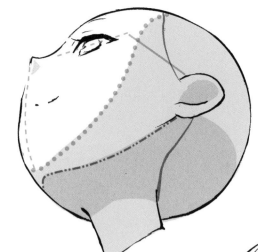

For this angle, the curve from the forehead to the tip of the nose is very gentle.

Draw a low angle side profile as if it is even more tilted. A problem with this angle is that it can look very fleshy under the mouth.

When drawing an illustration, you'll want to add as much shading as possible to show this area is under the chin rather than being part of an unnaturally large face. Give the hair volume to make the back lower.

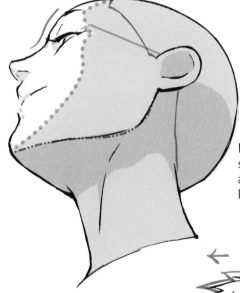

Male

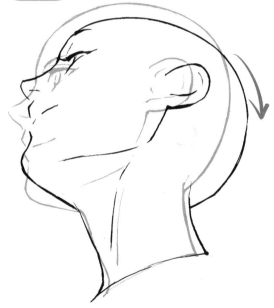

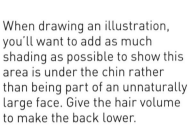

Male jawlines are more strongly defined, so create a wider area under the chin. Draw a faint jawline too.

For males, you can define the jaw-bone with a line, so it is less likely to look fleshy under the mouth.

Add bangs that sweep forward. Hair on the sides should flow along the hairline. For the hair at the back, have it flowing from the whorl and spike it where it is cropped.

Extremely Low 45° Angle

Female

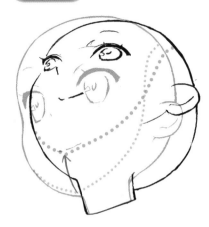

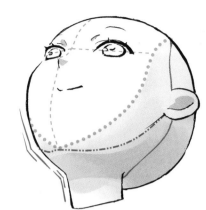

The outline from the cheek to the neck is round, but make sure to create a slight angle at the tip of the chin and the throat area.

A comparison with the regular low angle. The chin is raised up and the plane of the eyes approaches being horizontal. Omit the bridge of the nose to make the far eye visible.

Here the hair and body have been added. For an extremely low angle, if you cover the neck area or part of the jaw with hair or clothing, it will look more natural.

With a pose where the character is extending their neck, if you draw the mouth open, it will look less strange.

Male

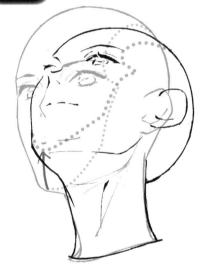

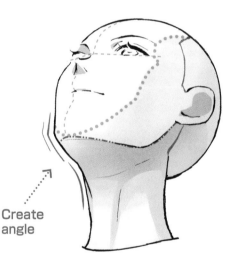

Create angle

For males, create a clear angle by drawing the area from the cheek to the jaw using an obtuse angle. Depict the throat area with a smooth curve.

As the jaw is tilted farther up than with a regular low angle, draw the outline with a more obtuse angle. The far eye is hidden by the bridge of the nose.

Here, the hair and body have been added. For males, the jaw and neck are clearly visible. Add shadow to give a three-dimensional effect.

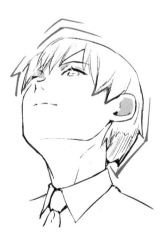

Angle the bangs and hair in the back, and add volume to the sideburns to adjust the shape.

Extremely Low 70°Angle

Female

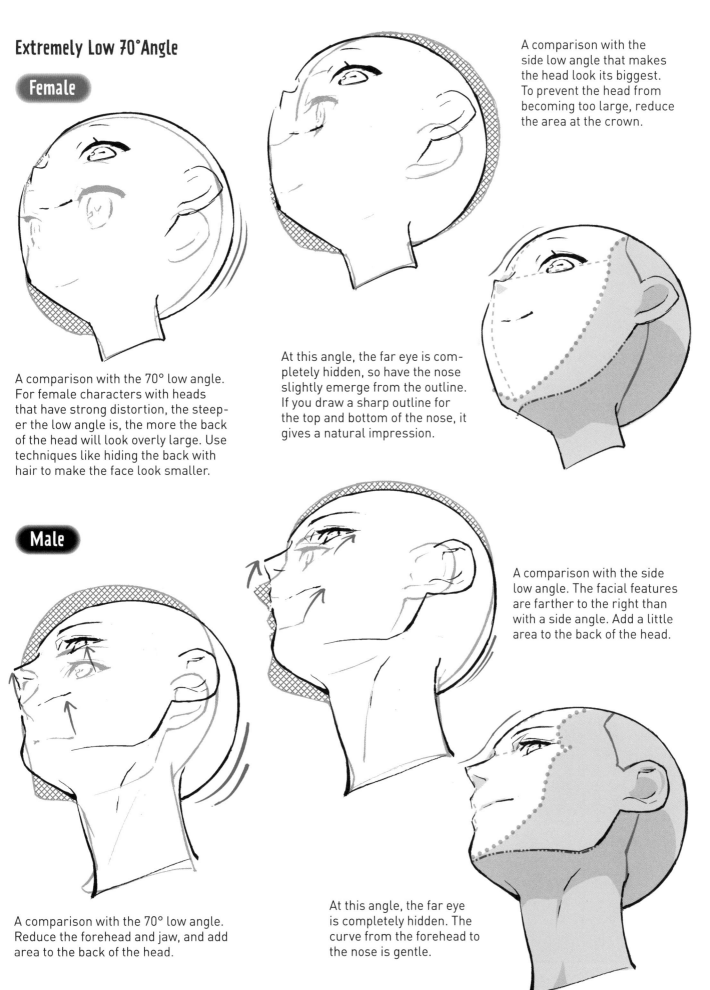

A comparison with the side low angle that makes the head look its biggest. To prevent the head from becoming too large, reduce the area at the crown.

A comparison with the 70° low angle. For female characters with heads that have strong distortion, the steeper the low angle is, the more the back of the head will look overly large. Use techniques like hiding the back with hair to make the face look smaller.

At this angle, the far eye is completely hidden, so have the nose slightly emerge from the outline. If you draw a sharp outline for the top and bottom of the nose, it gives a natural impression.

Male

A comparison with the side low angle. The facial features are farther to the right than with a side angle. Add a little area to the back of the head.

A comparison with the 70° low angle. Reduce the forehead and jaw, and add area to the back of the head.

At this angle, the far eye is completely hidden. The curve from the forehead to the nose is gentle.

Illustrations of Faces form Various Vantage Points

Here you can see all the faces as they change from angle to angle. With each one, take a look at how the eyes, nose, mouth and other features are positioned. Compare the shape of the outlines too. When you find yourself stuck on how to draw a manga or illustrated character, these pages will help you.

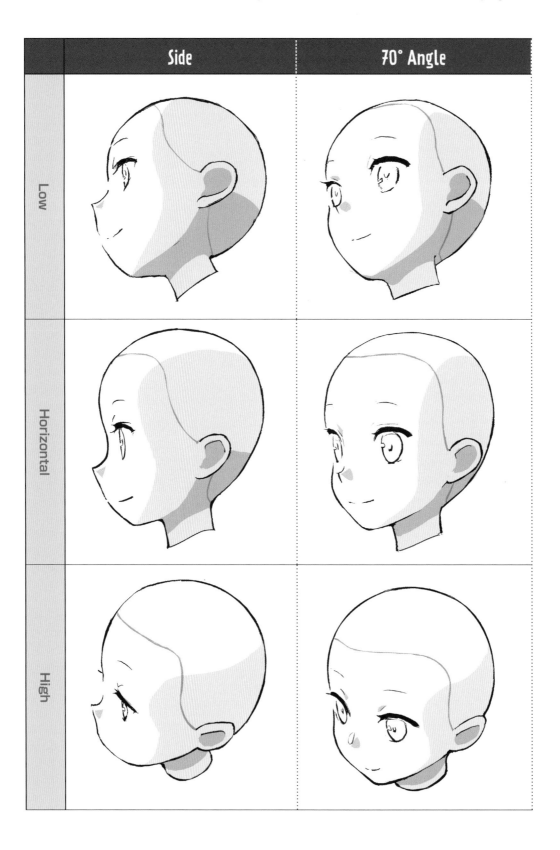

	Side	70° Angle
Low		
Horizontal		
High		

45° Angle	Front

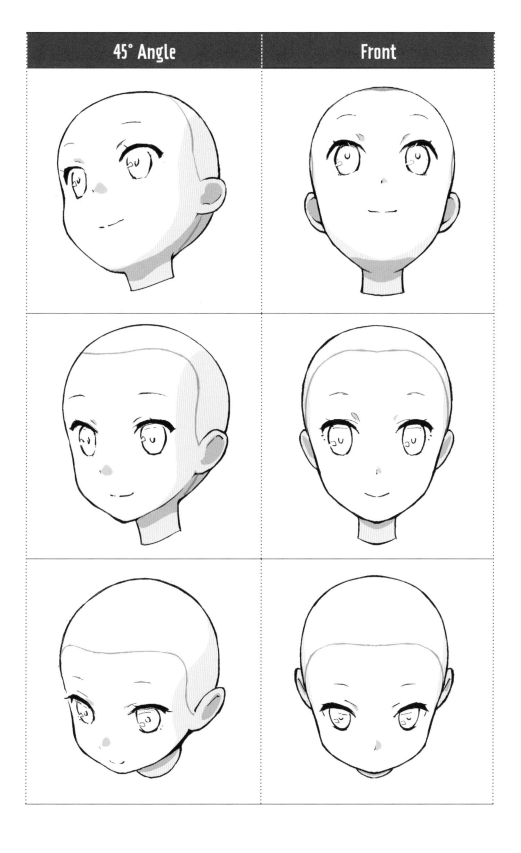

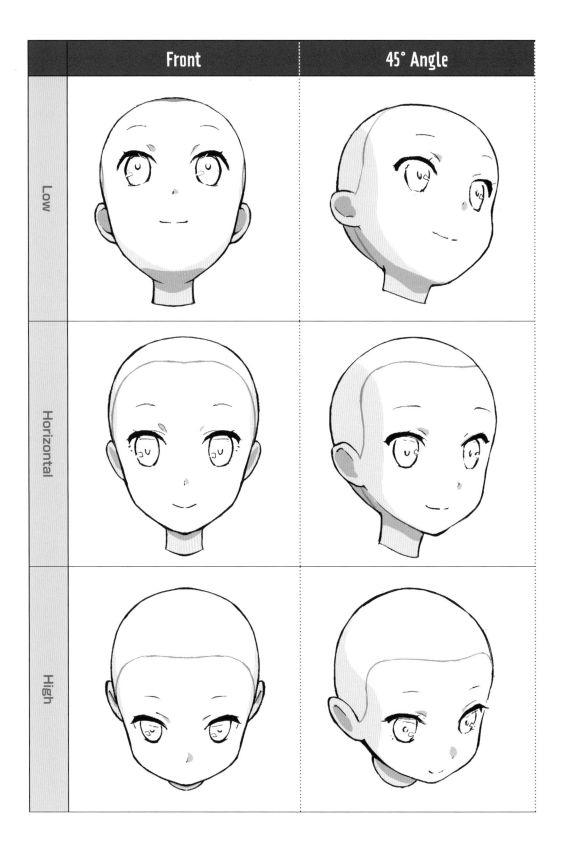

	Front	45° Angle
Low		
Horizontal		
High		

70° Angle	Side

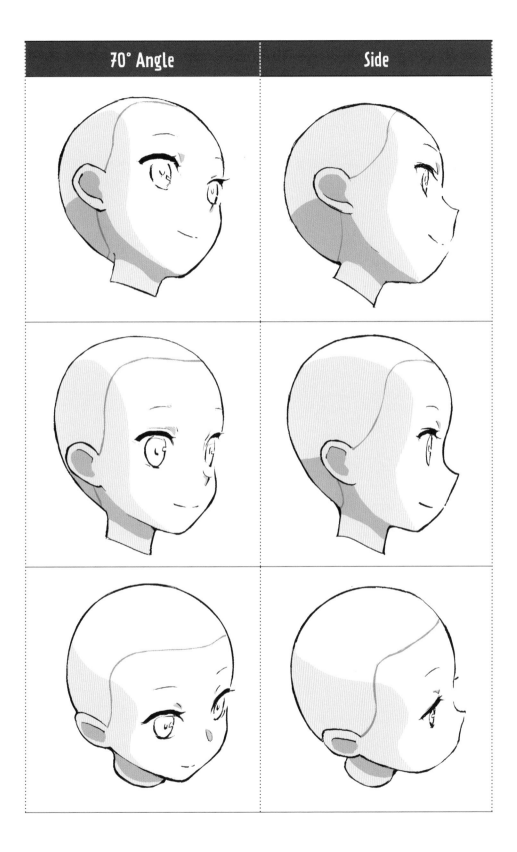

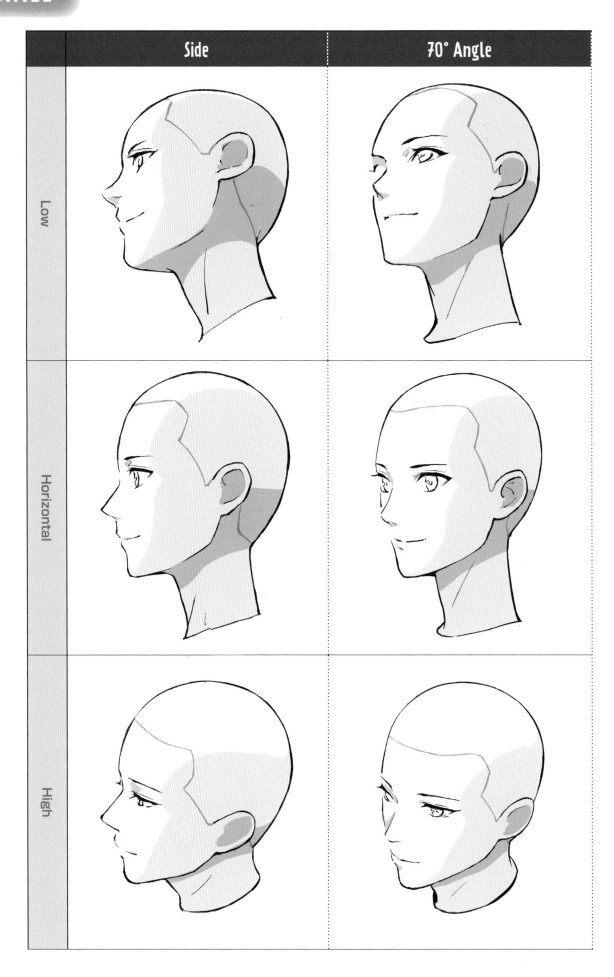

	Side	70° Angle
Low		
Horizontal		
High		

45° Angle	Front

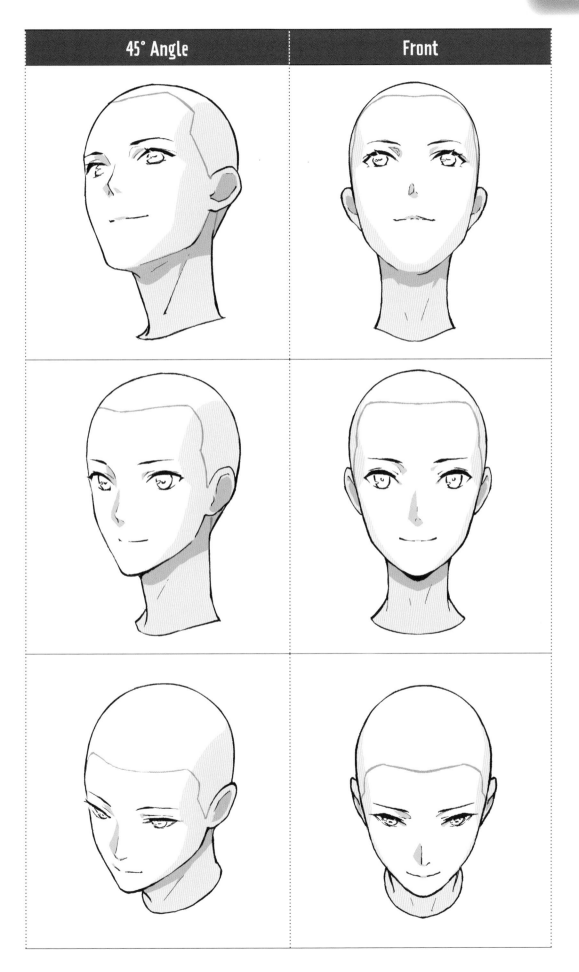

	Front	45° Angle
Low		
Horizontal		
High		

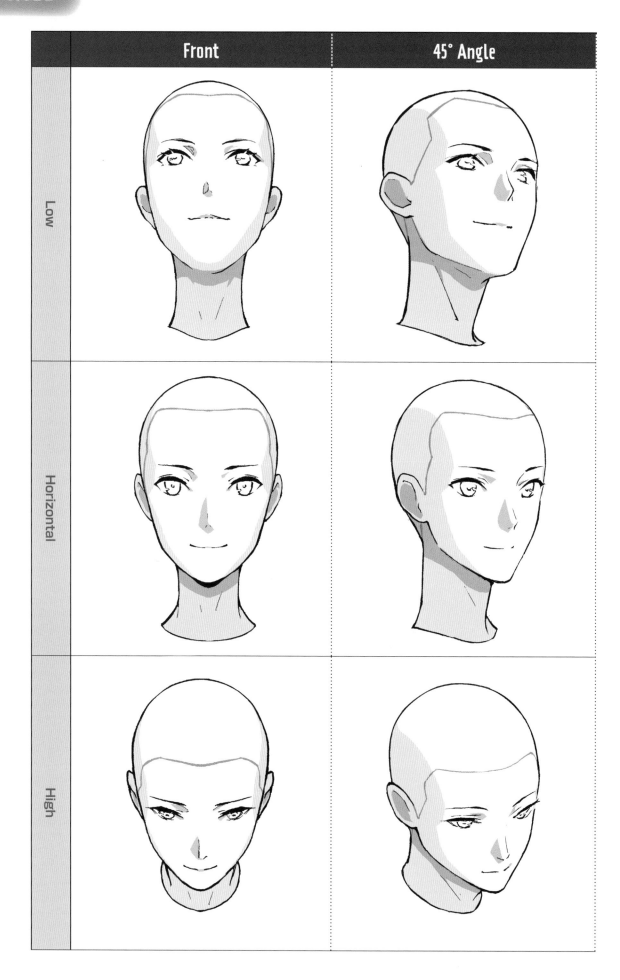

70° Angle	Side

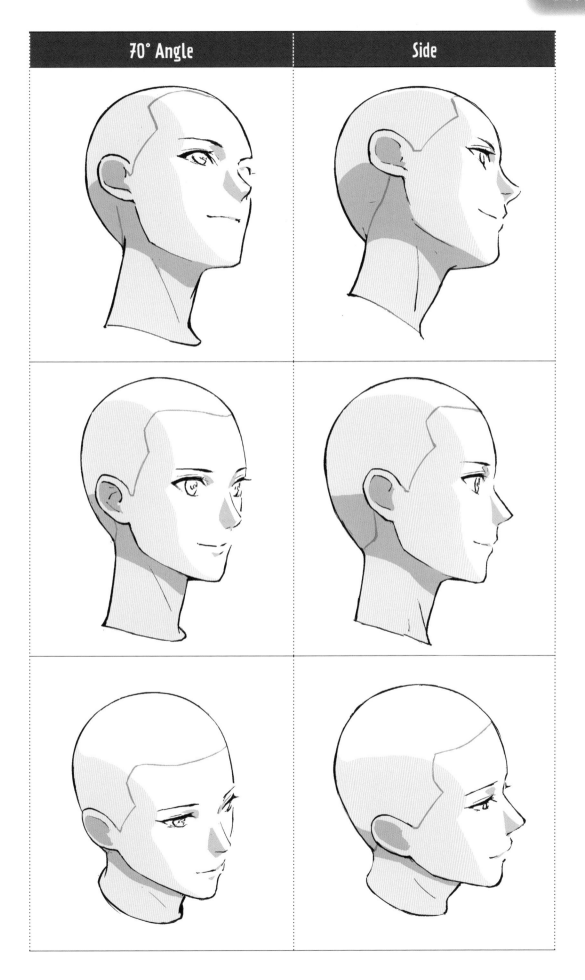

Drawing Characters of Different Ages

Children, young adults, adults, elderly people ... here we will look at drawing male and female characters of a wide age range. If you learn which features change with age, the range of characters you can draw will greatly expand.

Children—Rounder Heads, Minimal Gender Difference

Here are examples of children under ten years of age. For children in this age range, their heads are larger with smaller chins than teenagers. There is relatively little difference in features between boys and girls. The girl here has been drawn with a rounder outline for a more youthful look.

 Female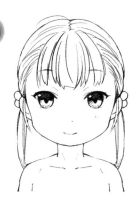

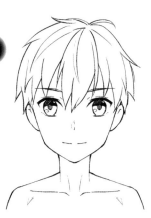 Male

Teenagers—Feminine Curvature / Masculine Straight Lines

This age range often appears in manga. This is the main type of character in this book too. Here, the girl is in her early teens with a cute appearance and the boy is in his late teens and has a mature look. This combination of characters is often used in manga and anime.

 Female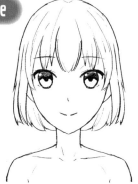

Male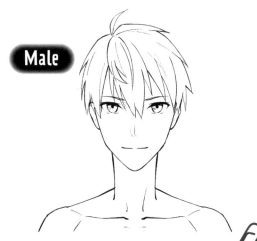

Character Combos in Manga and Anime

In manga and anime, even if the ages of two characters are the same, one tends to be drawn younger or more mature.

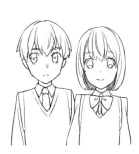

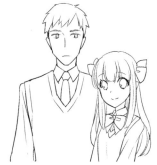

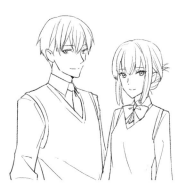

Both child-faced
This combination is often used to emphasize feminine cuteness.

Mature boy + young girl
This combination is seen a lot in manga.

Both adult-like faces
This style is often used to emphasize a cool, young masculine look.

NOTE

Young Adults—Feminine Rounded Shapes / Masculine Rugged Jaw

These are examples of characters in their 20s and 30s. Women have long narrow oval faces, while men have wider outlines with rugged features that jut out. Both have more defined nose bridges compared to teenagers. For men, add crease lines to the inner corners of the eyes and the cheeks for a realistic touch.

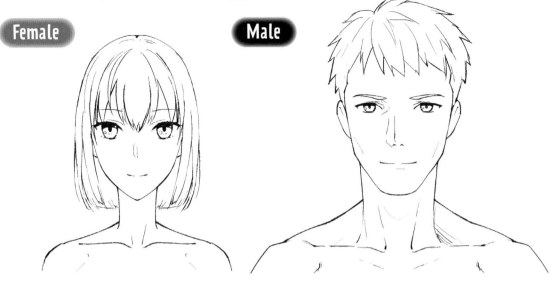

Middle-Aged Adults—Slack Eyelids and Cheeks

These characters are aged in their 40s and 50s. At this age, both men and women have eyelids and cheeks that sag downward. The eyes are narrower and drooping. They have moderate laugh lines and forehead crease lines.

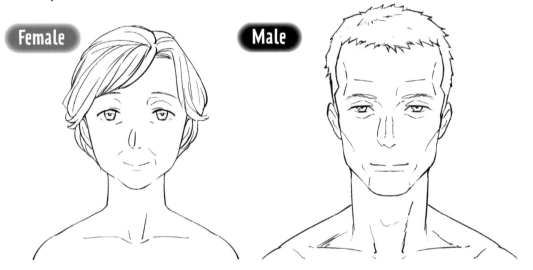

Senior Adults—More Creases and Slackness

These are examples of characters in their 60s and 70s. The jaws sag more than for mid-dle-aged characters and the start of the neck is not as defined. Both men and women have laugh lines, fore-head crease lines and more visible skeletal structure.

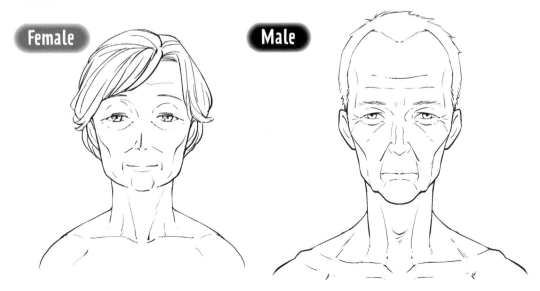

Children

 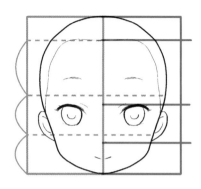 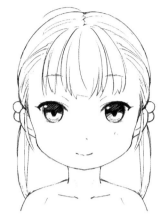

1 Draw the basic circle and then reduce both sides so that the head is larger and rounder than that for the girl character on page 19. The cheeks puff out and the outline from the forehead to the cheeks forms an S shape.

2 Draw the eyes, nose and mouth a lot lower than for the basic girl character.

3 Add hair and make adjustments. For young children, the shape of the neck is short and relatively thick. Don't add too much volume to the hair.

NOTE

Reflect Children's Features Realistically for a Younger Look

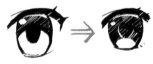

Small eyes with large pupils, a low nose and a short neck—if you exhibit these features, they give a stronger impression of a young child.

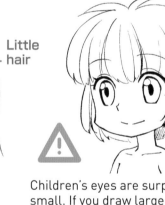

Little hair

Small white of eye

Short round nose

Short neck (looks thick)

⚠ Children's eyes are surprisingly small. If you draw large eyes, it will look less like a child and more like an SD ("super deformed") character.

Side profiles of children are a little difficult. Manga character side profiles, even adults, use distortion to make them look a lot more youthful. If you want to clearly differentiate from an adult, you need to use techniques such as, for example, making the lips and chin more realistic.

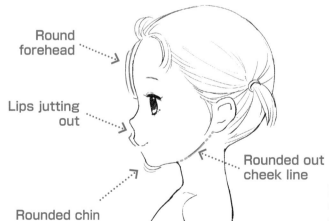

Round forehead

Lips jutting out

Rounded chin

Rounded out cheek line

⚠ If you draw a flat forehead and pointed nose, even with distortion, the character won't resemble a child.

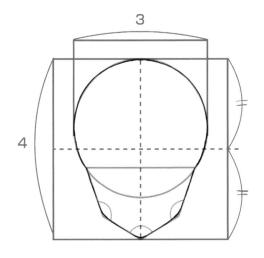

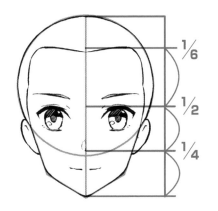

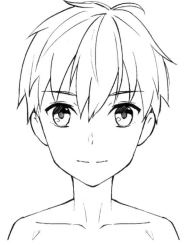

1 Draw a squat irregular pentagon well below the horizontal center of the circle. This will set the stage for a child-like face even if the jaw juts out.

2 The position of the facial features is the same as for the girl character on page 15. Change the shape of the jaw to express whether the character is a boy or girl.

3 Add hair to finish. For boys, the eyebrows should be a little lower and the neck very slightly thicker.

NOTE

Hold Back Here to Create a More Boyish Look!

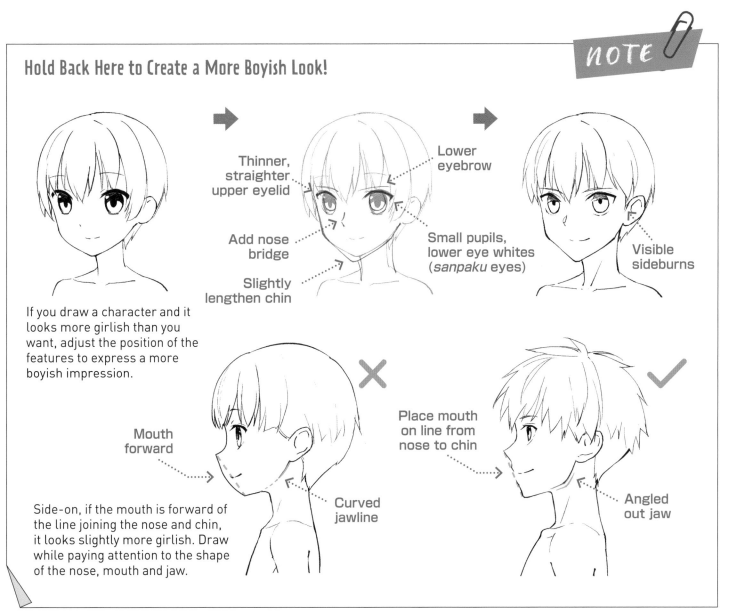

If you draw a character and it looks more girlish than you want, adjust the position of the features to express a more boyish impression.

Thinner, straighter upper eyelid

Add nose bridge

Slightly lengthen chin

Lower eyebrow

Small pupils, lower eye whites (*sanpaku* eyes)

Visible sideburns

Mouth forward

Curved jawline

Side-on, if the mouth is forward of the line joining the nose and chin, it looks slightly more girlish. Draw while paying attention to the shape of the nose, mouth and jaw.

Place mouth on line from nose to chin

Angled out jaw

Adults

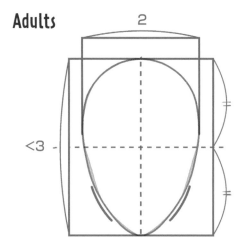

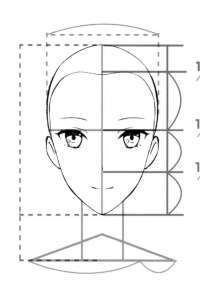

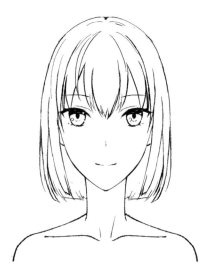

1 Use an oval outline for an adult woman's face. Reduce and sharpen the chin, while still keeping the roundness to create a feminine face.

2 The position of the facial features is the same as for the girl character on page 19. The neck is about the same length as for a young adult male.

3 Draw the hair and make adjustments. The eyes are longer sideways, with a look similar to that of a young adult male. But make the eyes, ears and mouth slightly lower and the nose slightly higher.

The side profile for an adult woman has the characteristics that both resemble a basic young girl and a young adult male. Draw the nose with a gentle curve and position the mouth so that it is just about touching the nose-to-chin line.

Gentle curved nose ·········

Mouth just about touching nose-to-chin line

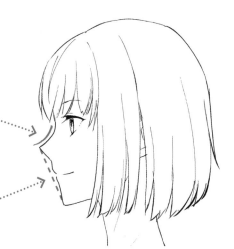

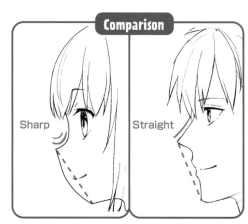

Comparison

Sharp

Straight

note

When You Want to Draw a Slightly Older Young Woman

Draw a well-defined nose bridge to create the image of slightly older age. If you draw the nose bridge and base like that of a young adult male, it gives the impression of a relaxed motherly type. If you draw the bridge of the nose and add almond-shaped eyes, you can create an attractive adult woman.

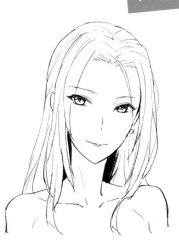

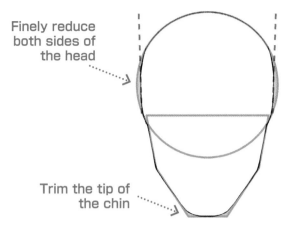

Finely reduce both sides of the head

Trim the tip of the chin

1 Add an irregular pentagon to the circle and then trim the point forming the chin to create an angular outline. It makes the jaw broader and the face larger widthwise.

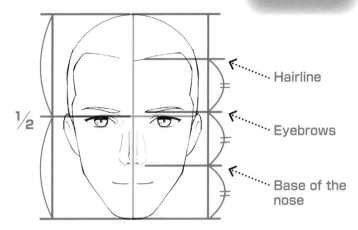

½

Hairline

Eyebrows

Base of the nose

2 The position of the facial features is the same as for the boy character on page 27. Draw the line of the nose to the side of the midline and create a broad nose with strong bone structure.

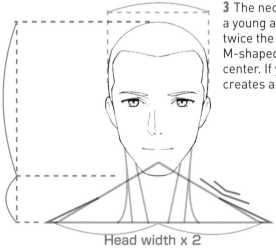

Head width x 2

3 The neck is the same length as for a young adult male. Draw a triangle twice the width of the head and add the M-shaped muscles of the neck in the center. If you draw this part clearly, it creates an image of masculine strength.

4 Add the hair and make adjustments. Then, draw more sturdy shoulders than for a teenage male to complete the look.

Comparison of Side-on Adult Male and Young Adult Male

The position of the facial features is the same as those for a young adult male, but the shape of the nose and jawbone differ.

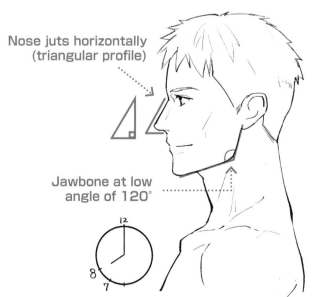

Nose juts horizontally (triangular profile)

Jawbone at low angle of 120°

Point tip slightly up

Jawbone at a slightly higher 130° angle

FEMALE

Middle-Aged Adults

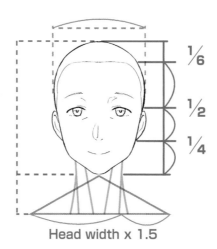

Head width x 1.5

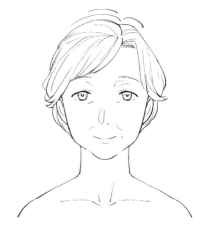

1 Draw the outline of the adult woman on page 94 and alter the jaw so it's rounder. Have it sagging down by imagining 3 small hanging mounds.

2 The position of the facial features and the neck length are the same as for the adult woman on page 94. Draw the M-shaped neck muscles, and then create a triangle 1.5 times the width of the head for the shoulders.

3 Soften the indentations in the outline. Make the eyes droop and faintly add fine crease lines around the eyes as well as laugh lines to complete the look.

NOTE

Emphasize the nose and slackened skin, but go easy on the wrinkles

There's a tendency to add wrinkles for middle-aged characters, but if you draw too many they will look older than desired, so keep it simple. Express the age by emphasizing the nose and crease lines.

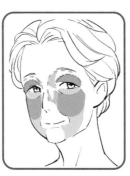

The sagging upper eyelids join to the crease lines of the outer corners of the eyes. The slack skin on the cheek is comprised of two separate parts.

Side view. Draw a thin eyelid and emphasize the line along the base of the nose. Add an indentation on the bridge of the nose at eye level. Slacken the chin and thicken the neck.

A Gaunt-faced Woman

As women age, if they are thin, their facial structure tends to become more prominent. Use an outline similar to a young adult male and trim off the tip of the chin. Then, indicate the cheek bones.

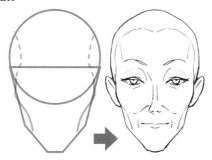

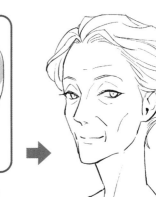

With an angular face, draw so that the smooth bulge of the cheek flesh is lost and add the cheek bones. Draw the indentations of the cheek lines along with the slackened skin.

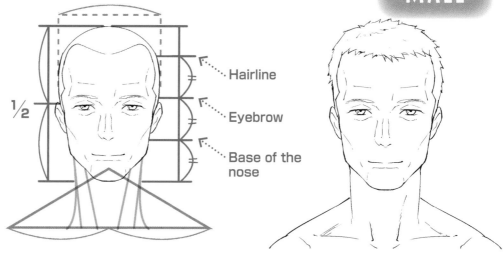

Hairline

Eyebrow

Base of the nose

½

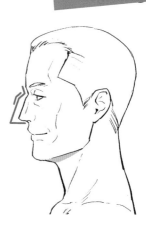

1 Draw an outline of the cheeks that is slightly lower than for the adult male on page 95. For men, accentuate the squareness of the jaw.

2 The position of the facial features is the same as for the boy character on page 27. Lower the position of the eyes slightly to account for the droop of the upper eyelids.

3 Draw slightly slouched shoulders and add thinning hair to finish. Depict the bridge of the nose with two vertical lines for emphasis.

NOTE

A Striking Nose and Cheek Lines

For middle-aged men, it's better to emphasize the cheek lines rather than the laugh lines.

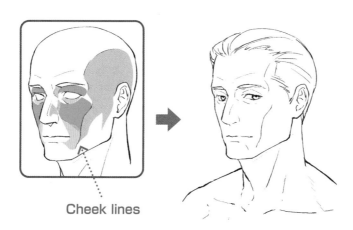

Cheek lines

Side view. The indentation at eye level is much more prominent than for a middle-aged woman.

A Chubby-faced Man

Here is an example of a slightly older man with a considerably fleshy face. Express the slack skin above and below the eyes, on the cheeks and jaw with lines.

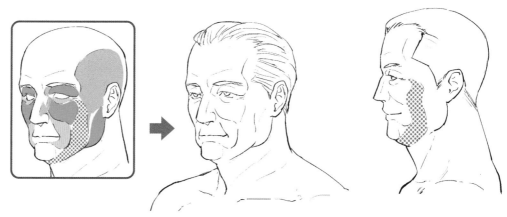

From the side, you can see that the slack of the double chin is connected to the cheek beside the eye.

Senior Adults

For senior adult characters, the flesh of their cheeks is even lower and their eyelids and lips sag more. Draw the crease lines without omitting any and express the cheek lines too. If you add in defined neck and shoulder muscles and bones, it will make the character look more aged.

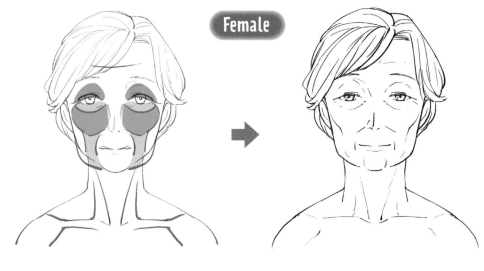

Female

For men, draw a receding hairline and have the bones on the shoulders stand out to appear more masculine. Make the jaw slacker and a little narrower. Make the slack on the sides of the mouth jut out slightly from the jaw.

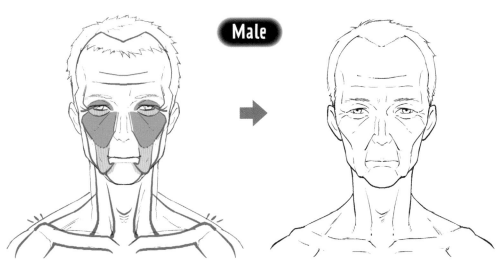

Male

Depending on the design, a realistic-looking senior adult character may not fit in well with a younger one. When that happens, just draw the minimum amount of lines to express old age and use distortion.

You'll find it effective to use distortion for the outline to balance the reduction in crease lines. Emphasize the cheekbones and draw slackened cheeks and neck.

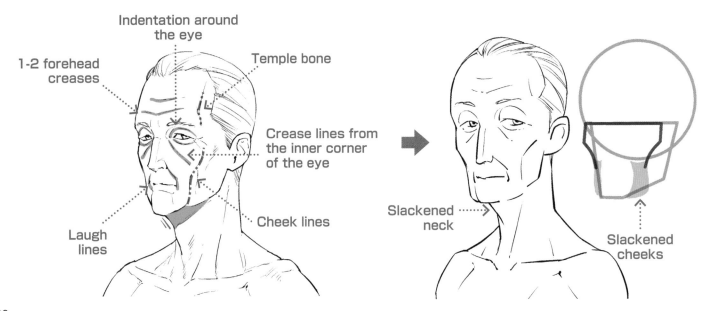

Indentation around the eye

1-2 forehead creases

Temple bone

Crease lines from the inner corner of the eye

Laugh lines

Cheek lines

Slackened neck

Slackened cheeks

Here, let's think about manga and anime where characters of different ages appear together in the same scene. Depending on the design and style, distortion may also be used for the adult characters, so make sure it doesn't look unusual when they are pictured together with young characters.

Emphasizing Age Difference Using Eye Highlights

The eyelids sag more with age, so the eyes get narrower and the irises become less visible, causing the highlights diminish in size and number. This helps to differentiate older characters from younger ones.

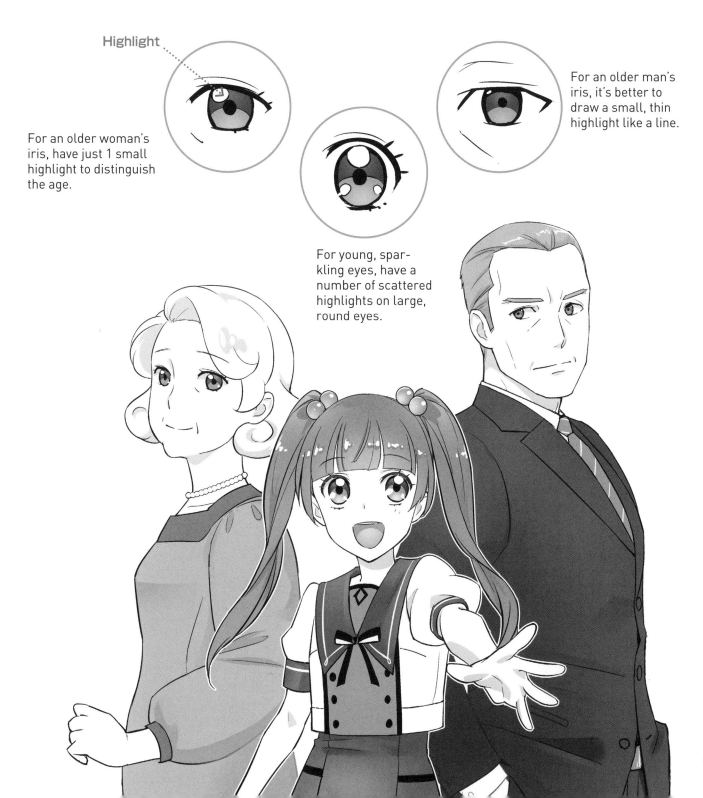

Highlight

For an older woman's iris, have just 1 small highlight to distinguish the age.

For young, sparkling eyes, have a number of scattered highlights on large, round eyes.

For an older man's iris, it's better to draw a small, thin highlight like a line.

99

Use Distortion for Adult Outlines to Better Pair with Young Characters

In *shōjo* manga and manga, it works well to draw a "super-deformation" outline for adult characters. Even with few crease lines, it will look like an adult face and still fit in with younger characters. Take the time to study and understand the following 3 types of outlines.

Square

The head and jaw are about the same width. This outline suits a solid-built middle-aged man expressed using distortion.

Round Head + Square Jaw

The head is round, while the jaw is a little thin and angular. This pairs well with a senior adult male or a thin middle-aged female expressed using distortion.

Round Head + Slack Jaw

The head is round and the jaw juts out a little from the square outline. This is well suited for a middle-aged female character.

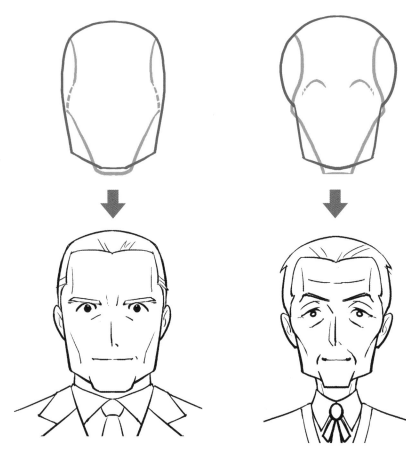

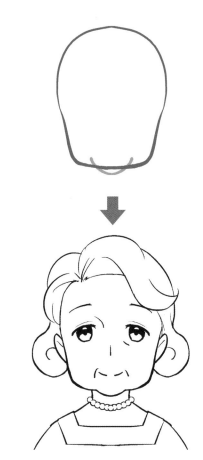

If you use clear distortion for the outline, you won't need to draw many crease lines to express age. Use either short or faint lines for the cheek indentations, the forehead wrinkles, the crease lines from the outer corners of the eyes and the laugh lines.

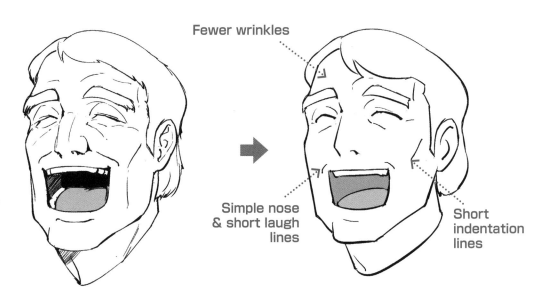

Fewer wrinkles

Simple nose & short laugh lines

Short indentation lines

CHAPTER 3

Learn to Draw Individual Features

In this chapter, we will look at all the individual facial features, such as the eyes, nose, mouth and ears, for male and female characters. What's the best way to draw feminine features like wide eyes and a small nose? How should you express a male's narrow eyes and defined nose? Learn each of them one by one.

Drawing Eyes

The eyes are an important feature that express the feelings of the character. To help distinguish gender, give males slightly deeper indentations around the eyes, and females wider, rounder eyes.

Male and Female Eyes Are Different

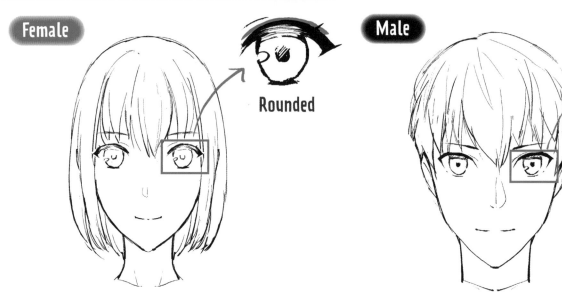

Female — Rounded

Male — Angular

Female facial bone structure exhibits relatively shallow-set eyes, so if you use distortion to create rounded, wide eyes, they will look feminine. Draw the eyelids with thick curved lines and make the irises and pupils large. If you indicate lots of highlights, the eyes will appear to sparkle.

Male facial bone structure exhibits relatively deep-set eyes. Draw the eyebrows slightly lower and with straight lines angled at the edge for a masculine effect. Men's eyes are drawn horizontally wider and the pupils are drawn smaller than their female counterparts. It's better to indicate smaller highlights too.

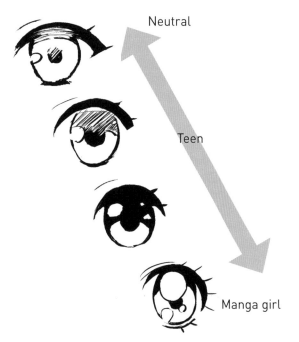

Neutral

Teen

Manga girl

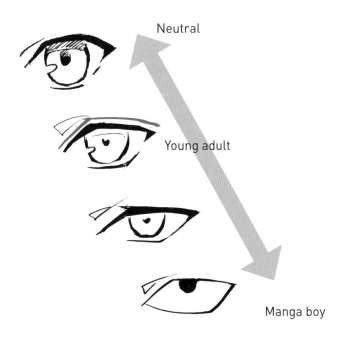

Neutral

Young adult

Manga boy

The rounder you make the overall shape, the more feminine and cute the eyes will appear. If you make them extremely round with sparkling highlights, they become like those of a young girl in manga.

If you make the pupils smaller and create "sanpaku eyes," with white under the iris, the eyes will look much more masculine. If you draw very small pupils and omit a lot of details, they become like those of a young boy in manga.

Distortion Around the Pupil

Female

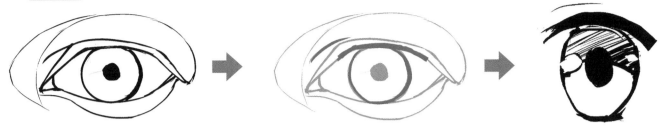

In manga and anime, female eyes are expressed by emphasizing and drawing the area around the pupils of realistic eyes.

Depending on the style, the outer corner of the eye may be drawn too. It makes the eyes appear darker and like those of a small animal.

Adding the Curves of the Eyelids

Male

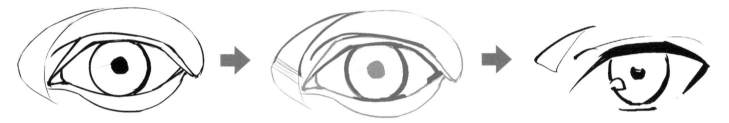

For males, draw the outer corner of the eye, the lower eyelid and the main part of the upper eyelid. Add the indentation above the upper eyelid too. Draw more detailed eyes for males.

TIP

How to Draw Narrow Eyes for Females

If you add a few feminine features, you can draw narrow eyes that don't look masculine. For example, curve the eyelids, indicate more eyelashes and make the pupils larger.

Curved eyelid

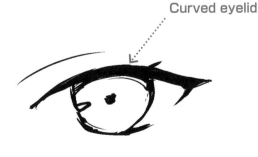

Larger pupil

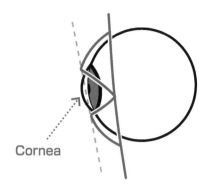

Cornea

Eyes that are realistic are dome-shaped and protrude slightly. The eyeball is a sphere with a transparent bulge (cornea) at the center. If you can keep this in mind, you will be able to draw 3D eyes.

If you simpy draw eyes as if they were projected against an angled plane, they will lack three-dimensionality and appear strange.

The Far Eye is Narrower When Angled

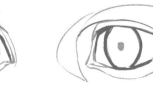

Female

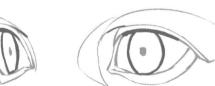

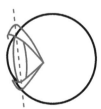
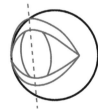

Male

At an angle, the far eye is narrower and the outer corner is hidden. Moreover, the curve of the upper eyelid doesn't go down to the hidden outside corner. Instead, it seems to stop suddenly at a place slightly higher than the outer corner of the near eye (circled in red).

A Side-on Eye Resembles an Angled Guitar Pick

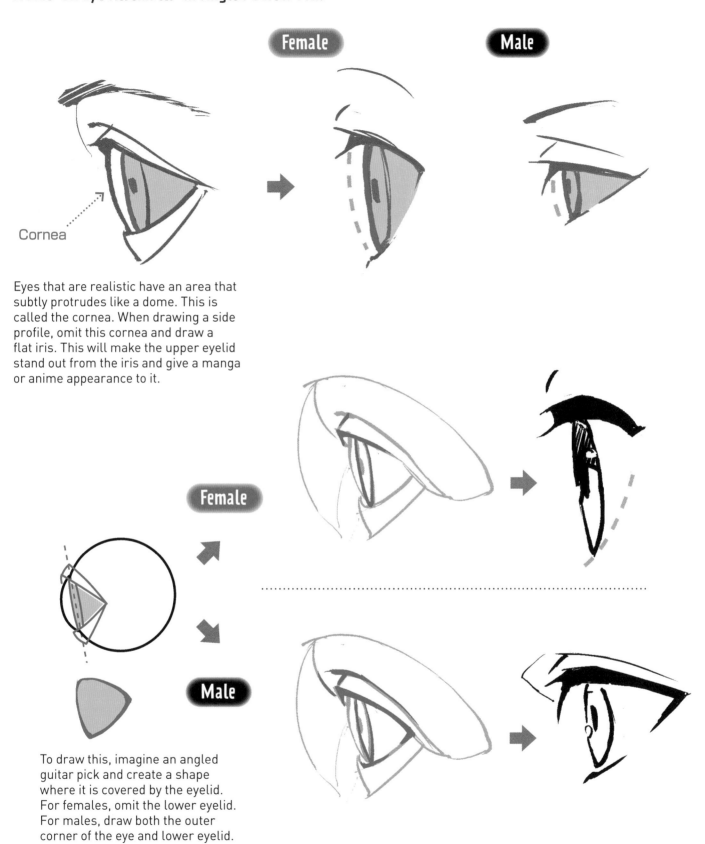

Female **Male**

Cornea

Eyes that are realistic have an area that subtly protrudes like a dome. This is called the cornea. When drawing a side profile, omit this cornea and draw a flat iris. This will make the upper eyelid stand out from the iris and give a manga or anime appearance to it.

Female

Male

To draw this, imagine an angled guitar pick and create a shape where it is covered by the eyelid. For females, omit the lower eyelid. For males, draw both the outer corner of the eye and lower eyelid.

Lower Outer Corners for Low Angle Eyes

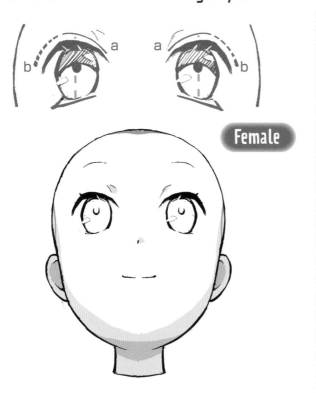

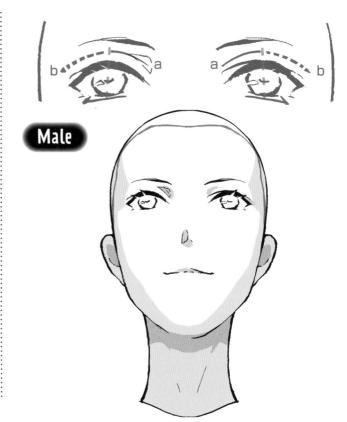

Female

Male

When drawing from a low angle with the character looking up, both males and females have outer corners of the eyes that slant down. Make the curve of the upper eyelid stronger. The curve of the lower eyelid is more gentle and touches the iris. By changing the length and shape of the inside (a) and the outside (b) of the upper eyelid, you can express a change in direction for the face.

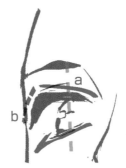

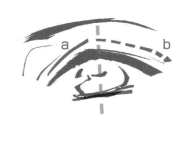

A titled low angle makes it very easy for the far eye to seem like it's drooping. The near eye has a flat shape, due to the direction of the face and that of the eye canceling each other out.

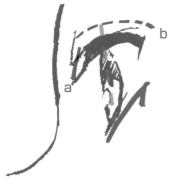

For a side-on low angle, however, the outer corner is rising, creating eyes that seem to slant up. The point here is to have the lower eyelid gradually rise and slightly narrow the eyes.

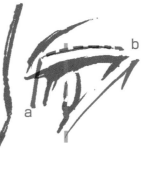

Higher Outer Corners for High Angle Eyes

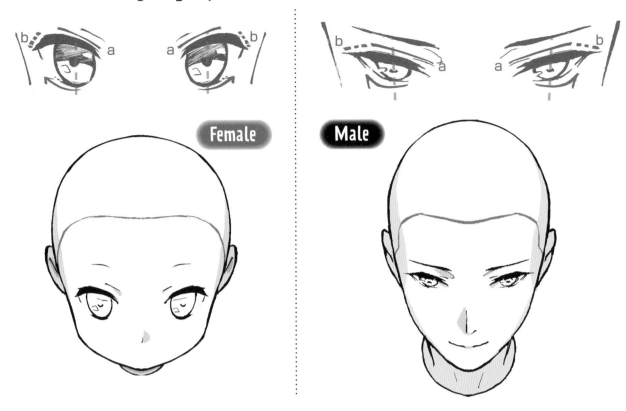

Female　**Male**

When drawing from a high angle, with the character looking down, the outer corners for both males and females appear to slant up. Make the curve of the upper eyelid gentler, while making the lower eyelid curve stronger. Here as well, pay attention to the length and shape of a and b when drawing.

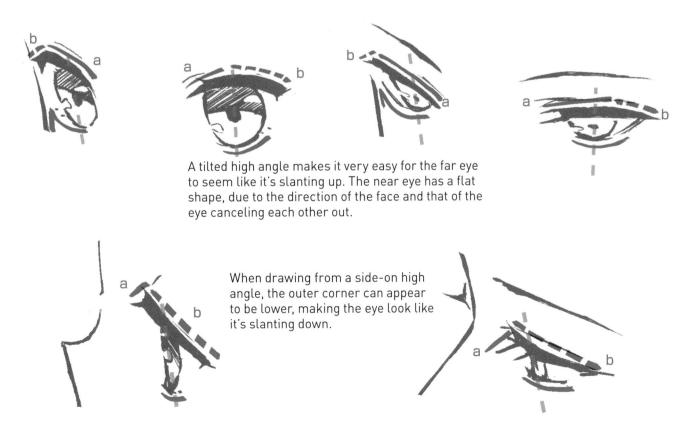

A tilted high angle makes it very easy for the far eye to seem like it's slanting up. The near eye has a flat shape, due to the direction of the face and that of the eye canceling each other out.

When drawing from a side-on high angle, the outer corner can appear to be lower, making the eye look like it's slanting down.

Draw Raised Eyes with Downward Inner Corners

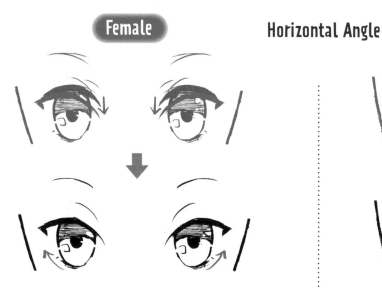

Female Horizontal Angle Male

The trick is to lower the eyelids at the inner corner instead of raising them at the outer corner. For women, just add dots for eyelashes on the lower eyelids of eyes that slant up to avoid making the eyes too sharp.

For men, it's fine just to draw lines on the lower eyelids. Join the upper and lower eyelids together to create sharper eyes.

When drawing from an angle or side-on as well, create the sense that the inner corners are lowering rather than the outer corners rising.

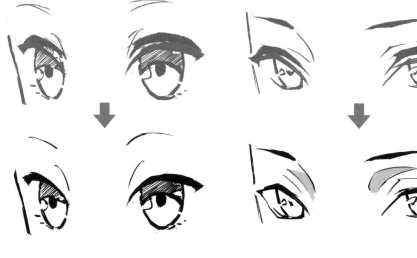

Angled

If you only raise the outer corners, it will affect the balance and make the eyes look strange.

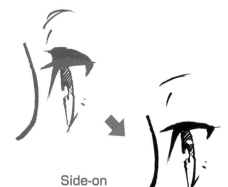

Side-on

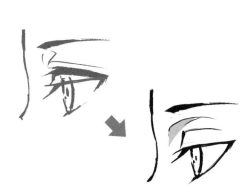

Low Angle
If you look at a character with eyes that slant up from a low angle, the sharpness of those eyes is understated. A drawing technique is needed here to clearly convey this is a character with raised eyes.

Female

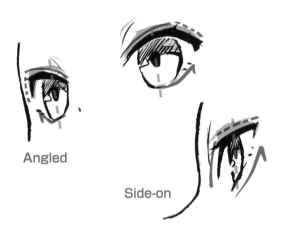

Make the inner corner of the eye longer so the peak of the upper eyelid comes closer to the outer corner. Express the lower eyelid with dots, so it seems to rise toward the outer corner.

Angled

Side-on

Male

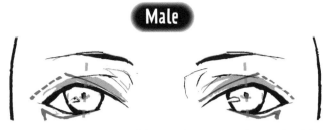

Make the inner corner of the eye longer so the peak of the upper eyelid comes closer to the outer corner.
If you angle and raise the lower eyelids toward the outer corners, it will express sharp upward slanting eyes.

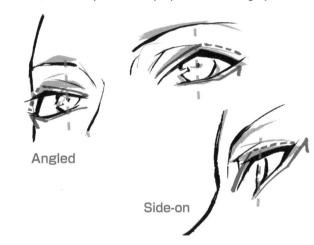

Angled

Side-on

High Angle
When viewed from a high angle, eyes slanting upward can look a lot sharper.

Female

If you make the upper eyelids raise straight up, it will be too sharp and not look feminine. When this happens, draw the upper eyelid with a rounded-out curve to keep the femininity.

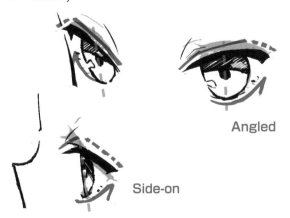

Angled

Side-on

Male

Draw the inner corners pointing down and this will add more sharpness. Join the upper and lower eyelids together at the outer corner to give a better impression of a high angle.

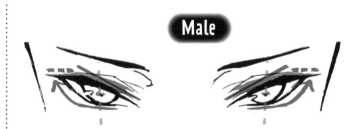

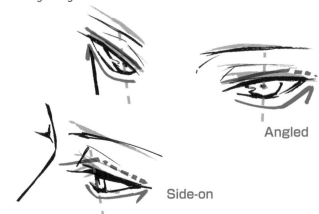

Angled

Side-on

Draw Drooping Eyes with Long Outer Upper Eyelids

Female　Horizontal Angle　**Male**

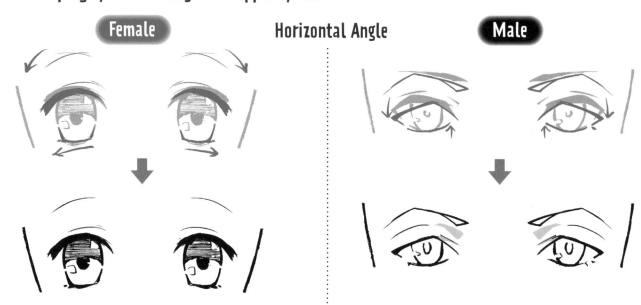

Draw the lower eyelids horizontal and so that they are slightly touching the irises. Make the outer corners of the upper eyelids longer, rather than drawing them slanting down, so the peaks of the curves come closer to the inner corners. Draw two long lines as well to emphasize the drooping eyes.

For men, along with moving the position of the upper eyelid peaks, draw the inner corners of the lower eyelids as if they are rising. If you add lower eyelashes, it will emphasize the drooping eyes and show this isn't just a simple background character.

If you characterize the eyes using double lines and lower eyelids, the eyes will appear to slant down even at angles where it's difficult to see the outer corners.

Angled

Even though these are drooping eyes, if you significantly lower the outer corners, the eyes will look blank and unnatural.

Side-on

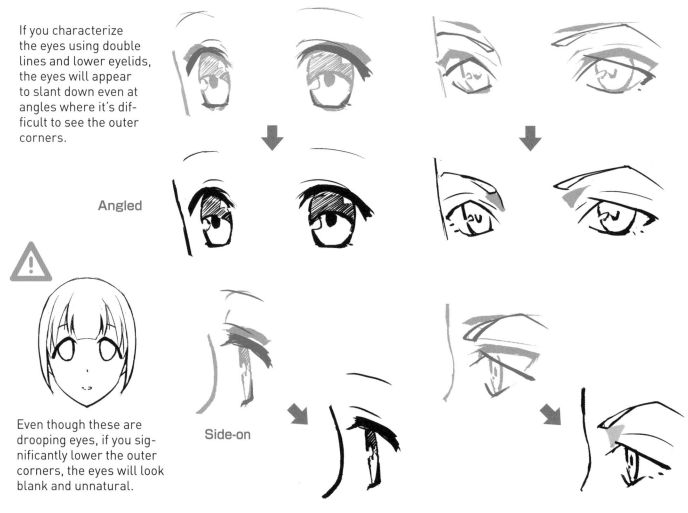

Low Angle From a low angle, drooping eyes look even more like they are slanting downward.

Female

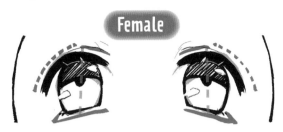

Draw the eyes so they're shaped like half moons elongated lengthwise. Draw the line of the lower eyelid only under the iris.

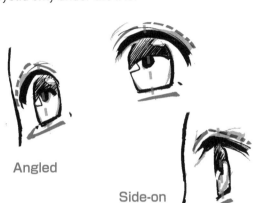

Angled

Side-on

Male

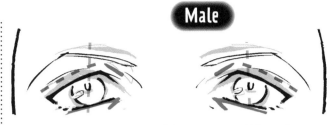

Draw short inner corners of the upper eyelids and make the inner corners of the lower eyelids longer.

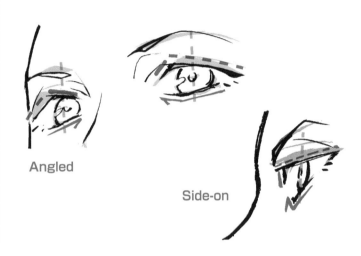

Angled

Side-on

High Angle Looking at a character with drooping eyes from a high angle, the eyes don't seem to be slanting down as much. A drawing technique is needed here to clearly convey this is a character with drooping eyes.

Female

You can express drooping eyes viewed from a high angle by drawing the eyes shaped like slightly squat half moons and add a little flat distortion.

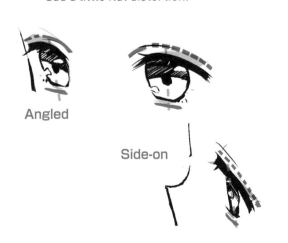

Angled

Side-on

Male

If you curve the inner corners of the lower eyelids upward, the eyes will look drooped, even if the upper eyelids are almost horizontal.

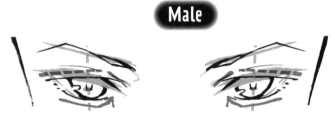

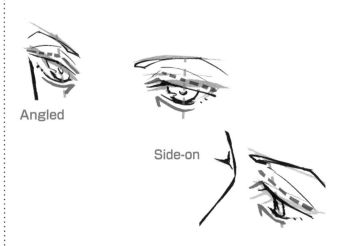

Angled

Side-on

A Lively Upward Gaze

Female

Horizontal Angle

Male

A Calm Downward Look

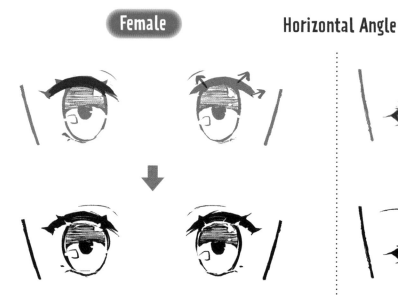

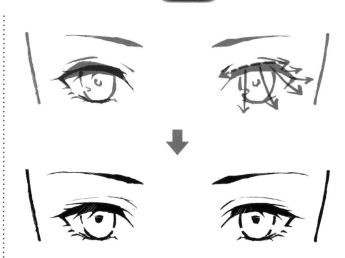

Draw eyelashes that point upward in a radial pattern to create big, cute eyes. Express the volume of the eyelashes by making the upper eyelid lines slightly thicker.

For men, draw the eyelashes pointing downward to create a calm impression and distinguish them from women's eyelashes. Have them going down in a radial pattern so that they become almost horizontal toward the outer corners. Add fine lines to the upper eyelids as well so that they stand out and create volume.

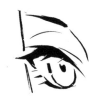

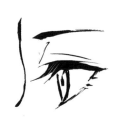

Here are examples of angled and side-on eyes. If you draw the eyelashes short and thick, even if they are black, they won't look heavy. The ideal is to have two eyelashes on the outer corners and one on the inner corners.

Here are examples of angled and side-on eyes. When you draw eyelashes just in black, limit how many you add. Add slightly more to the outer corners. From side-on, draw the eyelashes so they extend more at the front.

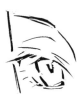

Here is an example of eyes drawn with fine lines. If you draw the upper eyelids and all the eyelashes using fine lines, you can add more eyelashes and still keep it light.

Keep the outline of the eyelashes and make the inner area white to create a delicate image. Draw them, remembering that the white parts are the eyelashes and the black parts are the lashes' shadow. If you draw the lashes angled upward a little and space them out, the eyes won't look crowded.

From a Low Angle

Female

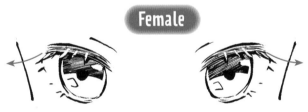

The trick here is to draw long, thick eyelashes at the highest point of the upper eyelids to create a 3D effect.

Male

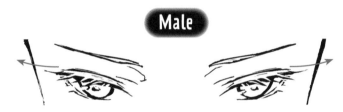

For low angle men's eyes, draw the eyelashes for both front-on and angled faces pointing up and for side-on faces have them slightly pointing down. Keep black lines in the indentations between each eyelash and remove the rest to make white space.

From a High Angle

Female

For a high angle, draw eyelashes pointing downward. Take note that the top and bottom lashes have slightly different radial centers. For a front profile, open up the inner corners a little and have the eyelashes concentrated around the outer corners.

With side-on profiles, if you leave space between the lashes that point forward and those at the outer corners, it will create a cleaner image.

At this angle place the lashes at intervals all across the upper eyelid.

Male

Note that, for men, the top and bottom lashes radiate from the same center. For front profiles, draw a lot of long eyelashes at the outer corners.

For side-on faces, draw the eyelashes so they jut forward and add only 1 or 2 that point toward the outer corners.

For angled faces, add in the eyelashes, leaving a small opening at the inner corners.

Drawing Noses

The nose is a feature that juts out like a mountain. They are easy to draw from the side, but from the front or at an angle, it is difficult to draw the curvature of the transition from the bridge to the base. By drawing the highlight and shadow formed by light on the nose, you can express the shape.

Men and Women Differ Here!

Omit the Bridge, Add Faint Shadow

Female

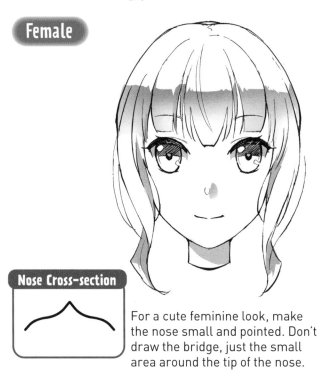

Nose Cross-section

For a cute feminine look, make the nose small and pointed. Don't draw the bridge, just the small area around the tip of the nose.

A Bridge Line with Clear Shadow

Male

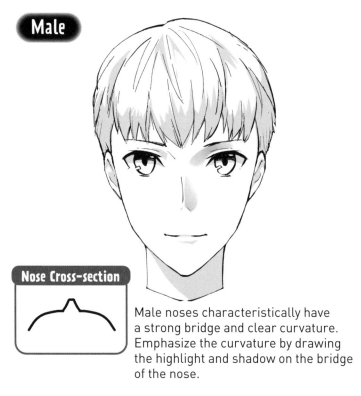

Nose Cross-section

Male noses characteristically have a strong bridge and clear curvature. Emphasize the curvature by drawing the highlight and shadow on the bridge of the nose.

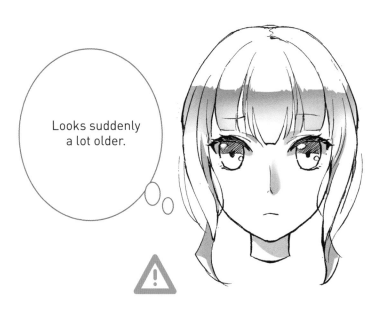

Looks suddenly a lot older.

⚠

If you draw a well-defined bridge, it will add about 10 years of age to a female character and makes the nose too big for a small round face.

Not bad, but a bit blank.

⚠

If you add a small nose to a young adult male's face, it will look slightly flat with a blank expression.

Express a Front-on Nose with Highlights or Shadow

Female

When you're expressing the nose in just a line drawing, the highlight (the part that catches the light) is drawn with a fine line around it. Omit the bridge and nostrils.

Highlight line

Here, shading has been added. The light is shining at an angle from the top left, so draw a small highlight on the left, around the tip of the nose, and express a large shadow to the right in the shape of a ginkgo leaf.

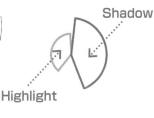

Shadow

Highlight

The red areas are where shadows naturally form. If you add this realistically, it will look like the diagram on the right. This creates an undefined shadow on the other side of the light source, framing the flat, smooth face. The round shadow near the tip of the nose is a little darker and the highlight next to it stands out. If you pick up on these points and draw them, you can create the two manga-style examples above.

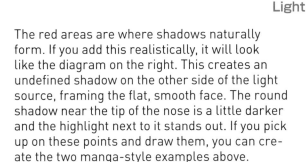

Light

Male

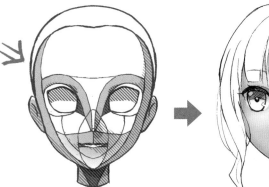

Start of the nose

Bridge of the nose

When creating only a line drawing, draw the shape of the highlight and shadow with fine lines to express the curvature. This curvature is a lot clearer for males than for females, so draw a long bridge and then add the shape of the top (where the bridge meets the eyebrows) and just one nostril.

Here, shading has been added. Draw a cherry blossom petal-shaped highlight and shadow on the bridge to emphasize the curvature. If you omit the outline of the highlight, it looks neater.

Highlight Shadow

The red areas are where shadows naturally form. If you add this realistically, it will look like the diagram on the right. The portion of the face on the opposite side of the light source is in shadow, except for rounded parts like the cheek and chin. The indentation between the eyes and the base of the nose, as well as the shadow between the nose and cheek, are particularly dark. If you pick up on these points and draw them, you can create the two manga-style examples above.

Light

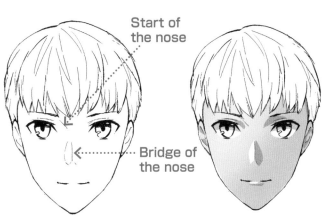

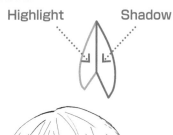

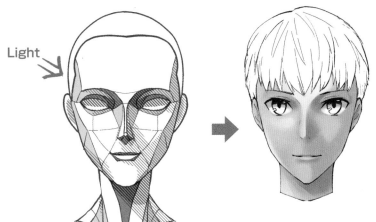

Simple Lines for A Neat Side-on Nose

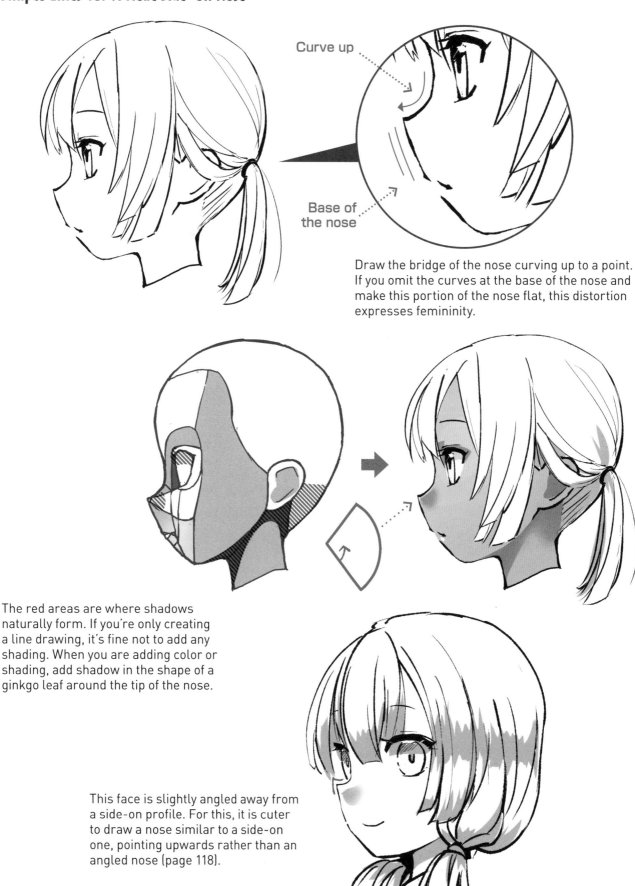

Curve up

Base of
the nose

Draw the bridge of the nose curving up to a point. If you omit the curves at the base of the nose and make this portion of the nose flat, this distortion expresses femininity.

The red areas are where shadows naturally form. If you're only creating a line drawing, it's fine not to add any shading. When you are adding color or shading, add shadow in the shape of a ginkgo leaf around the tip of the nose.

This face is slightly angled away from a side-on profile. For this, it is cuter to draw a nose similar to a side-on one, pointing upwards rather than an angled nose (page 118).

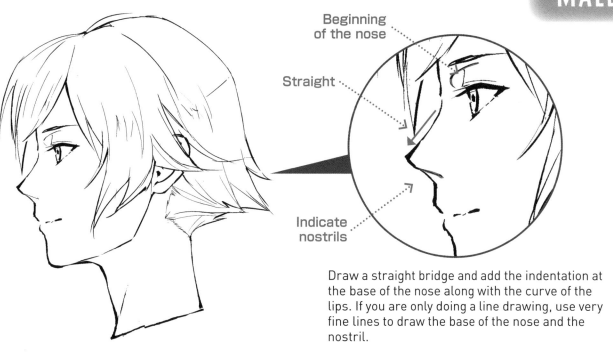

Beginning of the nose

Straight

Indicate nostrils

Draw a straight bridge and add the indentation at the base of the nose along with the curve of the lips. If you are only doing a line drawing, use very fine lines to draw the base of the nose and the nostril.

The red areas are where shadows naturally form. If you add color or shading, express the top of the nose by adding shading above the eyelid. Add a small shadow under the nose too.

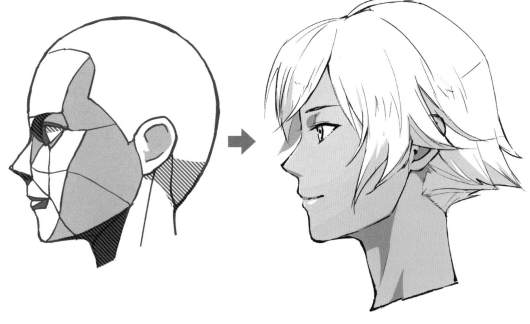

You can draw a character with a different impression from a classically handsome young man drawn with fine lines by shortening the bridge and rounding the tip of the nose. For this type of nose, the shape of the shadow when drawn front-on or at an angle is expressed using lines.

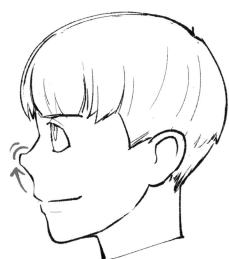

Sharp Angled Noses for Angled Faces

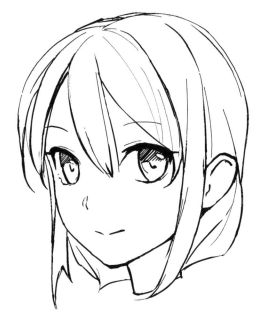

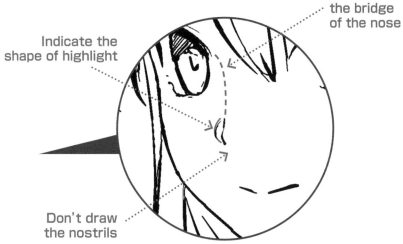

Indicate the
shape of highlight

Don't draw
the bridge
of the nose

Don't draw
the nostrils

For women, the nose is small and points up, so the tip is
drawn at a relatively sharp angle. When creating only
a line drawing, add the highlight next to that sharp angle.

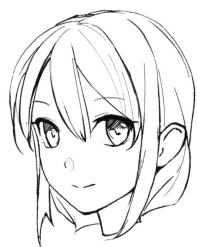

You can also draw just the
shadow and not the highlight.

When you want to make just a
simple relatively sharp angle, it's
better to have the nose point up.

If you draw a large straight angle,
you will lose the cuteness of a
small nose and the character will
look older.

The red areas are where shadows
naturally form. If you want to add
color or shading, it's fine to omit
the angle or make a small mark.
In this case, add highlight and
shading in the shape of a ginkgo
leaf around that point.

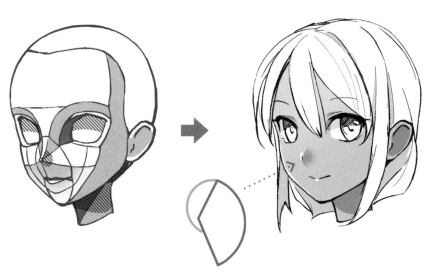

Line toward the inner corner

Draw long cheek lines

Draw the highlight outline

Draw a fine nostril

For men, the curvature of the nose is more pronounced, so draw a larger relatively sharp angle. When creating only a line drawing, draw the shape of the highlight with a fine line and indicate just one nostril.

If you draw the bridge of the nose connected to the eyebrows, it will create the impression of an aquiline nose. This can be used depending on the character or design style, but if you want to draw a gentle-looking man, it's best not to join up the features.

Another method is to take away the highlight and nostril and draw the shadow under the nose as a triangle.

The red areas are where shadows naturally form. When you add color or shading, if you add shading only to the indentation at the top of the nose (between the eyes and eyebrows) and under the nose, your drawing will look neater and create a modern feel. An important point is to break the line of the angle near its peak to express the highlight of the tip of the nose.

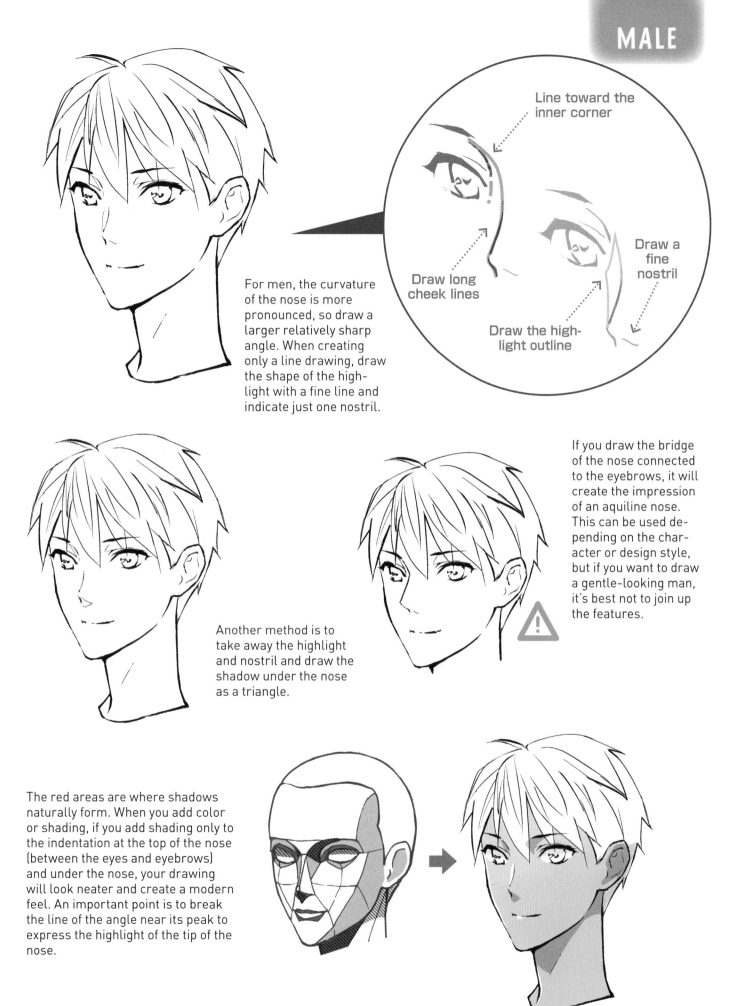

Drawing the Underside of the Nose for Low Angles

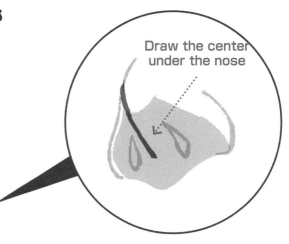

Draw the center under the nose

Realistically at this angle, you can see the nostrils, but as female characters have small noses, it's more natural to omit them. For a line drawing, just draw a line down the center under the nose.

Apart from drawing a center line, you can also draw the shadow of the nose with very fine lines. For a low angle, it's best not to indicate a highlight.

If you use color or shading to indicate the area under the nose, add a short, distorted ginkgo-leaf shaped shadow along the side of the bridge.

In the case of a low angle, the nose is placed closer to the far eye. Be careful when drawing a nose with a relatively sharp angle as it's easy for the nose to get placed too low.

The red areas are where shadows naturally form. If you want to add color or shading, it's fine to omit the angle or create a small mark. As shown in the right diagram, indicated the nose with a small line touching the lower eyelid at the angle of the outline where the bridge of the nose overlaps the eyes.

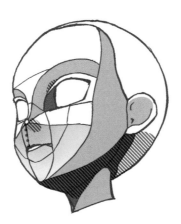

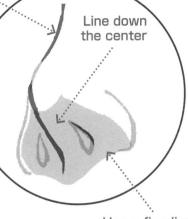

Draw the bridge of the nose

Line down the center

Use a fine line for the nostril

Draw a relatively sharp-angled nose close to the far eye. The area around the far eye and the bridge of the nose have lots of detail, so selectively omit parts of the inner corner of the far eye and lower eyelid to give a cleaner look.

The red areas are where shadows naturally form. If you make a triangular shadow under the nose and just draw the front nostril, it won't look upturned.

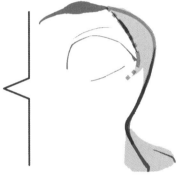

Realistically, the bridge has 2 lines - one from the eyebrow to the eye and one from the eyebrow to the top of the nose. For illustrations, parts of the lines are omitted and shadow used between the 2 lines as expression.

When you want to draw only lines with no shading, you can indicate the area under the nose as a triangle.

If you draw the nose in the center of the face, it won't look like it's being viewed from a low angle. Remember that the midline is closer to the far eye and that the tip of the nose comes halfway between the eyebrows and the mouth.

Here is an example of a low angle very close to a side-on profile. At this angle, the face outline, far eye and nose are all overlapping making it confusing. If you omit the details of the far eye or cover it with the bangs, it will make the bridge of the nose cleaner.

High Angles—Upward Concave or Downward Arrow Noses

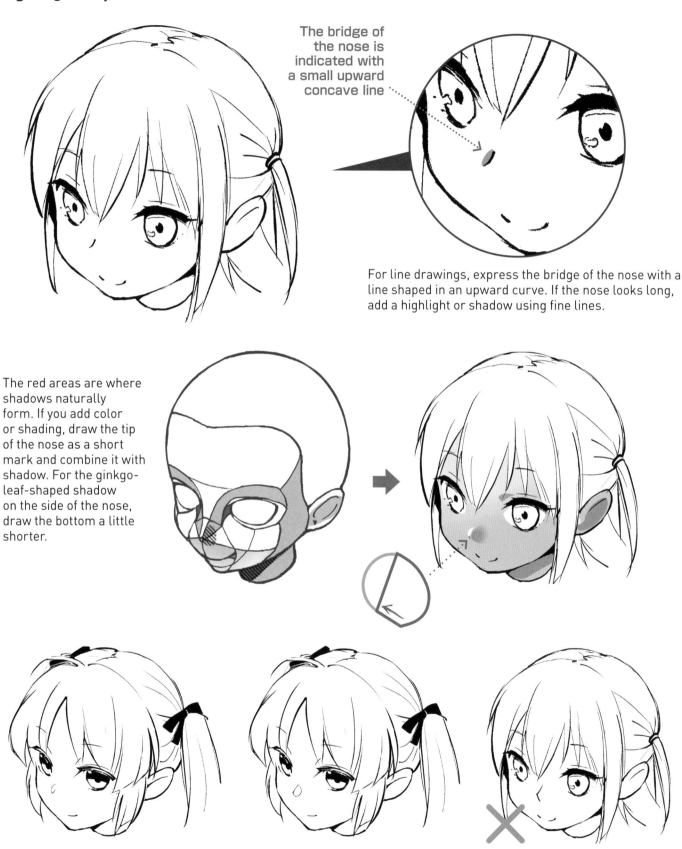

The bridge of the nose is indicated with a small upward concave line

For line drawings, express the bridge of the nose with a line shaped in an upward curve. If the nose looks long, add a highlight or shadow using fine lines.

The red areas are where shadows naturally form. If you add color or shading, draw the tip of the nose as a short mark and combine it with shadow. For the ginkgo-leaf-shaped shadow on the side of the nose, draw the bottom a little shorter.

For line drawings, it's also fine to use a highlight to express the nose.

Here, the nose is expressed using a line that indicates shading. The nose looks slightly larger, but you can choose this style if you prefer.

Drawing the nose with a relatively sharp angle makes it challenging to position the nose correctly between the eyes.

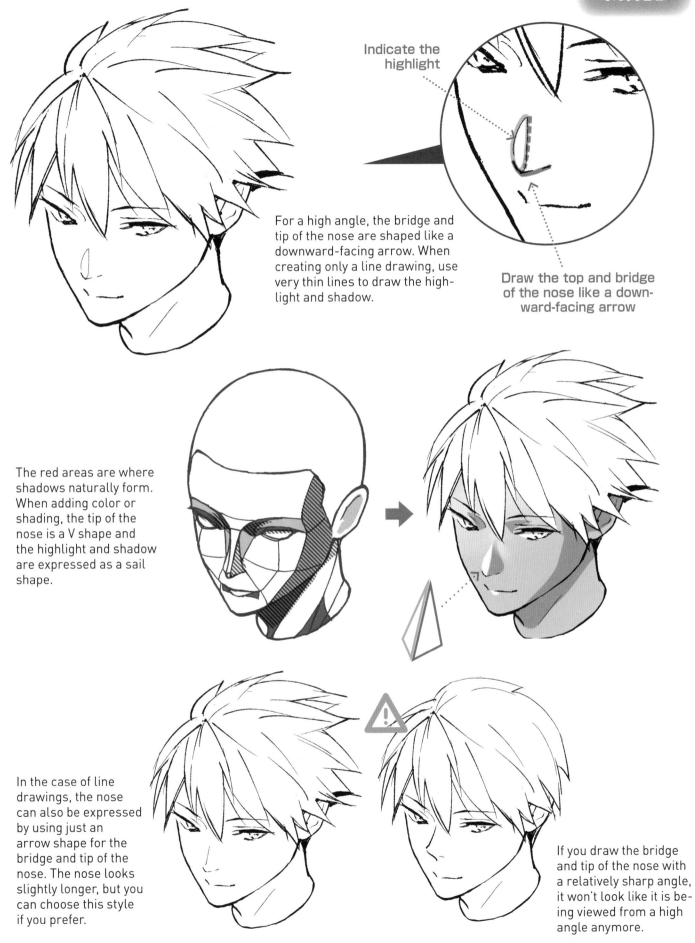

Indicate the highlight

For a high angle, the bridge and tip of the nose are shaped like a downward-facing arrow. When creating only a line drawing, use very thin lines to draw the highlight and shadow.

Draw the top and bridge of the nose like a downward-facing arrow

The red areas are where shadows naturally form. When adding color or shading, the tip of the nose is a V shape and the highlight and shadow are expressed as a sail shape.

In the case of line drawings, the nose can also be expressed by using just an arrow shape for the bridge and tip of the nose. The nose looks slightly longer, but you can choose this style if you prefer.

If you draw the bridge and tip of the nose with a relatively sharp angle, it won't look like it is being viewed from a high angle anymore.

Drawing Mouths

This facial feature has less presence than the eyes, but it plays a major role in distinguishing between males and females. Particularly for scenes where characters are speaking or exclaiming, the style used for drawing the mouth determines how cool or cute they look.

Female

Round and Narrow

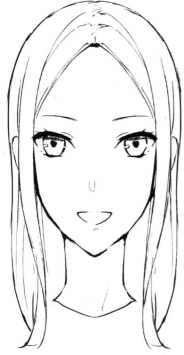

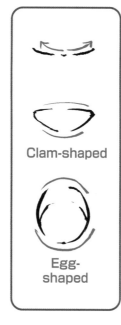

Clam-shaped

Egg-shaped

Male

Wide and Angular

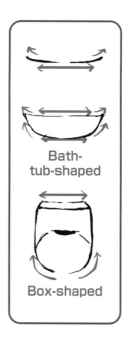

Bath-tub-shaped

Box-shaped

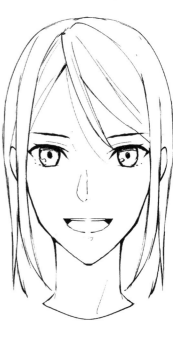

If you draw a small, round shape for the mouth, it will look cute. Draw a short curved line for a mouth that is closed.

Masculine mouths are larger and drawn using straight lines and angular shapes.

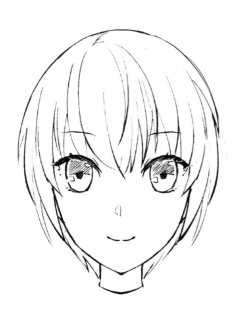

Here is an example of a male and a female who look like they could be twins. The face on the left with a rounded mouth looks feminine and the face on the right with a wide mouth looks masculine. So even if the faces are similar, if you can make clear changes to the mouth, you can distinguish between males and females.

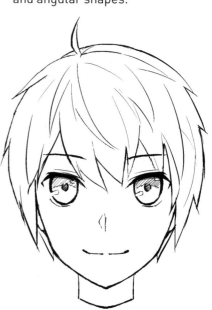

Altering the Shape of Realistic Lips

Side-on

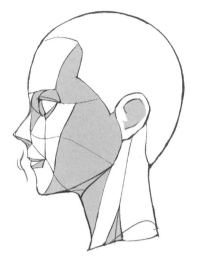

This is the realistic shape of a mouth. It protrudes forward like a beak.

Female

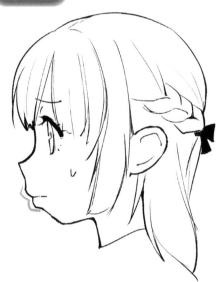

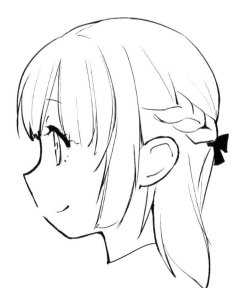

Female characters have small chins, so if you faithfully depict the curvature of the mouth, it will look simian. For males, draw the curvature of the mouth quite realistically, but if you make the nose too long, it affects the balance and can look simian too.

Ideally, the lips will be less prominent than the chin. Omit the outline of the lips for female characters. For male characters, draw the nose an appropriate length as this will help you draw a realistic mouth with attractive lips.

Male

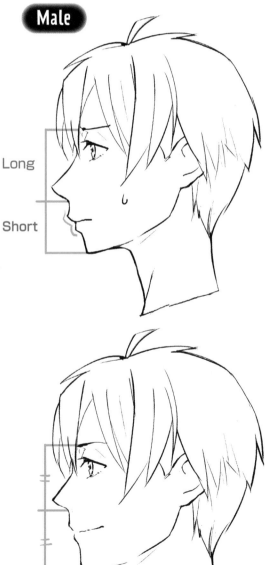

Long

Short

125

Angled

Female

Male

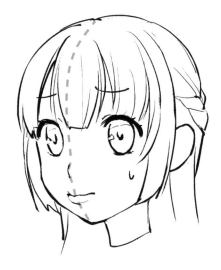

Realistically, the lips are centered on the midline and protrude a little like a beak. If you faithfully draw this on a manga-style character with a small chin, the lips will look pursed and strange.

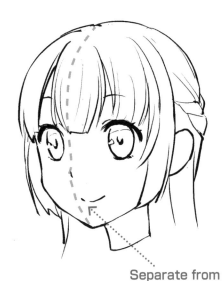

For manga-style character illustrations, draw the mouth slightly to the near side of the midline for a more natural impression. For females, depict the mouth completely off of the midline. For males, draw the mouth so that the edge is slightly over the midline.

Separate from the midline

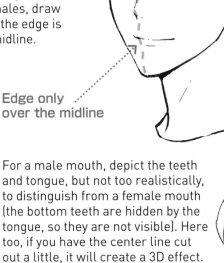

Edge only over the midline

With a female mouth, don't draw all the lines. Instead, have the line cut out a little. Don't draw the inside of the mouth or the teeth realistically either. Keep it simple to match with the style of distortion.

For a male mouth, depict the teeth and tongue, but not too realistically, to distinguish from a female mouth (the bottom teeth are hidden by the tongue, so they are not visible). Here too, if you have the center line cut out a little, it will create a 3D effect.

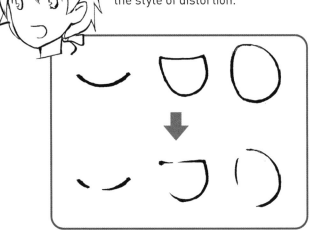

Capture All the Changes in Features

When you open your mouth, your chin moves and a small amount of tension is apparent in your eyebrows. Your nose and lower eyelids also slightly rise.

Side-on

Female

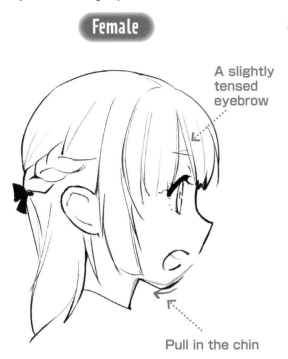

A slightly tensed eyebrow

Pull in the chin

As stronger distortion is used for female mouths, try not to express it too realistically. Lower the chin very slightly and have it pulled in toward the neck. Have the top and bottom lips of the mouth open equally.

Male

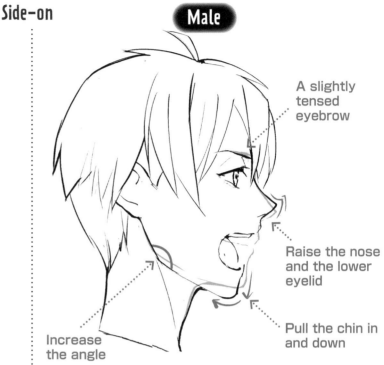

A slightly tensed eyebrow

Raise the nose and the lower eyelid

Pull the chin in and down

Increase the angle

Draw males more realistically. When the mouth opens and the jaw drops, the bottom lip also moves down quite a bit, while the top lip rises slightly.

Angled

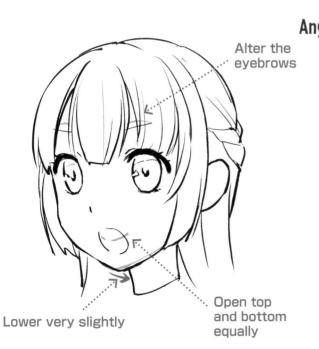

Alter the eyebrows

Lower very slightly

Open top and bottom equally

As strong distortion is used for females, it's fine to lower the chin just a little. Unlike a realistic mouth, draw the lips so they are equally parted. Very slightly elongate and distort the outline of the face.

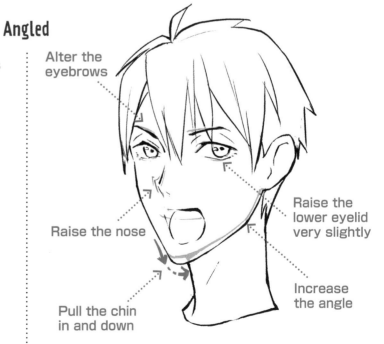

Alter the eyebrows

Raise the nose

Raise the lower eyelid very slightly

Increase the angle

Pull the chin in and down

For males, draw both the mouth and chin lowered. When the mouth is opened wide, the outline of the face becomes slightly elongated and distorted.

127

A Low Angle Mouth When Smiling or Laughing

A mouth viewed at from a low angle looks distorted, so it is difficult to depict when someone is laughing. It's important to express the subtle changes accurately.

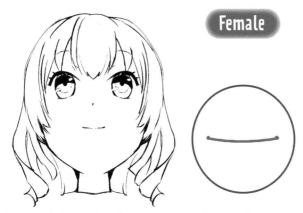

Female

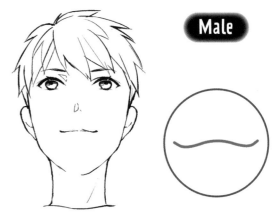

Male

The distorted shape that forms the mouth actually becomes a gentle curve. It's good to make both edges slightly bolder.

If you redraw the distorted shape into a rounded, almost flat W shape, you can create a smile while keeping the impression of a low vantage point.

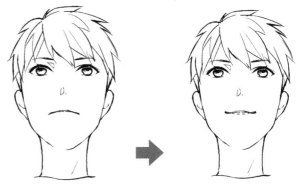

If you make the curve too strong, it won't look like it's from a low angle anymore. A gentle curve keeps the impression of a low vantage point.

The mouth at a low angle is shaped like a frown. Have just the sides of the mouth curl up gently to create a more realistic effect.

Bun-shape

When smiling with the mouth open, a female's top lip rounds out, so draw a bun-shaped mouth. If you add small indication of teeth, it makes a cute impression.

With a male's open-mouthed smile, the jaw becomes slightly narrower and elongated, while the nose rises a little above a large rounded-out bathtub-shaped mouth. From this angle, you would usually be able to see the back teeth, but omitting everything except the front teeth gives a more natural look.

High Angle Mouth When Frowning or Angry

Viewed from a high angle, the mouth curls up to look deceptively cheerful. Lower the corners of the mouth and you can draw a quite realistic angry expression.

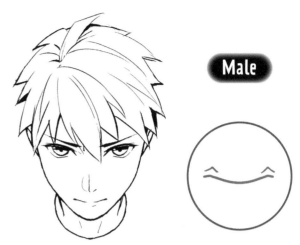

Lower the edges of the downward curve a little to create a small flying seagull-like shape. If you omit the center part of the line, it will look more natural.

Draw a gentle downward curve and create little mounds at the edges. The center part of the line can be omitted here too.

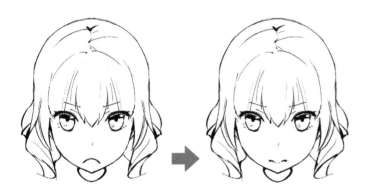

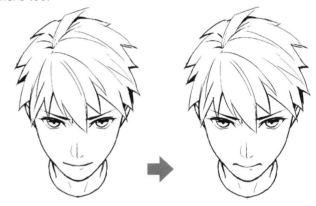

If you draw an angry face with a mouth using an exaggerated shape, it will look a bit flat. It's important to lower just the corners of the mouth.

The high angle mouth is a downward curve that can inadvertently create a cheerful impression. If you make small mounds at the corners of the mouth, it will look like an angry person with pursed lips.

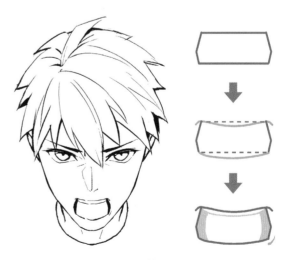

For an angry face with an open mouth, if you use an oval to draw a wide horseshoe shape and then reduce the oval at the top, it will give an angry expression. Add in the tongue to emphasize the high angle.

For males, imagine the mouth like a squat hexagon. The trick here is to lower both edges of the lips. It's good to draw small creases at the corners of the mouth too. Don't forget to have the chin stretch down slightly.

Depicting a Low Angle Mouth

For an angled face viewed from below, it's important to fill in the details of the top and bottom lips.

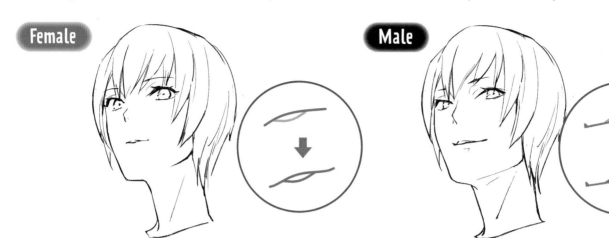

Female

For women, express the top and bottom lips with gentle curves. Draw 2 arcs and have the ends of the top arc rise slightly.

Male

Men's mouths are mostly straight lines. Draw a long straight line, with ends that are very slightly curved up, and add a small triangle.

A High Angle Mouth

For an angled face viewed from up high, making very small changes in the shape of the mouth can help distinguish between a man and a woman too.

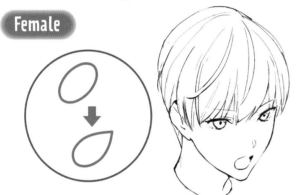

Female

Draw a round shape, and then amend it to look like a tilted droplet. Color a small part inside the pointed end to create the impression of a tongue.

Male

Create a box-shape with rounded edges. Draw in the top teeth and fill in more parts of the mouth than for a woman.

Line Breaks—Comparing Mouth Drawing Styles

A realistically drawn mouth may not fit certain face styles and mouths drawn using simple lines can tend to look flat. Drawing a mouth with a simple line and then adding a break at one part allows it to look 3D without being too realistic. This type of mouth can be used for a variety of expressions.

NOTE

Realistic

Simple line

Broken line

Depicting Glossy or 3D Lips

The mouth drawings introduced on pages 124 to 130 are mostly simplified line drawings. Depending on your style and purpose, you may want to depict lips. Let's take a look at how to express a woman's glossy lips and how to draw in a man's lips to make them appear three-dimensional.

Glossy Lips with Lipstick

Blur the outline for a natural look

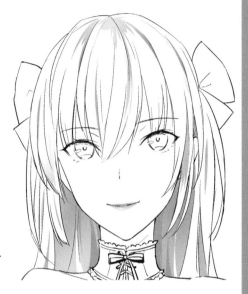

If the outline of the lips is too defined, it can look like the character made a mistake with their make-up.

For lips when lipstick is added, they look most natural when faintly blurred colors and shades are used.

How to Draw

1 Draw the shape of the bottom lip like a thin crescent and blur the outline in the center where the lip rounds out the most.

2 Make the top lip thinner than the bottom one. Gently curve it in the center, add an indentation and then blur it.

3 Add a highlight near the center of the bottom lip to create a glossy look.

Three-Dimensional Lips

Add shading to the top lip

When you want to depict a man's lips, imagine it as filling in shadow on the top lip. If you add a subtle redness to the border between the top and bottom lips, it won't look like lipstick.

Express the volume of the lips by adding a small line for the outline of the bottom lip. Instead of filling the lips in with color, add faint shadow to create a 3D effect.

Shadow of top lip

Outline of bottom lip

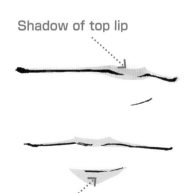

Drawing Ears

The ears don't stand out and are often hidden by the hair, but if you position them properly, it creates a balanced face and makes for a convincing picture. Depending on the art style and your taste, you can draw male and female ears the same. Here, though, female's ears are drawn round and cute, while male's are drawn more realistically to distinguish them.

Strong round distortion

Realistic Curves

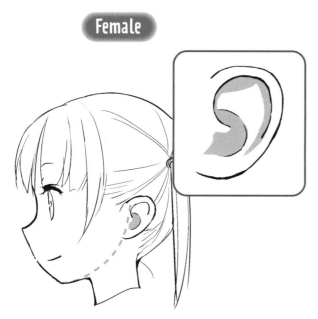

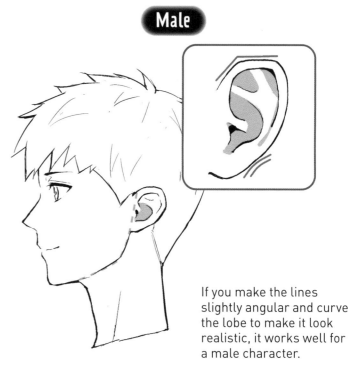

If you use distortion to create a round shape similar to a child's ear, it works well for a cute manga or anime female character. Only draw a few uneven parts inside the ear and omit the opening to the ear canal.

If you make the lines slightly angular and curve the lobe to make it look realistic, it works well for a male character.

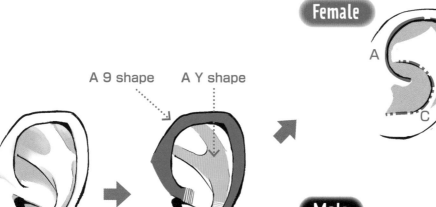

A 9 shape A Y shape

A realistic ear has a 9-shaped exterior and a Y-shaped uneven interior.

For females, use distortion to make the exterior round and omit the unevenness of the Y shape inside the ear. Lines A, B and C inside the ear are smooth curves.

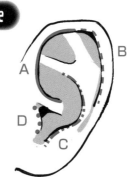

For males, draw the exterior shape slightly angular so that the Y is a little visible. The C line has a slightly complex shape like a sickle. Draw the detail of the opening to the ear canal too.

Front

Female

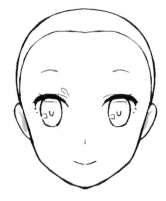

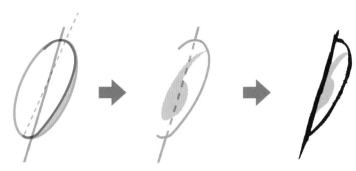

Draw a tilted oval that covers half the outline, remove parts of it, and then add shadow in the shape of a 6.

Male

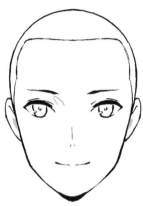

Line A

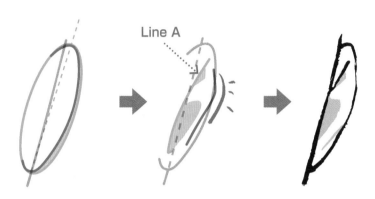

Draw a narrower oval than for a female and have the bulge slightly protrude. Line A that forms part of the inside of the ear (see page 132) is only slightly visible.

Side-on

Female

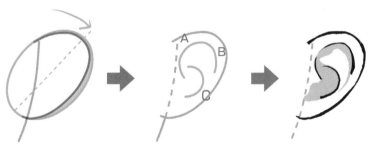

Draw a tilted oval so that it slightly overlaps the jawbone and then add 2 arcs. Add shading along lines A and B and to the area around line C.

Male

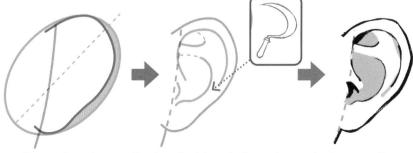

For males, draw a tilted oval with an indentation at the bottom. Reduce the lower of the 2 arcs to form it into a sickle shape and have a little of the unevenness of the interior Y shape show.

Angled

Female

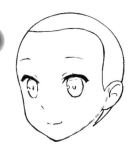

Draw a tilted oval and very slightly reduce the area at the bottom. For this angle, of the lines A, B and C that form the interior, B can no longer be seen and C is only partially visible. Add shadow just on the inside of the arc of line C.

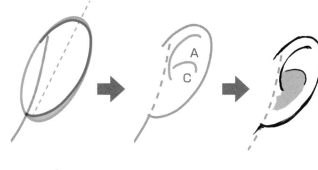

Male

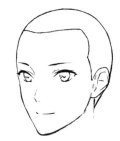

For males, draw a vertically longer oval and slightly reduce the area at the top and bottom. Draw a line to make it appear as if the bulge inside the ear is protruding and add shading to complete.

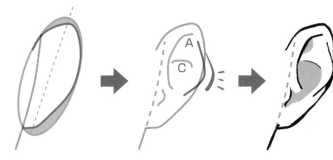

Rear Angle

Female

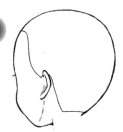

Create a triangle over the jaw line and reduce the angles. Draw line B that forms part of the interior so that it connects to the earlobe. Add shadow to the area inside line C and behind the ear to complete.

Line B

Shadow inside C

Male

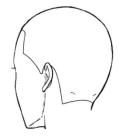

For men, draw a vertically longer oval and slightly reduce the area at the top and bottom. Draw a line to make it appear that the bulge inside the ear is protruding and add shading to complete.

A Y-shaped bulge

Base of ear

Directly Behind

Female

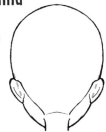

Draw a shape like a shell that is connected to the outline, and then add a line on the inside to form the rim of the ear. You'll find it effective to express the "step" in the shadow that forms on the rim.

"Step" in the shadow

Male

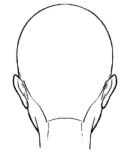

Draw an elongated oval and significantly reduce it to form an indentation at the bottom. As with a female's ear, add a line to express the shape of the rim of the ear.

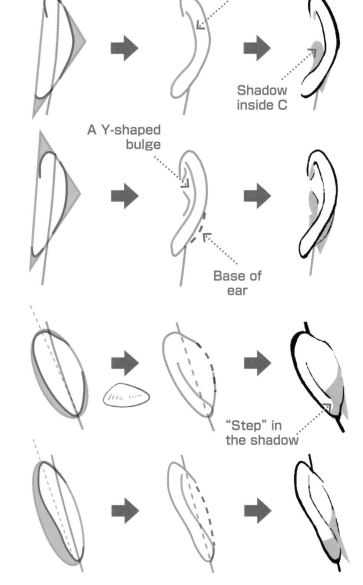

Low Angle The area under the earlobe can clearly be seen from this angle. Express the shape under the lobe using lines.

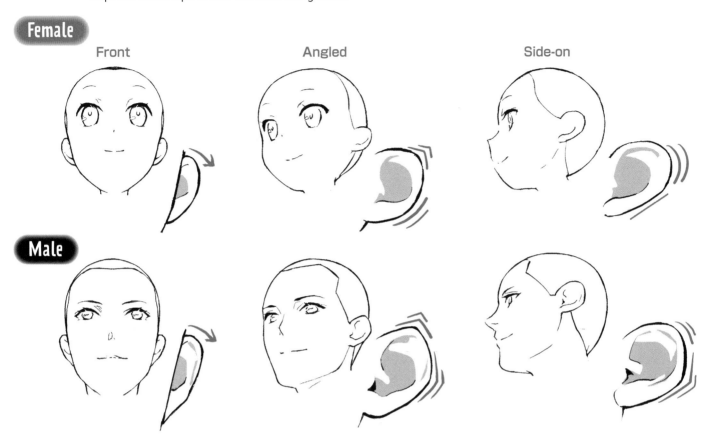

Female
Front Angled Side-on

Male

High Angle The area above the earlobe can clearly be seen from this angle. Depict the rim at the top of the ear using lines.

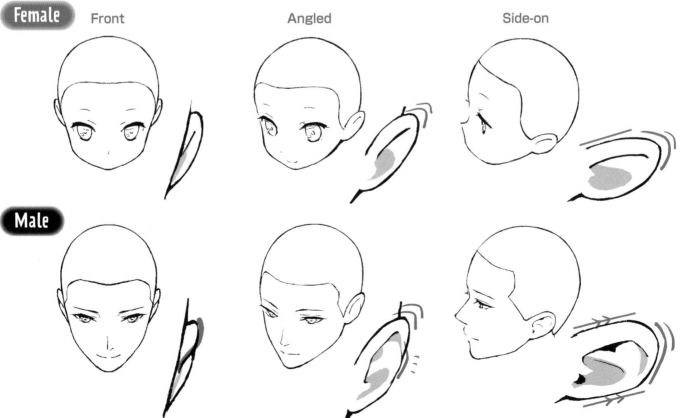

Female Front Angled Side-on

Male

Drawing Hair

The hair is an important feature that expresses the individuality of the character. Hair is drawn by style and by texture. You can indicate both, but even if you indicate only one of those characteristics, you can still expand the range of expression for your characters.

Different Hairstyles

You can choose the hairstyle you want for your characters, so there is no gender differentiation. Instead, you have styles that look serene or those that convey a kinetic sense, and these are drawn according to the character's personality.

Female

A 3-Section Hairstyle Creates a Serene Appearance

This is a hairstyle where the hair has 3 sections, with bangs, sidelocks, and hair on the back of the head. It creates a calm, graceful impression.

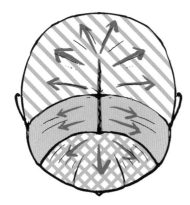

Here is the top view of the 3-section hairstyle: the bangs, the sidelocks and the back—and each flows in a different direction.

Male

Hair Whorls for a Kinetic Appearance

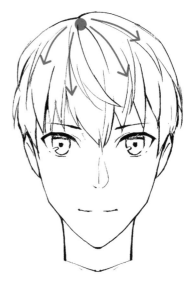

With this hairstyle, the hair flows from a single point (the whorl) on the head. The hair tufts have movement, so it creates a cool, active impression.

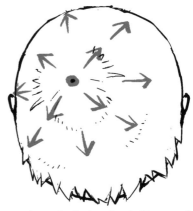

Here is the top view of a hair whorl. Short tufts radiate out from the whorl. Draw the whorl off-center on the head.

Female

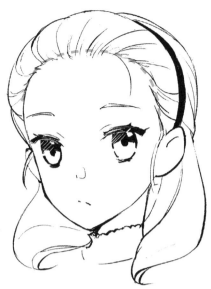

Soft, supple hair

Draw a female's hair so it appears soft and supple. The hairline is rounded, but indistinct with a lot of downy hair along it.

Male

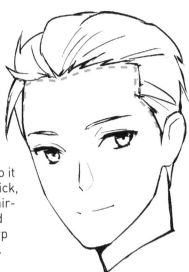

Stiff, thick hair

Draw a male's hair so it appears stiff, with thick, straight tufts. The hairline is clearly defined with a relatively sharp angle at the temples.

Stray hair

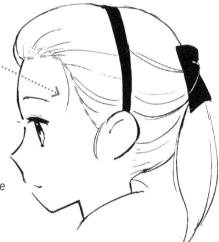

Here is a view from the side. If you use fine lines to express the flow of the hair, you can also express the softness. Add extra fine stray hairs to express more femininity.

Tuft of spiky hair

Here is a view from the side. If you clump the hair or have it sweeping together, spiky tufts will stand out at random.

TIP

How to Express Soft Black Hair

If you color black uniformly black, it will look thick and hard as if it has hair product on it. You can express soft or fine, silky black hair with dark gray coloring or add in fine stray hairs.

Solid black with no stray hairs

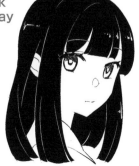

With dark gray

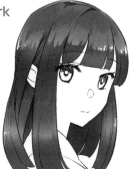

Add fine stray hairs

Build the Hair in 3 Sections

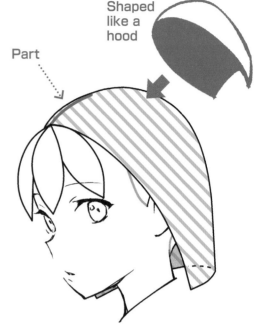

Shaped like a hood

Starting point of the bangs

Thick bangs

Part

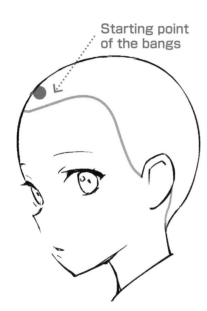

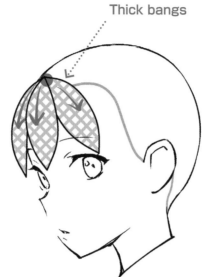

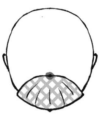

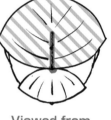

1 Mark a point a little way above the hairline. This is where the bangs start from.

2 Draw the bangs as 3 sections of hair radiating outward. The point here is to add volume that covers the roundness of the forehead. The thicker the locks, the younger the impression it creates.

Viewed from above

3 Draw a hood-shaped section for the hair in the back and have it meet the starting point for the bangs. Position the hair so that it overlaps the ears.

Viewed from above

Fly-away hair

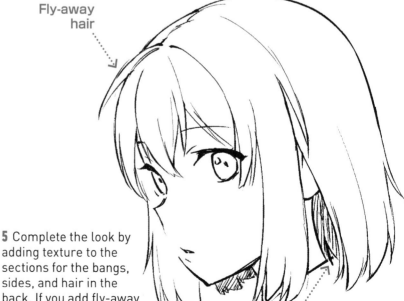

4 Shape the side section so it overlaps the hair in the back. Hiding the jaw and cheek with side hair makes the face look smaller.

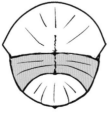

Viewed from above

5 Complete the look by adding texture to the sections for the bangs, sides, and hair in the back. If you add fly-away hair (short hair that can't be styled and sticks out) to the bangs and sides, it will create a more natural impression.

Draw inner hair to align with neck

Three-section Arrangements

Using distortion on the bangs and side hair will make a 3-section hairstyle look like a manga or anime hairstyle.

Side hair distortion

The style where the side sections have significant loft with an indentation at the center, forming an M shape, is known as an "intake" hairstyle. This can often be seen in bishōjo anime and video games.

If this feels too bold, try a smaller M shape.

Bangs distortion

Here is an example of distortion with exaggerated bangs. The way the side sections flow down like a paint brush is very characteristic of manga too. This is a good match for character designs that have a familiar feel and a retro aesthetic.

NOTE

3-Section Hairstyles on Men Creates a Sensitive, Handsome Image

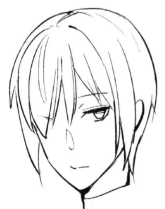

If you want to reflect more masculinity with a 3-section hairstyle, it's better to remove the bangs to reveal the forehead.

Male

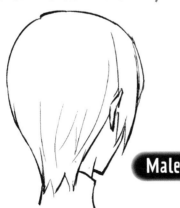

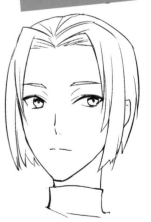

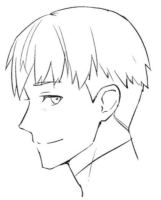

The 3-section hairstyle creates a reserved impression. If you draw this hairstyle for a male character, it gives the impression of the character being quiet and sensitive. A very peaceful look can be achieved if you don't have cropped hair at the back. This style suits elegant characters drawn with fine lines.

This also works if you make the side sections short to reveal the sideburns or use a cropped style.

Hair Whorls Radiate Outward

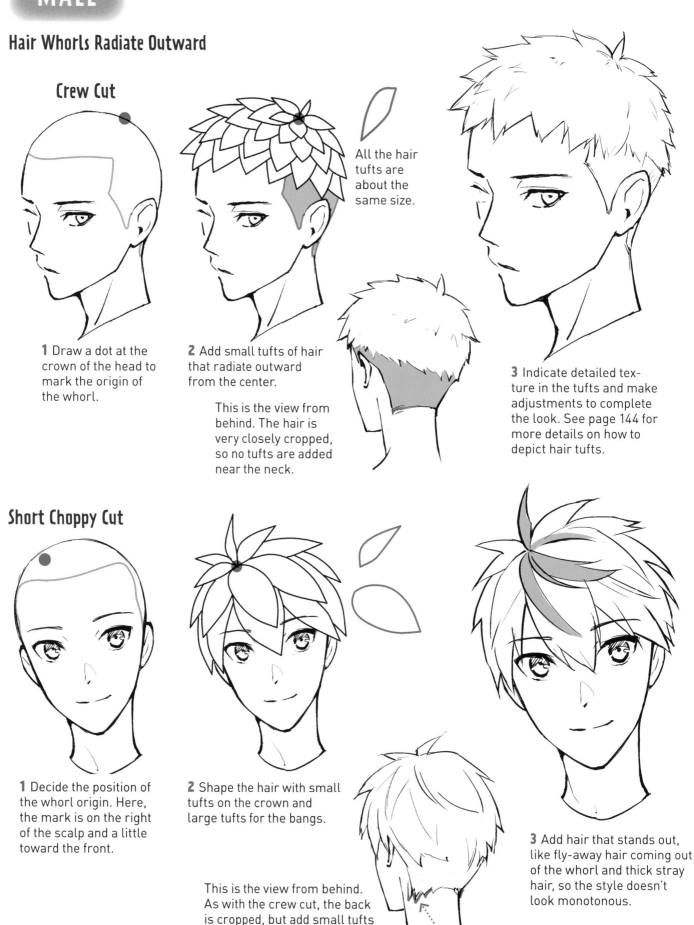

Crew Cut

1 Draw a dot at the crown of the head to mark the origin of the whorl.

2 Add small tufts of hair that radiate outward from the center.

This is the view from behind. The hair is very closely cropped, so no tufts are added near the neck.

All the hair tufts are about the same size.

3 Indicate detailed texture in the tufts and make adjustments to complete the look. See page 144 for more details on how to depict hair tufts.

Short Choppy Cut

1 Decide the position of the whorl origin. Here, the mark is on the right of the scalp and a little toward the front.

2 Shape the hair with small tufts on the crown and large tufts for the bangs.

This is the view from behind. As with the crew cut, the back is cropped, but add small tufts along both sides of the hair in the back border.

Hair border

3 Add hair that stands out, like fly-away hair coming out of the whorl and thick stray hair, so the style doesn't look monotonous.

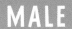

Hair Whorl Styles

You can draw various hairstyles by changing the length and shape of the tufts.

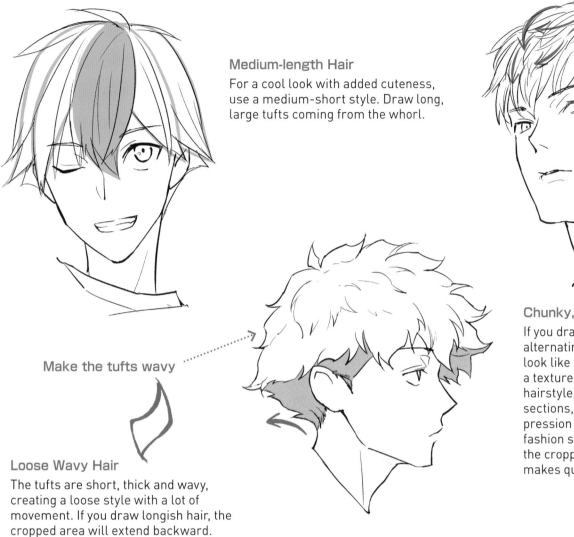

Medium-length Hair

For a cool look with added cuteness, use a medium-short style. Draw long, large tufts coming from the whorl.

Make the tufts wavy

Loose Wavy Hair

The tufts are short, thick and wavy, creating a loose style with a lot of movement. If you draw longish hair, the cropped area will extend backward.

Chunky, Textured Hair

If you draw fine, short tufts, alternating the curves, it will look like the character has a textured hairstyle. This hairstyle, with its 3D twisted sections, creates the impression of a man with high fashion sense. If you color the cropped part black, it makes quite an impression.

NOTE

Women's Hair Whorls Suit Quiet, Sweet Characters

Hair whorls create a lively impression. If you draw this hairstyle for a female character, it adds a sense of subdued sweetness. A medium-length whorl suits a sporty-type girl, while a long-length whorl is good for a cool-looking woman.

Female

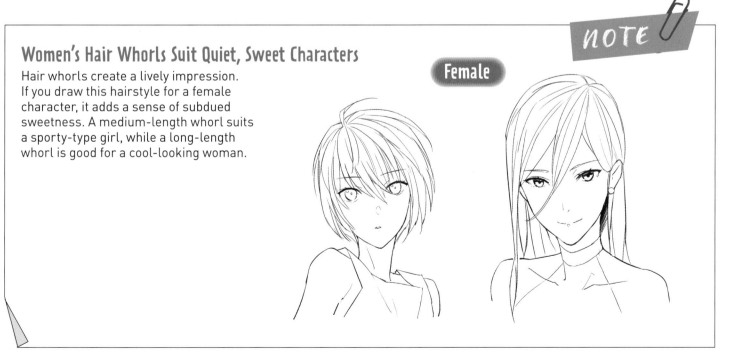

Draw 3 Tufts for 3-Section Hairstyles

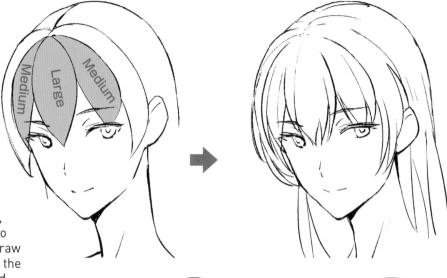

Basic Bangs

If you draw the bangs with 3 tufts, the eyes and eyebrows won't be so hidden and you can more easily draw the character's expression. Make the center tuft larger and add detailed splits to the hair tips.

Use 3 tufts for straight bangs too, overlapping them and then adding fine divisions. Make the space between the tufts narrower.

3 Steps for Depicting Detailed Hair Tips

It can be easy just to wing it when drawing the hair tips, but if you follow the 3 steps here, you'll be able to draw them convincingly.

Or this

1 Divide the hair tips with inverted V shapes. The trick is to make sure the split tips are not even on both sides. The same idea is applicable for straight bangs too.

2 Add thin crescent-shaped tufts from the base of the main tuft. For straight bangs, increase the lock detail without making the tufts thicker.

3 If the tufts appear large and elongated, add more of the finer tufts. Add to the inside of the tufts or draw on the opposite side to those addressed in step 2.

When you add the hair tips, always shape them from the roots. Think of it like adding bananas to a bunch. When you come to complete the look, make the lines at the roots fewer for natural appearance.

Roots

Center Part

For hairstyles where the bangs are divided in the center, be aware while you're drawing that the tufts overlap near the roots.

Side Part

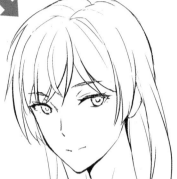

Part to the side

For side parts, pay attention not just to how the bang tufts overlap, but how the part shifts to the side.

Common Mistakes

Mystery tuft coming out of nowhere

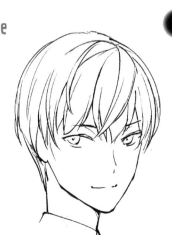

When you draw the hair tips, always shape them from the roots. If you don't remain aware of this, you will end up with a style where it's not clear which way the hair is flowing.

No clear flow of bangs

Unnecessary extra lock on the side

If you don't know the flow of the hair, you can't draw the roots, so you'll end up having to cheat by adding more lines at the tips, which looks messy.

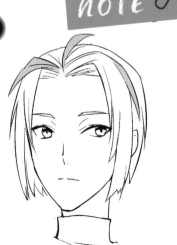

NOTE

Extra Tufts on Men's 3-Section Hairstyle Create a Great Look

The basic way to draw hair tufts is the same for men as it is for women, but you can create cool, textured loose hair if you add larger tufts and have some that flow in different directions.

Male

Draw Hair Whorls Like Petals

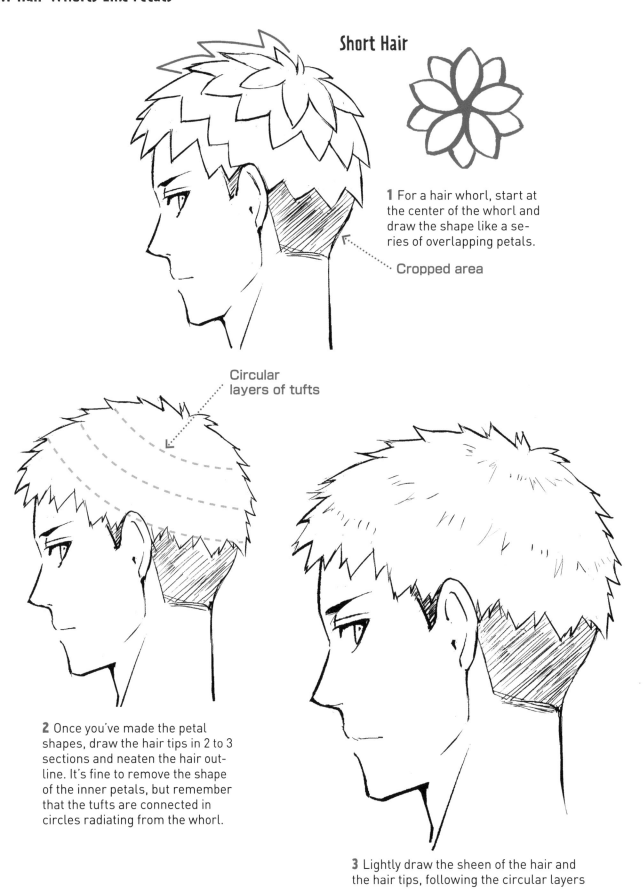

Short Hair

1 For a hair whorl, start at the center of the whorl and draw the shape like a series of overlapping petals.

Cropped area

Circular layers of tufts

2 Once you've made the petal shapes, draw the hair tips in 2 to 3 sections and neaten the hair outline. It's fine to remove the shape of the inner petals, but remember that the tufts are connected in circles radiating from the whorl.

3 Lightly draw the sheen of the hair and the hair tips, following the circular layers to complete the look.

Wavy Hair

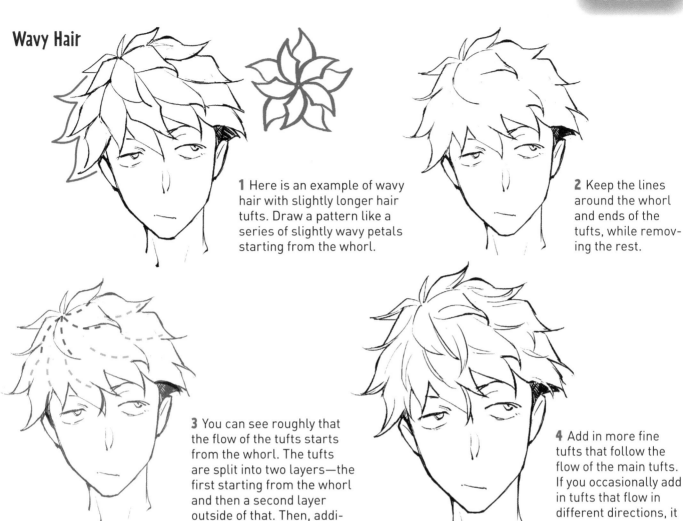

1 Here is an example of wavy hair with slightly longer hair tufts. Draw a pattern like a series of slightly wavy petals starting from the whorl.

2 Keep the lines around the whorl and ends of the tufts, while removing the rest.

3 You can see roughly that the flow of the tufts starts from the whorl. The tufts are split into two layers—the first starting from the whorl and then a second layer outside of that. Then, additional finer tufts, which flow in different directions, are added to cover the top portion of the face.

4 Add in more fine tufts that follow the flow of the main tufts. If you occasionally add in tufts that flow in different directions, it creates a loose look.

Short Bob

Long

For a short bob with long tufts, draw just one layer of petals from the whorl to form the shape. For men, the tips are pointed and the cropped part extends backward to express the stiff texture.

NOTE

Fine Lines Create an Airy Look for Women's Hair Whorls

Female

For women with soft-textured hair, even though it's the same short bob, don't make the tips too pointy. If you use fine lines with rounded curves, it creates a feminine impression. Another feature is that the cropped part in the back doesn't extend backward.

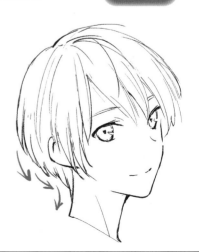

Locks of Long Hair Visualized as Vines and Strips

If you are mindful of the texture differences in long hair as it pertains to the different genders, you can add distinguishing hallmarks to male and female characters. Imagine women's hair being like long thin vines of a plant and men's hair being like long flat strips like noodles.

Straight

Female

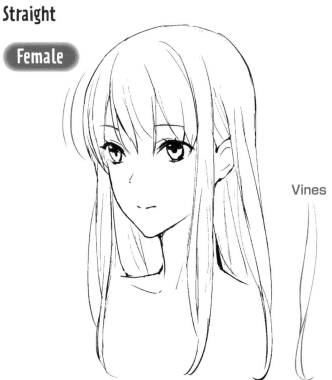

Vines

Add volume to the bangs by making them plump and round to inject femininity. Depict the flow of the hair on the side and in back with gentle curving lines that look like plant vines. Make each lock fine.

Male

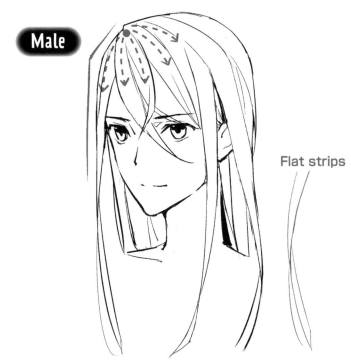

Flat strips

Men's foreheads are not as round as women's, so the bangs don't bulge out as much. If you draw the locks radiating out from the whorl and have them shaped like long, thick strips (like noodles), you can express their slightly stiffer texture.

Wavy

Female

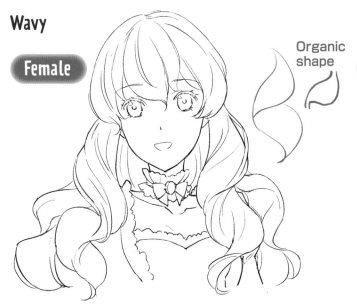

Organic shape

The tufts of the bangs are wide and the tips curve slightly. The larger and rounder you make the tufts, the cuter the impression will be. Depict the long hair in the back like a series of organic shapes. Express the soft waves with large round arcs.

Male

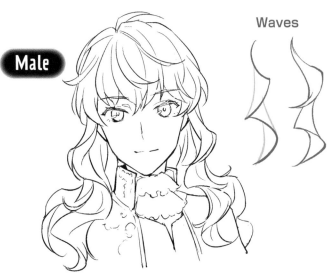

Waves

Men's wavy hair is drawn with angular waves to express the relatively stiff texture of the hair. It is relatively bouncier than women's soft hair, so add fine tufts that stand out in places to give this effect. Draw thick, defined lines.

How to Draw Straight Hair

Female

<----- Neck

1 Create the 3 sections of hair and shape them. The long hair in the back forms a shape like a bowling pin. It curves in at the height of the neck.

The view from the front. The hair in the back curves in at the height of the neck, so the flow of the hair is like an S shape.

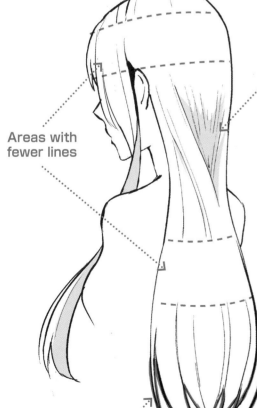

Areas with fewer lines

Add random tufts

× ⊔⊔⊔⊔
If you divide the parts evenly, they will look flat.

Add lines imagining a Y shape

2 Draw the flow of the hair. The locks of hair at the back converge in a Y shape, so add flow lines shaped like a Y using fine lines. If you add shading to the indentations of the Y shape, it will increase the 3D effect. Draw random small and large splits at the hair tips.

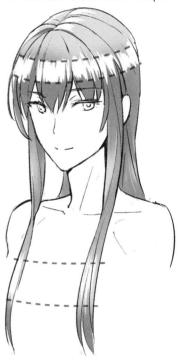

This is the view from the front. For both the bangs and hair in the back, reduce the number of lines in the area that bulges out the most to express sheen.

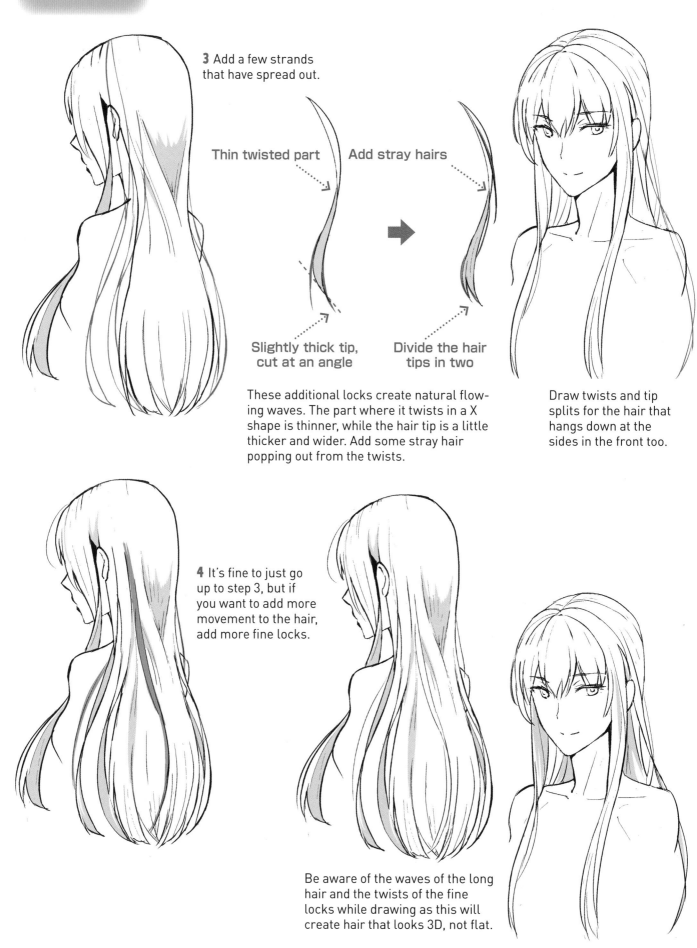

3 Add a few strands that have spread out.

Thin twisted part

Add stray hairs

Slightly thick tip, cut at an angle

Divide the hair tips in two

These additional locks create natural flowing waves. The part where it twists in a X shape is thinner, while the hair tip is a little thicker and wider. Add some stray hair popping out from the twists.

Draw twists and tip splits for the hair that hangs down at the sides in the front too.

4 It's fine to just go up to step 3, but if you want to add more movement to the hair, add more fine locks.

Be aware of the waves of the long hair and the twists of the fine locks while drawing as this will create hair that looks 3D, not flat.

Wavy Hair in the Back

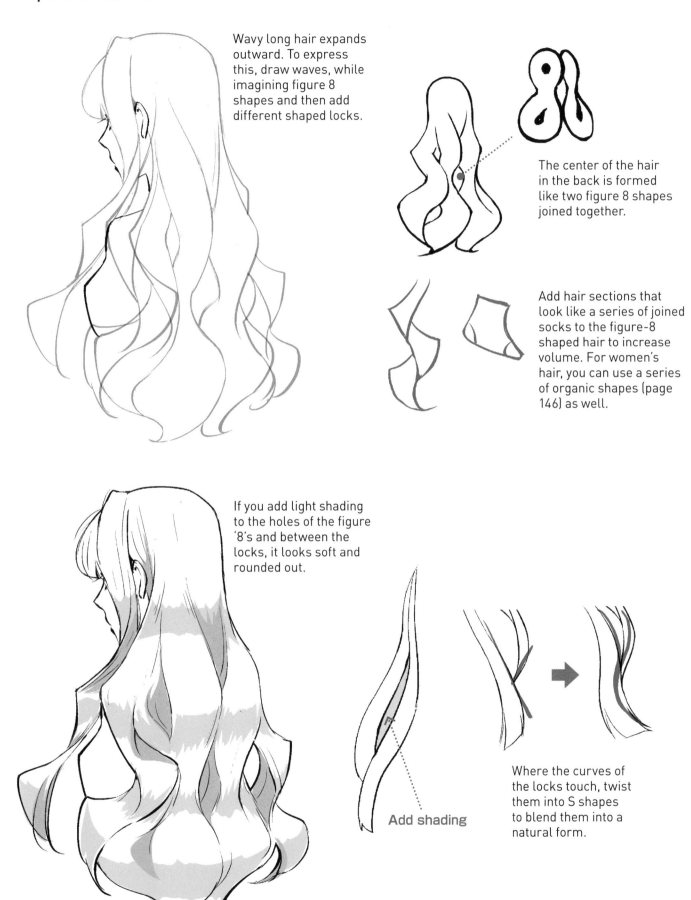

Wavy long hair expands outward. To express this, draw waves, while imagining figure 8 shapes and then add different shaped locks.

The center of the hair in the back is formed like two figure 8 shapes joined together.

Add hair sections that look like a series of joined socks to the figure-8 shaped hair to increase volume. For women's hair, you can use a series of organic shapes (page 146) as well.

If you add light shading to the holes of the figure '8's and between the locks, it looks soft and rounded out.

Add shading

Where the curves of the locks touch, twist them into S shapes to blend them into a natural form.

Ponytail

When drawing hair that is tied up, it's important to understand the flow of the hair from the hairline or part to where it is tied.

Female

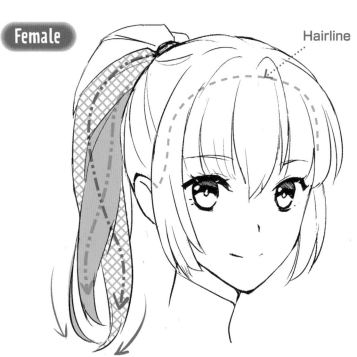

Hairline

The hair pulled from the hairline curves over the roundness of the head toward where it is tied. Draw the flow of hair while keeping this in mind.

For a single ponytail, the hair in the back flows from the hairline to the tie. The tail itself is made up of gentle S-shaped curved locks that overlap to create a 3D effect.

Here is the view from above. The flow of hair from the hairline and from the edge of the part are both toward the tie. The shape is like an inverted lotus flower.

Male

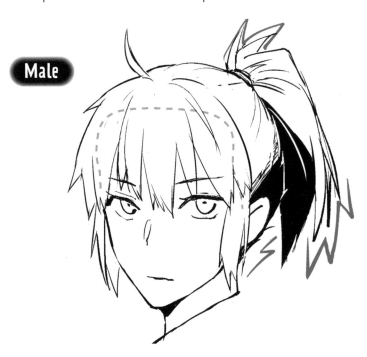

If the bangs are shaggy and long enough to hide the side hair, a ponytail with the 3-section hairdo creates an athletic, somewhat disheveled image. If you have short hair popping out near the tie and make the hair tips of the ponytail untidy, the hair will look stiff.

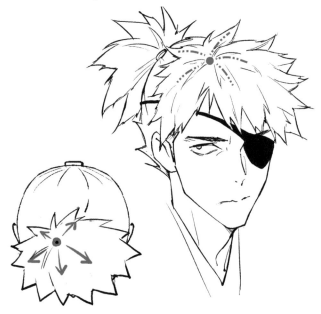

Here is a man's ponytail with even more bristly hair. Draw the bangs as for a hair whorl and then add hair tufts randomly radiating outward. When short stiff hair is tied up, the tail opens out from the tie in an untidy way.

Pigtails

As the hair has to be divided into 2 parts and tied on the left and right, you should study the steps for the 3-section hairstyles (page 142) carefully before drawing to understand how the hair parts.

Female

The hair flows from the center part to the tied bunches on each side. The pigtails themselves are made up of wavy S-shaped locks that overlap to create a 3D effect.

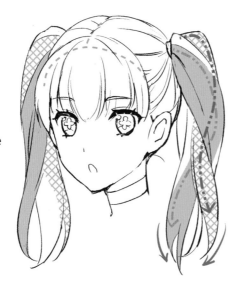

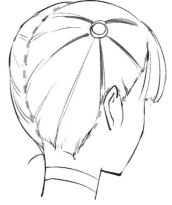

This is the flow of hair for pigtails. Take note that the flow goes not only from the part to the tie, but also from the hairline to the tie.

Male

Here is an example of pigtails for men. If you keep the bangs up and reveal the forehead, it makes it more masculine. Hair below the tie will drape and create strong curved lines.

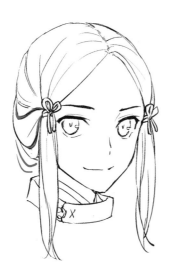

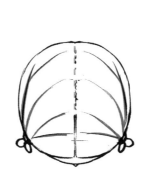

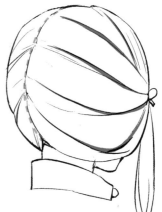

This shows the flow of hair for pigtails bound toward the front. You can see that changing the position of the tied parts significantly changes the hair flow.

NOTE

Tips on Drawing a Revealed Forehead (or Not)

In general, women's foreheads are round and men's are flat. If the forehead has bangs over it, it looks round and gives a feminine impression. If you're drawing a man with his hair tied up and he's looking like a girl, it can be improved by having the bangs up, revealing the forehead.

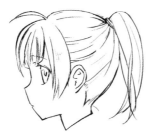

Loose bangs and sides
This is the most feminine and youthful look.

Just bangs
This gives a somewhat realistic impression. When you want to make a distinction between a man and a woman, alter the shape of the hairline.

Slicked back
Here, both the hairline and forehead are showing. As these features help distinguish men from women, this style is particularly suitable for drawing men.

Ringlets This is a hairstyle often seen in manga. Draw the ringlets by arranging them with the hair in the back for 3-section hairstyles or as ponytails.

Female

This style of ringlets is also known as "twin drills." Draw a series of tilted rectangles or trapezoids. The key is to have the twirl become smaller and narrower the farther down it goes.

These are the ringlets of an *ojosama*, a high-class young girl. Align several narrow ringlets together. Draw them so the twirls are loose at the top and get tighter toward the tips.

Male

You can differentiate men's ringlets by making them bold and irregular.

Reveal the hairline to provide an easy gender cue

Occasional stray tips

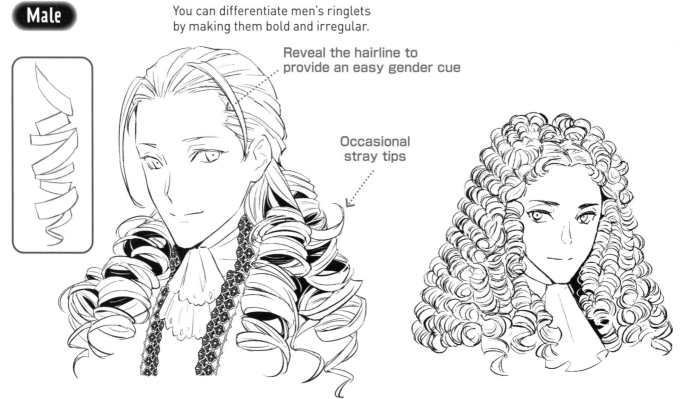

This is an aristocratic-looking style of ringlets. While it's different from the ringlet style of historical European aristocrats, it can still create a look of nobility. Make large, bold, irregular twirls with contrasting shadows.

This is a more historically realistic style. This hairstyle, popular in early modern Europe, was actually achieved with a wig. The ringlets are characteristically tight right down to the roots, and there is a lot of volume at the crown.

Hero Spikes You can create this energetic hairstyle by enlarging the tufts of a whorl and omitting the detailed splits to create chunky individual sections.

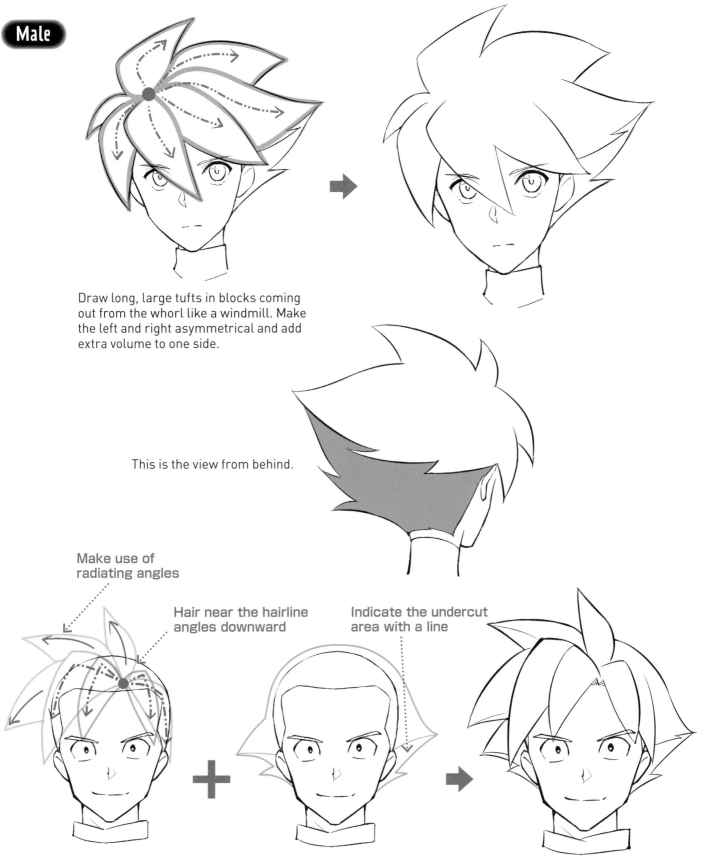

Male

Draw long, large tufts in blocks coming out from the whorl like a windmill. Make the left and right asymmetrical and add extra volume to one side.

This is the view from behind.

Make use of radiating angles

Hair near the hairline angles downward

Indicate the undercut area with a line

This style can be arranged in various ways by changing the position of the whorl or the shape and direction of the tufts. Shape the bangs and cropped areas separately.

153

Hair flutters in the wind and sways along with the movement of the characters. Learn how to add the appearance of movement to hair and draw it with vitality.

The Graceful Spreading of Long Hair Underwater

In water, hair floats up in bundles and rounds out due to water pressure. As it spreads in a soft, curved way, it works well when you want to portray an elegant female character.

Draw the round bundles as if they are overlapping teardrop shapes.

Female

The water pressure comes up from below (the opposite of the direction that the body moves). The hair spreads sideways and rises up.

Water pressure

Draw the area around the neck with locks of hair that bend downward in small curls.

Draw the hair bundles almost like round masses. When you are filling in more details, add openings rather than adding more fine division lines.

The Cool Look of Long Hair Flowing in the Breeze

Long hair tends to create a gentle impression, but when it's flowing in the wind, the movement lends a cool look. If you have the hair flowing up from the side, it goes sideways and then extends outward in S shapes.

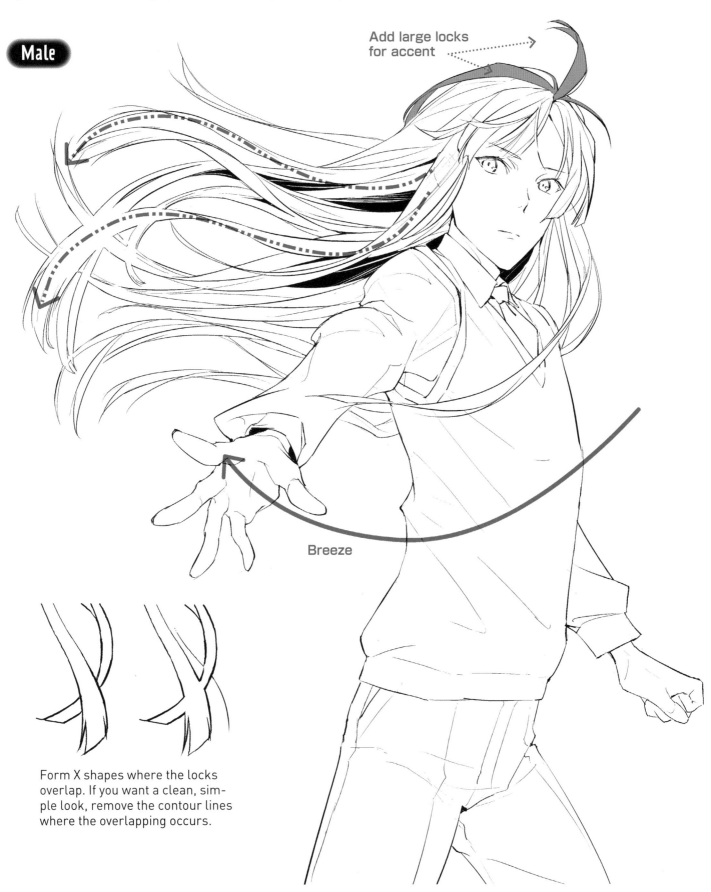

Male

Add large locks for accent

Breeze

Form X shapes where the locks overlap. If you want a clean, simple look, remove the contour lines where the overlapping occurs.

Create Beautiful Sprawling Hair with an S Curve

When a character with long hair is lying down, draw the hair so that it flows in an S-shaped curve. If you just draw it in an undefined way, it will look as if the hair is floating in the air. A drawing technique is needed here to clearly convey that the hair is spreading out across the ground.

Female

Draw a large S-shaped curve, and then draw a series of rings along it. Draw the rings so that the ones in the background are smaller and the ones in the foreground are larger.

Form the rings so that the nearer part is wider, and the more distant part is narrower.

Narrow

Wide

Add sections of overlapping wavy hair to create a 3D effect. Join up the hair sections, roughly following the shapes of the rings.

Draw the hair in waves and coils along the rings and add lines and shading (if using) to indicate the flow of the hair.

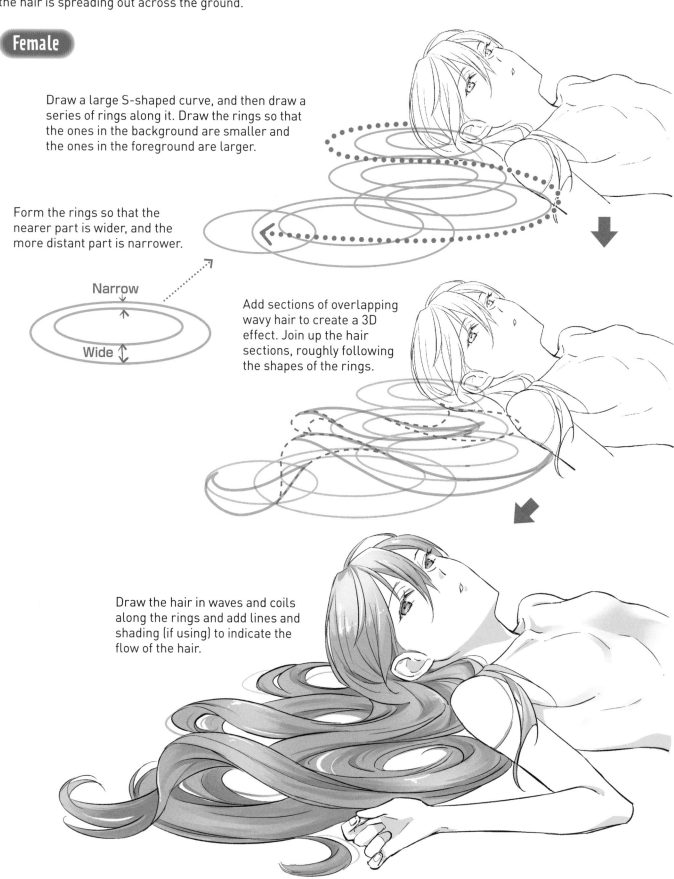

CHAPTER 4

Drawing Expressions by Gender

It's great to be able to draw a range of people's
facial expressions, including when they're angry or crying,
and of course when they have a broad smile.
In this chapter, you'll learn how to draw some lively expressions
that distinguish male and female faces.

Three Key Points to Drawing Expressions

Expressions of anger, laughter, shyness—these emotions are common in all people, but the facial expressions significantly differ between males and females. There are 3 points to keep in mind so that you can draw a variety of expressions.

Be Aware of Gender Differences for Mouths

The way the mouth moves is key to expressing strong emotions. Review page 124 and try to draw the mouths so that a man's is large with straight lines and a woman's is smaller with curved lines.

Female

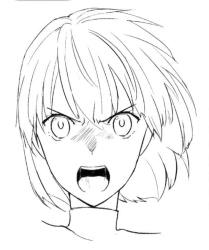

Here is an expression of anger. For women, even when the mouth is open in a scream, remember to keep in mind a round, soft shape.

Male

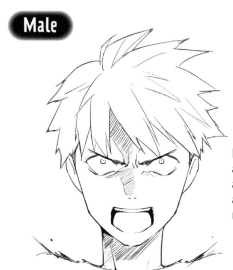

For men, depict a strong sense of anger by drawing a large, angular mouth.

Be Aware of Differences in Emotional Expression in the Eyebrows

Strong emotions create crease lines between the eyebrows. If the force of that emotion is very strong, the eyebrows will form a shallow V shape, while for a subtler emotion, they will form a shallow inverted V shape. If you keep in mind that men usually have V-shaped eyebrows and women have inverted V-shaped ones, you can create a distinction.

Female

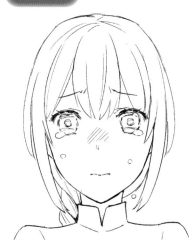

Here is an expression of sadness. If you draw the eyebrows in a shallow inverted V shape without bringing the eyebrows too close together, it creates a feminine look.

Male

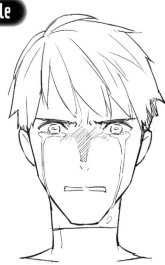

For men, you can express strong sadness along with resentment by drawing the eyebrows very close together in a shallow V shape.

3　Emphasize Cuteness for Females, Reactions for Males

When you express strong emotions, your facial muscles move a lot and more crease lines are revealed. If you draw this realistically, some of the cuteness is lost, so for women, refrain from expressing too many crease lines and shadows. For men, on the other hand, exaggerate their reactions to distinguish them from women.

Female

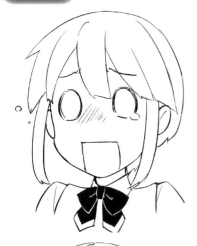

Here the character is expressing shock and disappointment. If you draw this realistically with wide open eyes and mouth, it will lose some of the cuteness, so incorporate a simple comically exaggerated expression.

Male

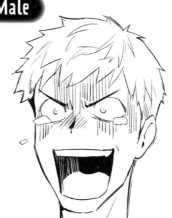

For men, it's fine instead to draw wide open eyes with small irises and a huge mouth. It also works to add lines exaggerating the expression of a face turning pale.

Here the character is crying in shock. For women, prioritize the cuteness, so the eyes remain large. The mouth is also drawn small to keep a feminine image.

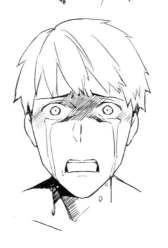

For men though, it's fine to draw an exaggerated expression. Express the amount of shock by drawing the eyes wide open and separate from the upper and lower eyelids, while the mouth gapes open in shock.

NOTE

Feel Free to Adapt Your Style

The points introduced here are just general guidelines. Depending on the type of scene and style you want to draw, it's fine to depict expressions without being overly concerned with adhering to these guidelines.

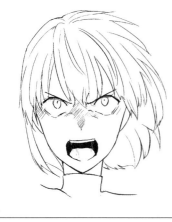

Here, the angry woman from the facing page has a large, powerful mouth and *sanpaku*-style eyes with added realism. It may be less cute, but it is effective for expressing strong emotion.

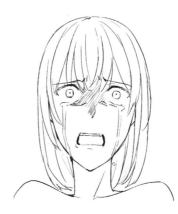

This crying woman's mouth has been enlarged, the eyes widened and crease lines expressed realistically. This expression is a bit unsettling, but it emphasizes shock, so this type of depiction is also effective.

Drawing Joyful Faces

Male and female eyes both narrow when expressing happiness and laughter. You can draw various expressions of joy by narrowing the eyes and changing the shape of the eyebrows and mouth.

Differences in Basic Smiling Faces

Female

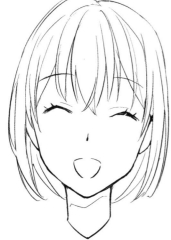

Male

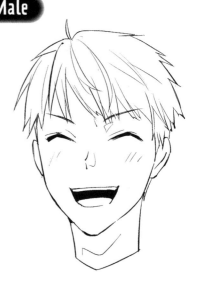

Unisex Drawing Tip

For eyes that have narrowed in a smile, draw them where the center of the open eyes would be. This is because when you smile, the cheeks rise, so the upper and lower eyelids nearly meet in the middle.

Draw the eyes in downward arcs with no visible irises. If you make the arc of both eyebrows a shallow arching shape, it creates a soft, relaxed smiling face. It's cuter if you don't fill in any details inside the mouth.

If you form the eyebrows in a shallow V shape, it creates a slightly more masculine smile. Draw a large mouth at a slight angle and then indicate the teeth and tongue within.

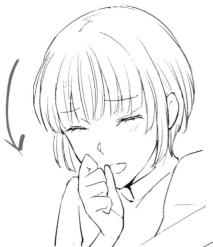

With her hand near her mouth and head slightly angled down while smiling, this creates a feminine impression. When looking down and smiling, the curves of the eyelids are very subtle.

In contrast, a broad smile while looking up creates a masculine impression. When looking up and smiling, the curves of the eyelids are more pronounced.

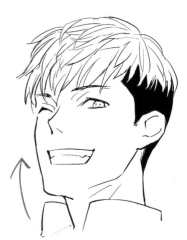

For men's mouths, if you lightly raise one edge at an angle, it creates a confident smile.

For women, you don't need to fill in the mouth too much, but if you add a slight glimpse of the top front teeth, it will look cute.

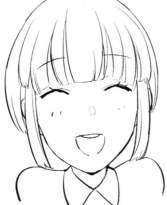

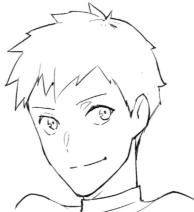

"I want to draw a smile, but it keeps turning into a grin"—this is a problem many people seem to have. Let's take a look here at the difference between a gentle smile and a slightly sinister grin.

Smiling

Draw the eyebrows slightly away from the eyes to create a gentle, relaxed expression. Finely narrow the eyes, but take care not to have the lower eyelids curve up too much.

Female

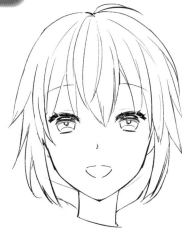

Draw the inner corners of the lower eyelids a little higher. After drawing the shadow of the eyelashes using fine lines across the top of the pupils, add large highlights.

Male

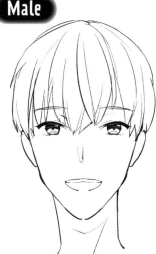

Draw the inner corners of the lower eyelids a little higher. Have bold shading across the top of the pupils, making the eyes a little darker.

Grinning

The key here is to draw the lower eyelids of the narrowed eyes with upward curves to give the impression of a the cheeks being drawn up into a grin. Don't place the eyes and eyebrows too far apart.

Female

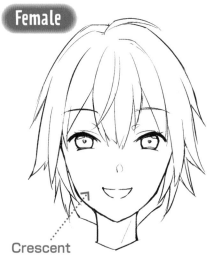

Crescent

For women, make the curve of the lower eyelid especially strong. The eyes have a small amount of brightness, so draw small pupils with highlights in the center.

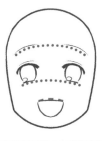

Male

Thin, leaf-like shape

Men's lower eyelids also rise up with the swell of the cheeks. If you draw the pupils as small points, this will create a slightly sinister smile.

NOTE

Check This if You Can't Seem to Draw it Right!

If you thought you'd drawn a smile, but it looks like a grin, check the curves of the eyebrows, lower eyelids and top lip.

Smiling
The eyebrows and lower eyelids together form large downward curves. The top lip is also a downward curve.

Grinning
For the eyebrows and lower eyelids, draw small curves on each side. The top lip forms an upward curve.

Tearing up with Laughter

This expression is when something is so funny, you tear up with laughter. There's more strength in the eyebrows than with a normal smile. This type of laughter is often connected with over-reaction, so if you have the face angled up or down in some kind of movement, it will be more realistic.

Female

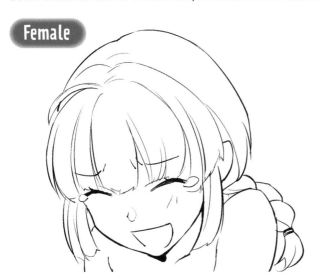

Male

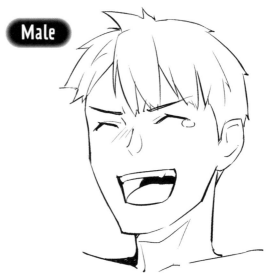

Add just a few crease lines between concerned-looking brows that are shaped roughly like an inverted V. If the face is angled down, it will look a little feminine even if the laugh is hearty.

Add just a few crease lines between V-shaped eyebrows. If you raise the face and make the teeth and tongue visible, it looks bold and bright.

Happy Tears

This is a smile accompanied by tears when you've been touched by someone's kindness or compassion. Slightly pained, inverted V-shaped eyebrows are paired with a smile that rises up at the corners of the mouth.

Female

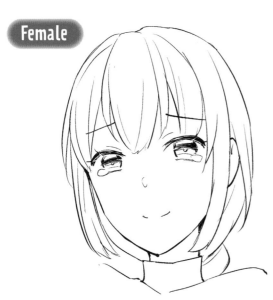

Male

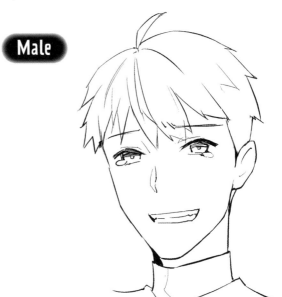

The eyes are slightly narrowed, as with a smiling expression. Draw faint tear drops with very fine lines under the irises. If you draw the mouth closed or slightly open, it will work well here.

As with women, draw the shape of the eyes as with a smiling expression. Draw nearly horizontal eyebrows and add just a few crease lines between them. It's fine to have the mouth closed too, but if you show a smile with the teeth showing, it injects masculinity.

A Downward Smile

Here the smile is slightly downturned with the eyes downcast too. It creates a more nuanced impression than just a broad smile. With the basic smile, the eyes curve down, but for this expression, the eyes curve up.

Female

Depict the eyebrows with relaxed, natural curves. Add more eyelashes than for when the eyes are open.

Male

For men, draw shallow V-shaped eyebrows with a small amount of tension between them. By making the eyelashes less visible, you can distinguish here between males and females.

An Upward Laugh

This is a cheerful smile with a wide-open mouth. When someone looks up, the bridge of the nose is less noticeable, but the nostrils are much more visible. The key here is to simplify this.

Female

Relax the eyebrows and have them droop down a little. Completely omit the nostrils and draw the highlight (the part that catches the light) with very fine lines.

Male

The eyebrows here are a slight V shape with a small amount of tension in them. Express the nose by drawing the shape of the shadow using very fine lines. If you slightly round a man's large, straight mouth, it creates a gentle smile.

Drawing Angry Faces

When expressing anger, both male and female eyebrows are basically drawn using a V shape, whether it's an angry glare, yelling or an intimidating look. Try drawing a range of angry expressions.

Drawing Basics

Female

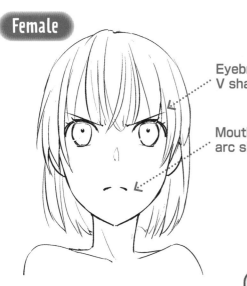

Eyebrows in V shape

Mouth in gentle arc shape

Male

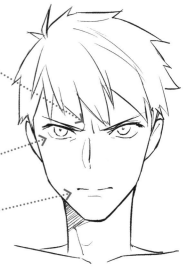

Eyebrow and inner corner eye crease lines

Sanpaku eyes (only the upper eyelids touch the irises)

Lower the corners for a clenched look

For women, you'll want to find ways to draw angry expressions that are still cute. If you add crease lines around the eyes or make other changes, some of the cuteness is lost, so keep the eyes simple.

Unisex Drawing Tip

Remove the highlights from the irises and draw small, unusually-shaped pupils.

For men, drawing crease lines to express anger doesn't diminish the courageous look. Draw firm crease lines between the eyebrows and at the inner corners of the eyes to express the intensity of the anger.

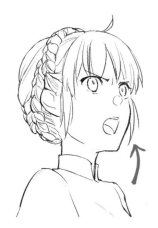

Giving female characters an angry expression with a raised face creates dignified charm. Draw it as if the character is looking defiantly up at someone larger than herself.

With male characters, you can express strong anger by tucking in the chin and having them glare upward. Draw it as if the character is looking threateningly at someone of about the same height.

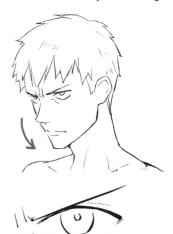

This is the eye of an angry man seen from a front-on perspective. The eyebrow is raised, but not the outer corner of the eye.

To depict the anger as being more intense, instead of raising the outer corner of the eye, angle up the inner corner of the lower eyelid. If you add more crease lines, it will create an even angrier expression.

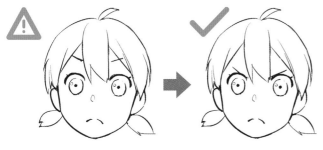

For female characters with large eyes, the eyebrows are usually drawn high up, except when they are angry. Then, they are drawn touching the upper eyelids. If you keep the eyebrows high, the character won't look very angry even if you draw V-shaped brows.

Raising the outer corner of the eye too much will make it look like the person is being viewed from a high angle or that it's an exaggerated expression using distortion.

A Downward Glower

This is not just anger—it has a sense of strong intimidation too. It's more effective if you add shading that looks like the face is lit from below or darkened due to light from behind. This is an exaggerated expression, so you can use it as a comical reaction too, if you make some changes.

Female

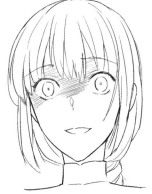

Widen the eyes and draw small irises. With the eyebrows, go for keeping them like an inverted in a shallow V shape and draw a smiling mouth to add a sinister element.

Draw the upper and lower eyelids with straight lines to create a comical feel.

Male

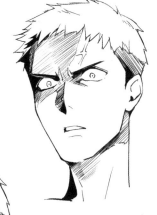

Draw small irises and make the eyebrows V shaped. If you draw a raised vein on the forehead and slightly open mouth, it creates a more potent image.

For a comical reaction, the upper and lower eyelids are straight and the eyes blank. Draw a flat shadow across the face and use a hashtag-type motif on the forehead to represent a raised vein.

If you draw the face looking up without a shadow, it will create a resolute expression, rather than anger.

An Upward Glare

An upward glare paired with a tucked-in chin naturally makes the eyes more forceful. With men, you can leave the expression as it is, but you need to modify the technique to add cuteness for women.

Female

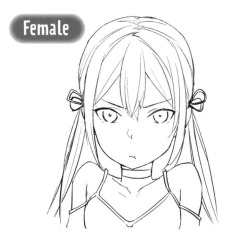

You can soften the strength around the eyes by drawing the V-shaped eyebrows a little distance from the eyes. Adding bulge to the cheeks and sharpening the angle of the mouth will create a cuter look.

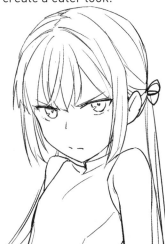

For women, if the V-shaped eyebrows touch the irises, the eyes become more forceful and give the impression of a very strong-willed character. It will be less cute, but this is also fine, depending on the character's personality.

Male

If you have the character holding a glare while looking up from an angle, it creates the image of a person who is harboring resentment. It's better to have the mouth angled down slightly.

165

Yelling

The depiction of the mouth is important when expressing a character yelling angrily. When drawing the mouth, keep in mind the tips on how to draw an angry-looking mouth, as well as the points explained on page 124.

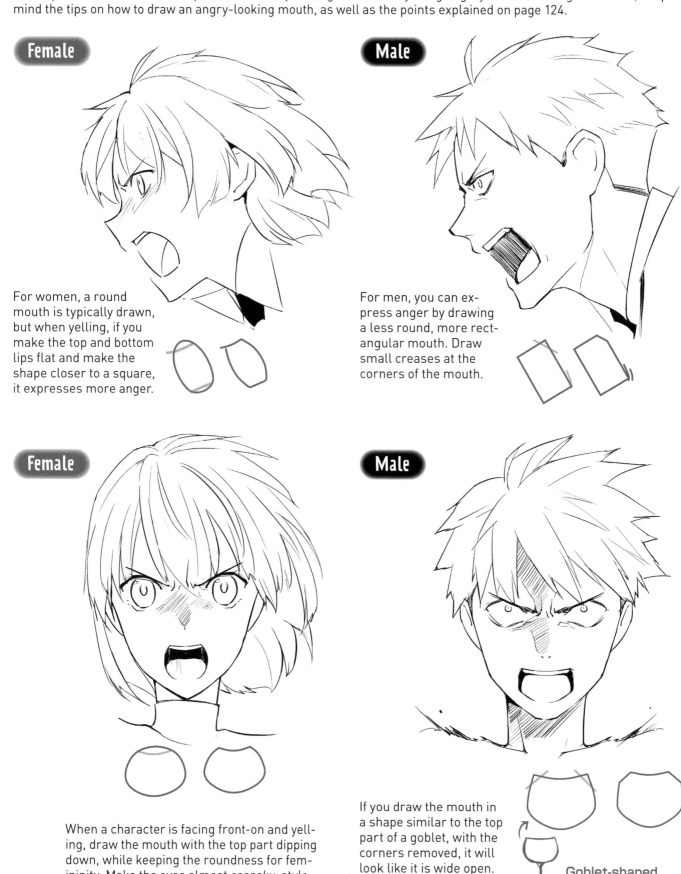

Female

For women, a round mouth is typically drawn, but when yelling, if you make the top and bottom lips flat and make the shape closer to a square, it expresses more anger.

Male

For men, you can express anger by drawing a less round, more rectangular mouth. Draw small creases at the corners of the mouth.

Female

When a character is facing front-on and yelling, draw the mouth with the top part dipping down, while keeping the roundness for femininity. Make the eyes almost *sanpaku*-style with the irises high up.

Male

If you draw the mouth in a shape similar to the top part of a goblet, with the corners removed, it will look like it is wide open. Draw the irises particularly small.

Goblet-shaped

Intimidating

Draw a large shadow on the face to express the anger. Very few changes are made to both men's and women's expressions so as to create a quiet, sinister impression. Draw small crease lines between the eyebrows and slightly lower the corners of the mouth.

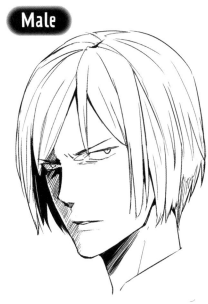

If you draw lines under the eyes to look like bags, it increases the threatening appearance. The trick here is to draw them at the outer corner because if you add them to the inner corner, it makes the character look old.

In contrast, for men, draw several crease lines on the inner corner of the eye to create a disconcerting look. Adding small crease lines to men's eyes doesn't really add age to their appearance.

Clenching Teeth

For women, if the teeth show too much, the drawing will lose some of its cuteness, so express only the minimum amount of the open mouth. In contrast, for men, baring their teeth expresses strong aggression.

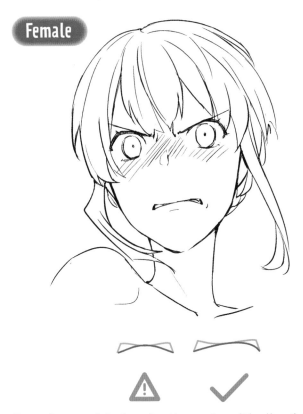

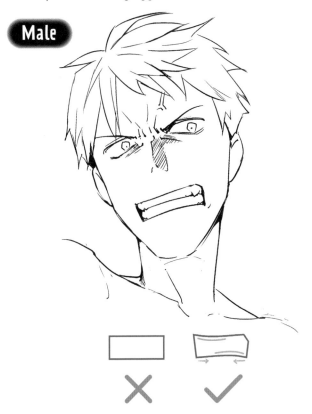

Draw the mouth by keeping the center of the lips tight together and a peek at the clenched teeth visible at each edge. If you make the bottom lip asymmetrical, it gives a more powerful look.

Here the teeth are clenched so much that you can see the gums. Draw the shape of the mouth by gently curving the top and bottom lips, and then very slightly narrowing the bottom lip.

Drawing Sad Faces

The key to expressing sadness is through the eyes. You can express deep sadness by adjusting how you draw the eyes. Tears well up in women's eyes, while men's eyes waver with deep emotion.

Drawing Basics

Female

If you draw slightly relaxed inverted V-shaped eyebrows that don't come too close together, it will result in a feminine expression of sadness.

Male

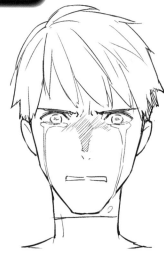

For men, you can express strong sadness along with regret by drawing eyebrows very close together in a shallow V shape.

To express eyes that are welling up with tears, draw the irises and pupils with double lines or draw the pupils with wobbly lines.

Distorted irises create an expression of teary-eyed agitation. Using broken lines, draw the irises shaped as polygons. Draw empty circles for the pupils.

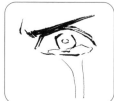

Women's tears are expressed in a cute way with drops that spill down. The gesture of wiping away tears with the hand makes the character appear young, so this is also a suitable action for girls.

If you draw a man with tears flowing down his cheeks without wiping them away, you can express profound masculine grief.

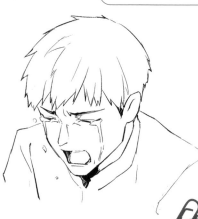

What Happens When the Eyebrow Direction is Reversed?

Men with V-shaped eyebrows and women with inverted V-shaped eyebrows work best for expressing crying. But depending on the character's personality or the situation, the opposite direction is possible.

When female characters with V-shaped brows cry, it creates a stronger sense of anger than sadness. This matches scenes where the character is fuming with anger and is also crying.

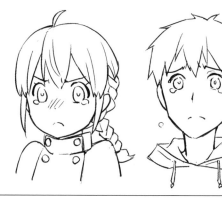

When male characters with inverted V-shaped brows cry, it creates a youthful, tender impression. This is good for cute young male characters and sensitive characters too.

TIP

Sobbing

When you sob, you do it with strong emotion, so if you have a character standing up straight, it will look a little strange. It's important to express the raised face as well as the apparent retraction of the neck accomplished through the raising of the shoulders.

Female

If you draw the eyes in arcs and the eyebrows with an inverted V shape, it will create a powerful expression of sobbing. Slightly compress the outline of the mouth.

Male

The face is angled up enough to hide the eyes and strong sadness is expressed with thick streams of tears. The mouth is shaped like a distorted trapezoid with the corners omitted to create a 3D effect.

Despair

This expression shows a character who is devastated and speechless. In this case, men also have inverted V-shaped eyebrows. Add shading around the eyes to give an even deeper impression of despair.

Female

For this expression, the woman's tears are drawn with lines too. Drawing a narrower flow creates a delicate feeling and distinguishes it from men's crying.

The characters are conveying shock, so draw both men and women with their lips parted. Create a shape like a springy compressed rectangle.

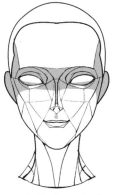

When the face is lit from below, shadows form around the eyes and the sides of the head. Add this shadow to deepen the feeling of despair.

Male

Even if the eyebrows are shaped like a shallow inverted V and you add a lot of crease lines, it won't weaken the effect. Draw the eyes wide and the irises small.

Quiet Sorrow

No tears are shed with this expression. It gives a quiet, mature impression. If you try raising the corners of the mouth in a smile, it will result in a wistful expression.

Female

Male

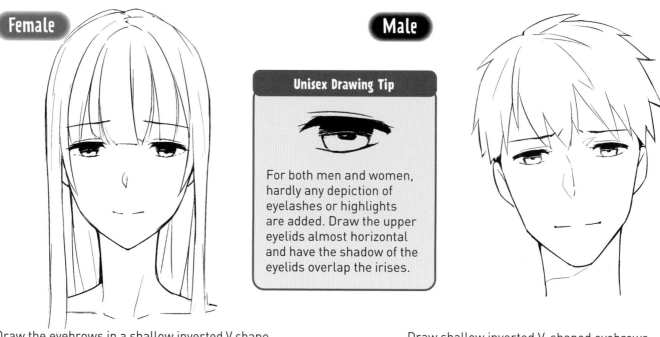

Unisex Drawing Tip

For both men and women, hardly any depiction of eyelashes or highlights are added. Draw the upper eyelids almost horizontal and have the shadow of the eyelids overlap the irises.

Draw the eyebrows in a shallow inverted V shape, but don't add any crease lines. Make the eyes downcast and draw the mouth with a very slight curve.

Draw shallow inverted V-shaped eyebrows and add small crease lines between them. Make the eyes downcast and very slightly raise the corners of the mouth.

Averted Eyes

This is a pose where the character is holding back their sadness and has turned away to hide their tears. By intentionally hiding the eyes, you can express the depth of the sadness. Hiding the face using the hands is also effective.

Female

Male

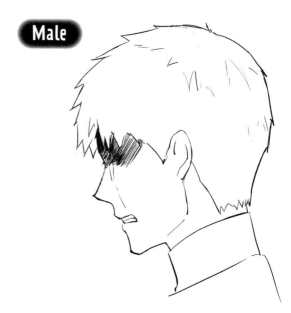

Draw the face angled down a little and use the hair to hide the expression. If you draw the mouth so it is closed and without expression, it will increase the impression of sadness.

For men with short hair, use shadow around the eyes to hide the expression. Although it's fine to have no expression, if you add a glimpse of tear streaks and clenched teeth, it creates a slightly different effect to the woman's expression.

Comical Reaction

This expression is perfect for conveying a comically exaggerated look of shock and disappointment. For this, it's good to have the eyes and mouth wide open to show the over-reaction.

Female

Male

If you draw the wide-open eyes realistically, it will lose some of the cuteness, so use super deformation to form round blank eyes. Use distortion for the mouth too so that it merges with the chin.

Draw in more details for men's comical reactions. Draw the eyes wide open and add smaller irises. If you slightly raise the corners of an extremely wide open mouth like a laugh, it creates a face distorted with shock.

Pouting

This expression conveys sulking while crying. There is a small sense of anger, so the eyebrows for both men and women are drawn shaped like a V.

Female

Male

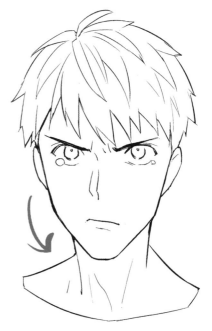

If you draw a woman with a raised chin, it gives a cute appearance of someone sobbing in heaves. The mouth is drawn with crimped lines to create a look of pent-up frustration.

For men, if you pull in the chin and draw the eyes in a glare, it gives a calmer impression than heaving sobs. Tilt the mouth slightly to create the impression of the jaw being set.

Drawing Other Expressions

There are a wide range of facial expressions apart from the basic emotions. Let's take a look here at how to draw shock, fright and panic, as well as the various ways to express embarrassment.

Tips For Drawing Shock, Fright and Panic

With all three of these expressions, the eyes and mouth are wide open, so they can tend to look similar. Learn here how to draw them well enough to distinguish between them.

Female

Male

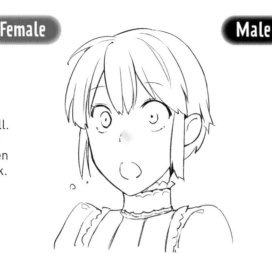

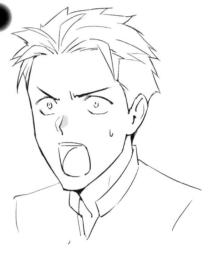

Shock

The key is to draw the eyes wide open in shock and have the pupils be extremely small. If the left and right irises are different sizes, it adds an even stronger impression of shock. It's fine for male characters to have their mouths so wide open, it looks as if their jaw might hit the floor.

Female

Male

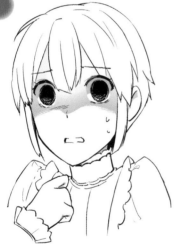

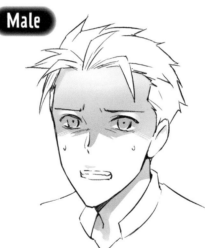

Fright

To express fearful eyes well, keep the irises large and remove the highlights. Add lines under the eyes to look like bags and draw the teeth lightly clenched to express fear. If you fill in the irises completely for a woman, it will look cute even when she is expressing fear.

Panic

If the irises are too small, it will look like an expression of shock, so draw the irises only a little smaller. Crimp the lines of the mouth and add drops of sweat to create an impression of panic.

Female

Male

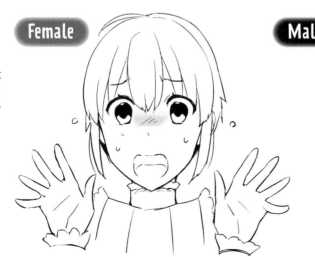

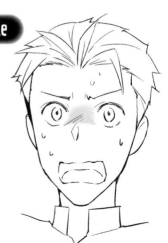

Female

Male

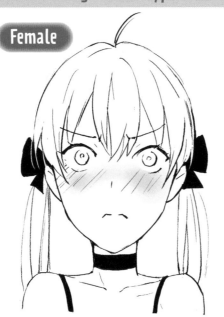

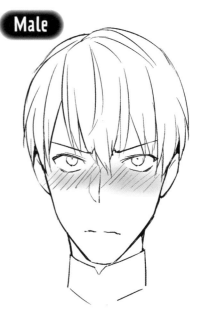

When Angry

This isn't pure anger, so don't add as many crease lines between the eyebrows. The eyes are open extra wide in indignation. For women, draw a slightly uneven bottom lip as if it's being bitten, and for men, draw the mouth at a slight angle and as if the jaw is being clenching.

Female

Male

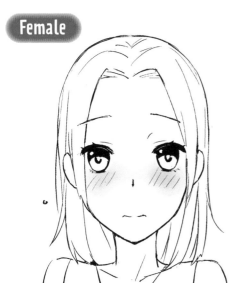

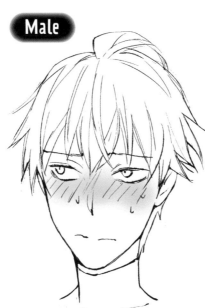

When Ashamed

The characteristic of this expression are the inverted V-shaped eyebrows that slope down toward the outside edges. The line for the mouth is incomplete and shaped like a seagull in flight. For women, make the eyebrows wide and depict them with gentle curves. For men, when the face is front-on, this expression can look like angry embarrassment, so avert the eyes to denote the difference.

Female

Male

When Happy

This expression is conveyed with a happy yet embarrassed look and the eyes lowered at the corners. Draw light crease lines between the eyebrows for both men and women. Women have a round, clam-shell shaped mouth with the top front teeth slightly visible to add cuteness. For men, raise up the corners of the mouth, so even with a smile his face looks gallant.

Drawing Unusual Expressions

This chapter introduced various facial expressions conveying emotions in a straightforward way. If you want to expand the range of expressions you can draw even more, try drawing unusual and unsettling expressions that don't reveal the character's true feelings. Make the eyes particularly distinctive to create an impact.

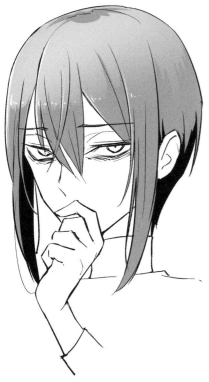

An upward glare with bags under the eyes

This is the suspicious look of someone with a closed heart. They may be distrusting or they may be plotting something. Avoiding a direct front-on angle and hiding part of the face can be effective for heightening this expression.

Amphibian-like eyes

The pupils are slightly elongated sideways and the eyes are like those of a frog's or other amphibian's, creating an eerie look. Whether the character is smiling or angry, the look is definitely unsettling.

Eyes with no light in them

These eyes have huge pitch-black irises, but no highlights. At a glance, this looks cute, but it has an empty feeling and a mysterious aura.

Afterword

Thank you for choosing this book

I think there are two types of people who practice drawing pictures. The first are those who innately enjoy drawing art. The second are those who don't really enjoy drawing, but they want to be able to draw.

People who enjoy drawing keep practicing and practicing, letting the enjoyment push them on. On the other hand, those who don't enjoy it tend to give up after a couple of days. They want to be able to draw, but they get stuck thinking that practicing is hard and it's a chore to pick up a pen.

If you are this type of person, don't worry too much about pushing yourself to continue practicing. Instead, find a posture and rhythm that helps you become absorbed in the practice. You could try imagining you are keeping a chick in your head—bear with me, I'll explain!

I recently heard an illustration about how if you imagine you are chasing a chick while ascending flights of stairs, you'll have gone up a dozen or more floors in no time. The "chick" is anything that distracts you from thoughts of weariness or frustration and leads you forward at a comfortable pace—a great companion for drawing!

The form of this chick will vary from person to person—it could be the sound of inspiring music, a luxurious chair or the appearance or voice of a beloved person. Among them, the strongest chick is the one that can get you to enjoy the process of a drawing taking shape.

I've explained in this book about how to draw characters and in particular how to distinguish different faces. If you're having a hard time practicing, starting from the face is one way

Try Keeping a Chick in Your Head!

to go. This is because it gives you a sense of accomplishment in a shorter amount of time than it takes to draw an entire body, so you can get right down to the fun of drawing!

To begin with, use this book as a reference to draw just one character's face. You can just skip reading the text and copy the parts you like. If the face you draw surprises you by looking better than you expected, then the chick may start chirping happily in your head.

On days when the drawing isn't going well, don't push yourself and instead go to bed early and get some rest. When you feel you've done well with a drawing, go ahead and praise the chick that helped you practice drawing. As long as you have faith in that chick, your champion chick will never fail.

Then, when you start thinking that it is fun to draw and you want to carry on and draw more, that's when you realize that the inspirational chick has become your faithful partner in success!

"Books to Span the East and West"

Tuttle Publishing was founded in 1832 in the small New England town of Rutland, Vermont [USA]. Our core values remain as strong today as they were then—to publish best-in-class books which bring people together one page at a time. In 1948, we established a publishing office in Japan—and Tuttle is now a leader in publishing English-language books about the arts, languages and cultures of Asia. The world has become a much smaller place today and Asia's economic and cultural influence has grown. Yet the need for meaningful dialogue and information about this diverse region has never been greater. Over the past seven decades, Tuttle has published thousands of books on subjects ranging from martial arts and paper crafts to language learning and literature—and our talented authors, illustrators, designers and photographers have won many prestigious awards. We welcome you to explore the wealth of information available on Asia at www.tuttlepublishing.com.

Published by Tuttle Publishing, an imprint of Periplus Editions (HK) Ltd.

www.tuttlepublishing.com

DANJO NO KAO NO EGAKIWAKE
Copyright © YANAMi / HOBBY JAPAN
All rights reserved.
English translation rights arranged with Hobby Japan Co., Ltd. through Japan UNI Agency, Inc., Tokyo

Staff (Original Japanese edition)
Editing: Seiko Kawakami (Hobby Japan)
Cover Design / DTP: Hiromasa Itakura (Little Foot)
Planning: Yasuhiro Tanimura (Hobby Japan)

English translation © 2022 Periplus Editions (HK) Ltd
Translated from Japanese by Wendy Uchimura

ISBN 978-4-8053-1718-1

25 24 23 22
10 9 8 7 6 5 4 3 2 1

Printed in China 2206EP

Distributed by

North America, Latin America & Europe
Tuttle Publishing
364 Innovation Drive
North Clarendon, VT 05759-9436 U.S.A.
Tel: (802) 773-8930
Fax: (802) 773-6993
info@tuttlepublishing.com
www.tuttlepublishing.com

Japan
Tuttle Publishing
Yaekari Building 3rd Floor
5-4-12 Osaki
Shinagawa-ku
Tokyo 141-0032
Tel: (81) 3 5437-0171
Fax: (81) 3 5437-0755
sales@tuttle.co.jp
www.tuttle.co.jp

Asia Pacific
Berkeley Books Pte. Ltd.
3 Kallang Sector #04-01
Singapore 349278
Tel: (65) 6741 2178
Fax: (65) 6741 2179
inquiries@periplus.com.sg
www.tuttlepublishing.com